Murray Books

FOOTBALL

FOOTBALL

TOOTS™

"Think out of the Square"

First published in 2007
by Murray Books (Australia)
Reprinted in 2008 and 2009
This edition published in 2010
www.murraybooks.com

Copyright © 2007 Murray Books (Australia)
Copyright © 2007 Peter Murray

ISBN 978-0-9803131-7-8

Design and Production: Peter Murray

INSIDE

FOOTBALL

THE WORLD GAME

Football is truly a global phenomenon. The modern game, originating from Britain in the middle of the 19th Century, has touched virtually every corner of the globe. It stretches from the Western world's richest school playing fields to the dusty refugee camps of Sub-Saharan Africa and the backstreets of South America's slums. Its supporters follow the fortunes of the world's richest clubs such as Manchester United and Real Madrid, full of players with multimillion dollar superstar lifestyles, to the much more modest champions of FK Paxtakor in Uzbekistan and Kossa FC in the Solomon Islands – not forgetting all the thousands of children and amateur teams who give up their time to train and play for nothing more than the enjoyment of the game. The game is played by men and women, young and old, people of all races and religions. Even more experience it as spectators, either live in the stadium or via the mass communications technology of television, radio and the internet. It is universal. This book is a small attempt to give a window onto that world. Of course not everyone likes the game or even understands its appeal but even nations traditionally resistant to football, such as the United States and Australia, have begun in the last few decades to take the game seriously and is being played by ever increasing numbers as its popularity continues to grow.

Many of the players chosen for this book would be included in anyone's list of great players to grace the game and was was roughly based on the Top 100 lists compiled by various people such as Pele and organisations such as FIFA. There are at least a hundred players that could have easily been included and should have if space permitted. Inevitably with increased media coverage (especially through television) and the celebrity culture we now live in, a good players exploits today are magnified a hundred-fold compared to an amazing player of the past. This book in some ways unfortunately reflects this bias with only post-war players represented. There is an argument that the player's of the past would not be able to compete in today's game as it has changed and is much faster. However, this seems to me to be a fairly weak argument. How much better would an exceptional player of yesteryear be today if they also had the same nutritional diet, scientific based training, equipment, and coaching of today's stars? Enjoy this beautiful book and keep it for generations to come as a memento of the World Game.

THE ORIGINS OF FOOTBALL

Football has its roots in the team ball games of ancient civilisations. The game continued in various forms in Britain and Europe until the 19th Century. As Britain became more industrialised towns and cities grew and became increasingly connected by an expanding railway network. Teams now had the opportunity to play opponents from different towns. However, to play each other a unified code was needed. This would eventually split the game in two – into rugby union and modern association football - as fundamental differences in how the ball was to be primarily played emerged.

Early Ballgames
Team ball-kicking games date back to ancient times, some of which can be seen as precursors to the modern game of football.

Cuju (China)
In China a game called Cuju (or Tsu Chu) was popular as early as China's Spring and Autumn Period (770 BC - 476 BC) in one of the biggest cities in the world Linzi (its ruins lie today in the Linzi District of the Shandong province). "Cu" means to kick and "Ju" is a type of leather ball filled with feathers. Over time the game developed more established rules, with a designated special pitch called a Ju Cheng with moon shaped goals at either end. Although the game would be very different to today's game, it still included two teams (of between 12 to 16 players), goals with a net to score in, and kicking the ball without being able to use your hands. Its appeal grew and spread during the Warring States Period (roughly between 500-221BC). It was used in military training to improve coordination, leg strength and agility before becoming a form of entertainment. Played in the courts of the Han Dynasty (206 BC–220 AD), games would often be played during court feasts and diplomatic meetings. Professional players and clubs also began to appear. Its popularity continued until the Ming Dynasty (1368-1644 AD) when royalty neglected the game and it died out.

Kemari/ Kenatt (Japan)
In Japan a team ball game was played called Kemari, it was a non-competitive game that included between 2-12 players. Players were only allowed to use their feet and had to keep the ball in the air (like a large game of keepy-uppy or hacky sack) and passed it to one another. The ball is known as a Mari and is about 8-10 inches in diameter, covered in deerskin and stuffed with sawdust or barley grains. The pitch is called a kikutsubo marked out by trees, either grown to keep a permanent playing area or in pots to have an adjustable set-up depending on how many were playing. Traditionally cherry, maple, willow and pine trees were used. It was extremely popular in the 10th to 16th Century and is still played today by a small group of people who try to preserve this ancient sport.

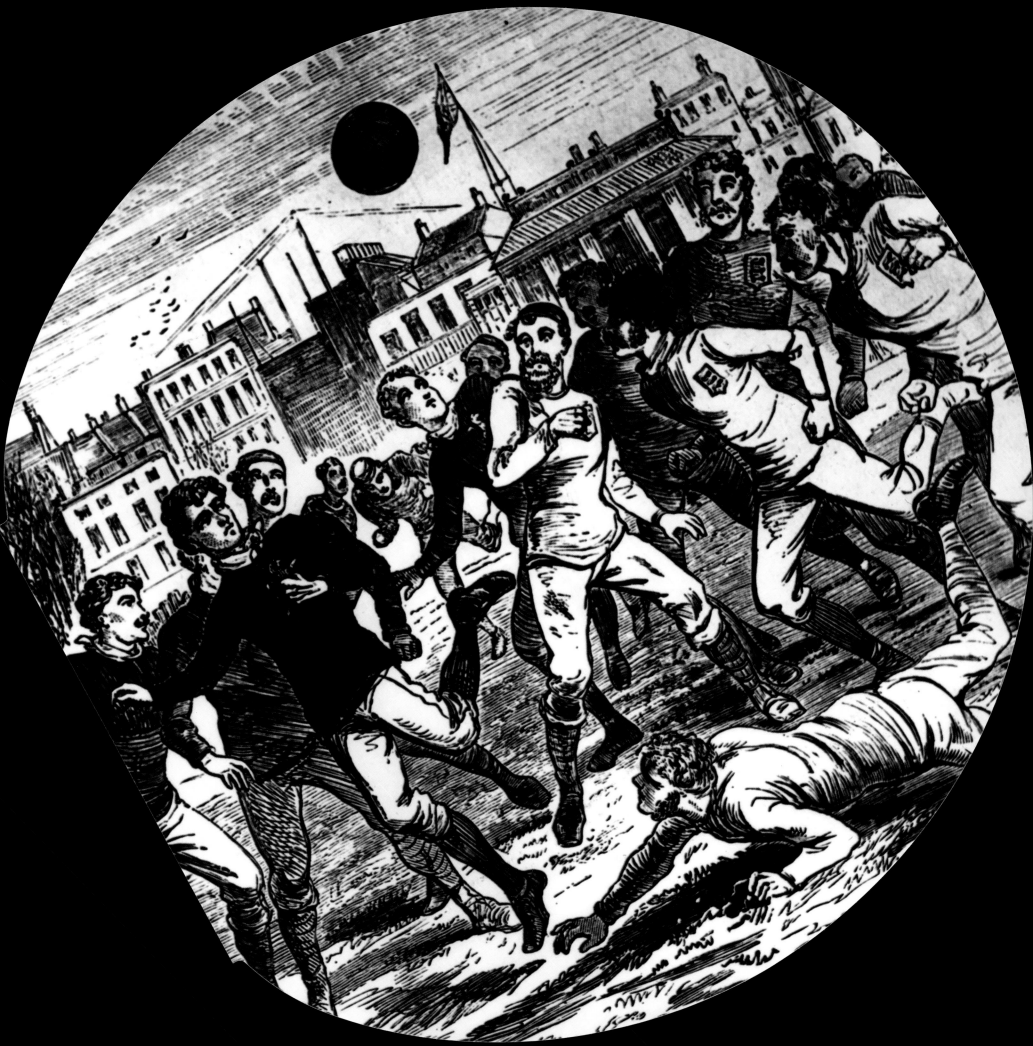

THE ORIGINS OF FOOTBALL

Europe

Episkyro (or Phaininda)/ Harpastron (Greece)

Team ball games were also played in ancient Greece, two of which have been claimed to be forerunners of today's football. Episkyro was recorded as early as 800 BC and has certain similarities, with 12 players on each team and a similar size of playing area. It was usually played nude predominantly by men but also women. However, this was not the only difference to today's game as it (and a similar game Harpastron) allowed players to use their hands, so probably more closely resembled rugby than association football.

Harpastum (The Roman Empire)

After the Romans conquered Greece in 146 BC they will have discovered these Greek ballgames, adapting and refining them into Harpastum. It was a rugby style game using both hands and feet that was practised by the Roman Army to improve their fitness. The ball was about 8 inches in diameter and was made from a stitched leather skin, stuffed with sponges or animal hair. The pitch was rectangular and a little smaller than an average football pitch today. It was a fast violent game as teams of 5-12 people tried to score by getting the ball over the opponent's line with only the person playing the ball allowed to be tackled. Local populations all over Europe (including Britain) picked the game up as the Roman

Empire expanded - remaining popular for 600-800 years before dying out.

The Americas

Pok-A-Tok/ Tlachtli (Mesoamerica)

The ancient civilisation of the Mesoamerican people (ancestors of the Mayans and Aztecs) were known to play a game called Pok-A-Tok as early as 3000 BC with a walled court in all their major cities. In 1985 archeologists found the oldest playing court at Paso de la Amada in Chiapas, Mexico. It dates back to 1400 BC, is 80 m long and 8 m wide with stone bench seating around the court, like a mini-stadium. Court ruins have been found as far north as Arizona, south as Nicaragua and also on Caribbean islands Cuba and Puerto Rico. The game is believed to have been played casually but also had ritual, political and social significance. Exemplified by the Aztec adaptation of the game, Tlachtli which was recorded by Spanish conquistadors in 1519 AD. The game was played in an I or H shaped court with disc markers, and a stone ring at each end of the court 8 – 10 foot off the ground, with a hole less than 30 cm wide. The ball was 10-15 cm in diameter and made of hard latex tapped from the rubber tree. Players could use their elbows, knees or feet and the ball was to be kept off the ground – in some ways an ancient version of basketball, volleyball and football all rolled into one. The Aztecs also attached cosmic meaning to the game with the ball

THE ORIGINS OF FOOTBALL

Choule/Soule (France)

Another adaptation of Harpastum was the French game of Choule or Soule. It is recorded as early as the 12th Century and originated from Brittany, Normandy, and Picardy. The game was often played between two villages after church services on Sunday until sunset or during religious holidays (such as Easter and Christmas). The game started after the ball was thrown up into the air (to represent the sun) at the midpoint between the villages with the aim to score a goal. The ball usually was a heavy leather stitched "ball" but could also be made from a filled pigs bladder or wooden solid ball. The goal could be to either bring the ball back to your own or your opponent's parish church, or simply marked out by a tree, wall, stream or even a home's hearth. Aristocrats referred to this violent proto-rugby football game as La Choule while the rest of the population called it La Soule until royalty and the clergy increasingly prohibited the game.

Mob football (England, Ireland, Scotland, Wales)

Numerous ball games have been played in Britain dating back to the medieval times and probably even earlier. Often referred to as mob football, which could have been influenced by either Harpastum or Soule (after the Norman conquest of 1066), it was often played on religious holidays such as Shrove Tuesday. It was an aggressive game between two nearby villages, both trying to get the ball into the opponent's town square or market place.

Despite being extremely popular after 1314, when King Edward II tried to suppress the game due to its impact on merchant activity, the game came under increasing pressure from royalty, nobility and the clergy as it was seen as uncivilised and interfered with trade. The name football first appeared in the 15th Century but referred not to how the ball was kicked but by people on foot rather than sports played by the rich on horseback. Despite being under attack by the Puritans and the powerful with threats of fines and imprisonment the game continued into the 19th Century.

THE MODERN GAME

Historical orthodoxy claims that this brutish game of the commoners was then refined by the elite public schools of England that split the game into rugby and association football. After which, rulebooks were published and missionaries of the game then took it to the general population in the late 19th Century.

However, this ignores the evidence that by this time a great variety of football style games existed; some unregulated free-for-alls like Shrove games but also more regulated Football such as Joseph Strutt chronicled in The Sports and Pastimes of the People of England published in 1801. He describes a game played between two teams of equal numbers on a pitch 75-90 m long with goals at either end (that included posts a yard/ 9 m apart). The aim was to force the ball (an inflated bladder encased in leather) into the other team's goal.

In a much more contemporary challenge to this theory, Adrian Harvey, in his painstakingly researched Football: The First Hundred Years, the Untold Story, published in 2005, details many instances of organised football within the working class communities from the mid-1800s onwards (often centered around the pub and church). He details 93 teams from a wide variety of backgrounds already

playing games to predetermined rules with fixed numbers of participants between 1830-59 - including schools/ universities (such as Richmond Grammar, Edinburgh Veterinary College and Manchester Athenaeum), army regiments (such as Bolton Rifle Regiment, Grenadiers 3rd Battalion and 1st Battalion Rifles), and workers (such as Deanston Cotton Mill, Blairdrummond Estate Workers, Sidney Smith's Tavern, and Whitford Lads). Harvey also details Britain's first football culture, an era usually passed over by historians, in the industrial Yorkshire city of Sheffield. Sheffield FC was formed in 1857 from middle class gentlemen as an athletics and cricket club but began to play football between members within the club. Not long afterwards they pieced together a rulebook with 11 laws; significantly it did not allow players to run with the ball in hand, hack and deliberate trip opponents, as well as inventing free kicks for fouls, corner kicks and crossbars. By 1863 there were 17 clubs in the city, adhering to the same rules, regularly playing each other. Sheffield FC also began organising games against teams outside the area from Lincoln, Nottingham and even a London Football Association team. By 1867 a regional knockout competition, the Youdan Cup, was also organised with neutral referees and some 3,000

Above: Illustrations of the first international football match, Scotland v. England, November 30, 1872. Opposite: January 1st, 1867: Soccer Eleven Members of the Harrow Soccer Eleven sitting in front of a pair of Gothic windows in their sports outfits.

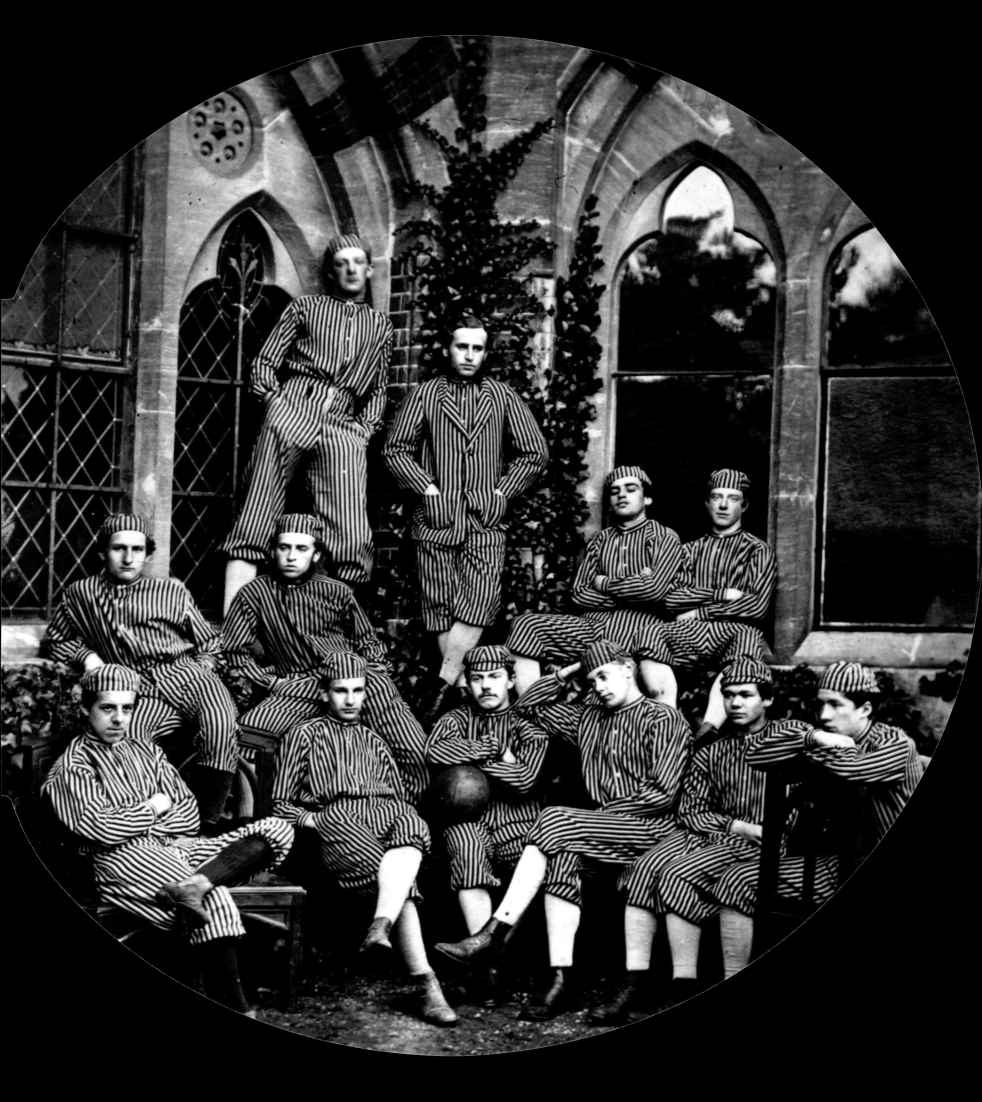

THE MODERN GAME

paying spectators. This group of teams became the Sheffield Football Association and also played a major role in the formative years of the Football Association.

It is also true, however, that ball games with differing rules had been played for years at England's elite (or public) schools with Rugby, Cheltenham, Marlborough and Westminster preferring to play a game that allowed carrying the ball with the hands while Eton, Harrow, Charterhouse and Westminster based on rules were kicking and dribbling the ball with the feet. There had been growing calls for a unified national code within England's public schools, to allow teams to play each other, which resulted in a number of attempts to reconcile the codes such as the Cambridge Rules in 1848. Later, one of its instigators a schoolmaster called J.C. Thring published his own set of rules derived from this in 1862 called The Simplest Game. Ebenezer Cobb Morley, captain of the London Barnes Club (now a rugby union team) and founder of the Football Association (FA), called for a governing body to administer the game in a sports chronicle, Bell's Life in London. It led to a meeting of twelve London teams at the Freemason's Tavern in London on the

evening of 26th October 1863 including Barnes, Blackheath Proprietary School, Charterhouse School, Civil Service, Crusaders, the original Crystal Palace, Forest of Leytonstone (later known as The Wanderers), Kensington School, N.N. Kilburn (or No Names), Perceval House, Surbiton. It took a further 6 meetings before the rules, largely based on Thring's Simplest Game, could be agreed upon and by then a major schism had developed within the delegates over rules only allowing the ball to be caught with the hands in a "fair catch" (after which a player makes his mark and was not allowed to carry or run with the ball in his hands), and hacking (kicking an opponent's legs below the knees) and tripping was disallowed. This eventually led to the split that created modern rugby football. The Rugby Football Union in 1871 (with the foundation of the Rugby Football Union in 1871) and association football. Clubs such as Sheffield and Nottingham (who became Notts County), became members of the FA, and were joined by Nottingham Forest (to begin football's longest derby rivalry), Stoke and Chesterfield. The game also flourished in Scotland during this period with the formation of the Scottish FA in 1873.

Above: The Royal Engineers team that reached the first FA Cup final.

Opposite: Cup Final 21st April 1900: Bury and Southampton in action during their FA Cup final match at Crystal Palace. Bury won 4-0.

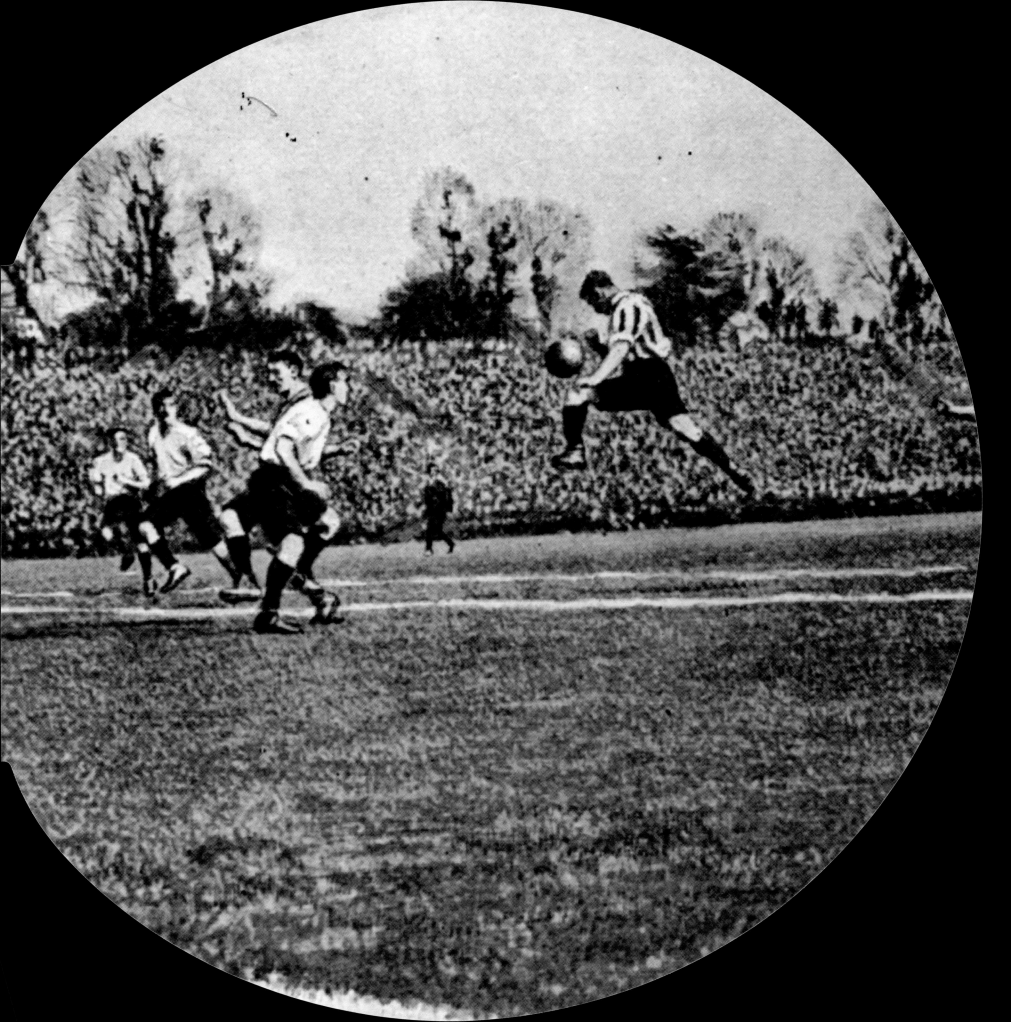

THE MODERN GAME

In 1871 a national Challenge Cup (or the FA Cup) was established. It was won for the first time in 1872 by The Wanderers who beat the Royal Engineers 1-0, making it the oldest surviving football competition in the world. The FA Cup was extremely popular and as all competing teams had to conform to FA rules it helped spread a universal code of the game throughout Britain. The game, however, officially stayed within the realm of privileged "southern gentlemen" amateur teams with the Wanderers, Oxford University, Old Etonians, Old Carthusians and Royal Engineers all winning the competition until professional teams from the north began to dominate with first Blackburn Olympic (1883) and then their arch-rivals Blackburn Rovers (1884-86) winning the trophy.

Creeping professionalism was creating further controversy and after years of debate was reluctantly legalised in 1885. It is widely seen as the point that the public schools primary interest became rugby as the sport of choice and football became a game of and for the workingman.

In 1888, William McGregor, a director of Birmingham based Aston Villa, held a series of meetings in London and Manchester that included 12 teams with the intention of forming a national league. This meant that professional teams could guarantee regular permanent

fixtures as each team played each other twice, both home and away, with 2 points for a win and 1 point for a draw. As there was regular income they could pay their players to train and play - greatly improving the standard. Preston North End became known as the Invincibles as they remained unbeaten to win the first league as the modern era of football truly began. British migrant workers, merchant seamen, traders, engineers, educators, and the military all took the game with them around the globe as its popularity flourished in the British Empire and began to penetrate into Europe and South America with the foundation of numerous clubs and leagues.

Over the following century the game continued to refine its rules and administration, as well as improve its tactics, training, equipment and facilities. It made football (or soccer), both to play and watch, the most popular sport in the world with millions involved. Today there is a football team in nearly every town in the world, with over 200 countries organising a national league (usually supported by numerous leagues beneath), and a plethora of local, regional, national and international competitions. It continues to play an important, sometimes vital, role in the lives of individuals as it has become interwoven into the fabric of nearly every society on earth.

Above: Blackburn Rovers 1884. Opposite: January 1st 1888: The Royal Arsenal football squad. Previously known as Dial Square and then Woolwich Arsenal, the team became known simply as Arsenal in 1914.

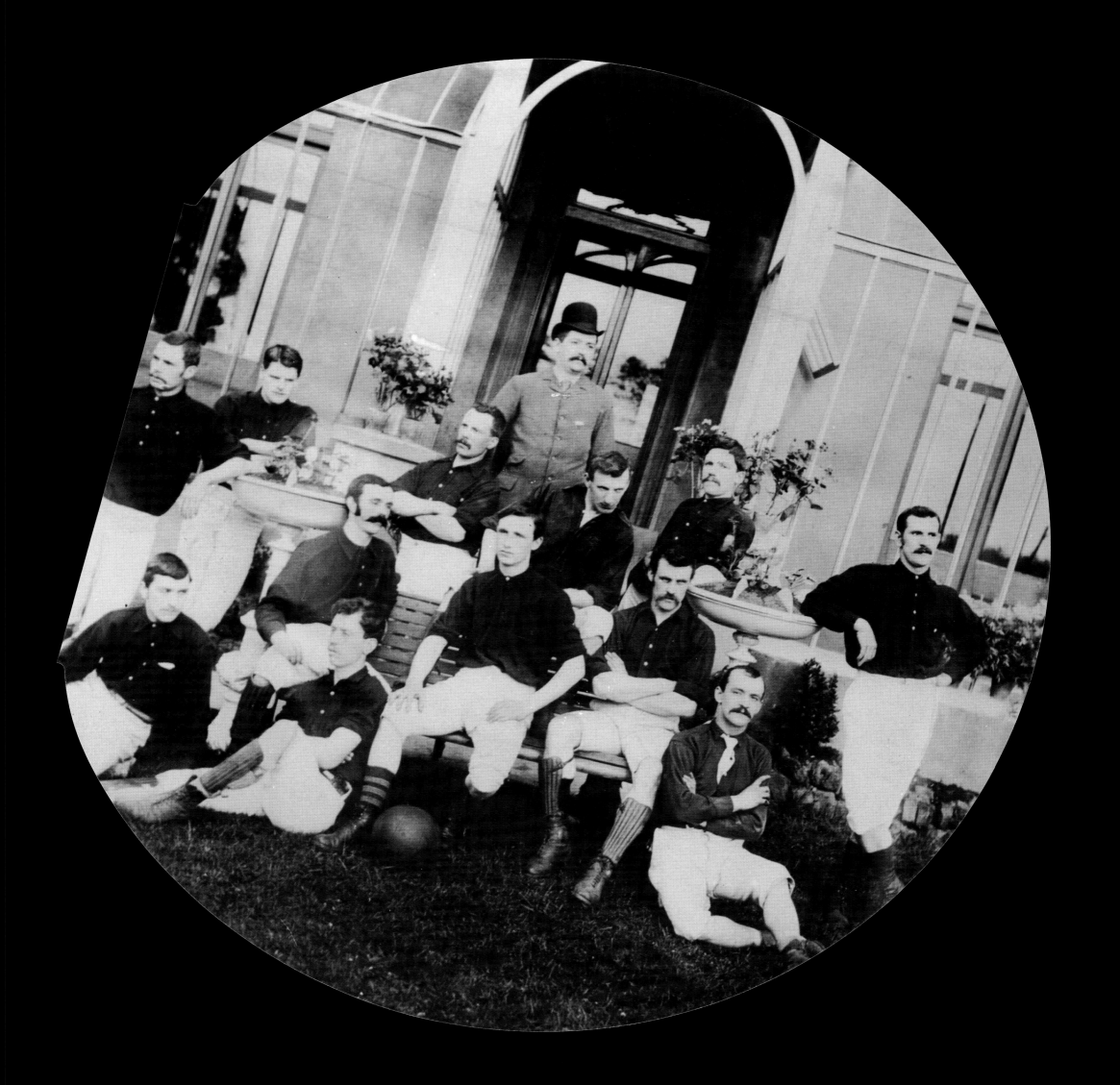

LAWS OF THE GAME

Part of football's appeal is its simplicity. All you need is a ball (of some description) and a couple of players divided into two teams. Mark out two goals with a couple of items of clothing, two sticks, or even a parked car and you have a game. However, the professional game with such intense pressure and money involved has strict rules about how the game is played. Despite tinkering here and there, however, the game still generally adheres to the rules put forward in the late 19th Century at the formation of the English Football Association. The aim of the game is simply to score more goals than the opposing team. Only goalkeepers are allowed to use their hands and only in their own penalty area but can use their feet anywhere. Outfield players can only use their feet, except when taking a throw-in. If a ball is deliberately hand-balled (this includes from the fingers to the shoulder) then a player is penalised. Depending where the hand-ball took place a free kick or penalty is awarded to the opposing team. If a ball is hit at a part of the body, however, then it is classed as "ball to hand" and therefore unintentional, is ignored and play continues.

Players/ Officials
Teams

A football match is played between two teams of eleven players, one of which is the goalkeeper. An official match cannot start or continue if either team consists of less than 7 players. Famously in England, during the Battle of Bramall Lane, when Sheffield United played West Bromwich Albion in March 2002, a game was abandoned after Sheffield United were left with only 6 players on the pitch. Losing 3-0, having had 3 players already sent-off, two Sheffield United players left the pitch apparently injured – meaning the game was halted on the 82nd minute and the controversy began. Neil Warnock, United's manager, was accused of deliberately trying to void the match - in the end, he was fined £10,000 by the Football Association and the result was allowed to stand.

Officials

The game is controlled by the referee, aided by two assistant referees (who remain on the touchlines) and where available a fourth official outside the field of play. The ref acts as timekeeper, ensures all rules are kept, punishes infringements, stops the match for any injuries and can abandon a match if necessary due to severe weather or crowd violence. The assistant referees help with any incidents the ref has missed, offside decisions, which side is entitled to a corner/ goal kick, when a substitution is requested, and advises on whether the ball has been kept in play. Without doubt it is a thankless task, as both receive a fair degree of pressure over decisions from players and supporters.

FOOTBALL

LAWS OF THE GAME

Kick-off/ Duration
Kick-off
Before the game starts a coin is tossed and the winning team decides which goal it will attack in the first half, the opposing team kicks-off first. In the second half the teams swap ends and the other team kicks-off. A kick-off is used to start a game at the beginning of either half and extra-time or to restart after a goal has been scored by the opposing team. For kick-off, both teams must be in their own half and outside the centre circle (except two players from the team kicking-off). The ball is placed on the centre mark and when the ref blow his whistle is kicked. The first player to kick the ball is unable to play the ball again until another player has touched it.

Drop Ball
Play can also be restarted after a stoppage while the ball is in play through a dropped-ball – the ref simply drops the ball to the ground and play continues when it touches the pitch.

Duration
The match lasts for two periods of 45 minutes each (although if both teams and ref agree before kick-off, a game can be played for less time, i.e. if there is insufficient light). The game is divided by a half-time interval of 15 minutes when teams can leave the pitch and interact with managers, physios, etc. Time is added, at the discretion of the ref, for substitutions, injuries, removal of injured players from the pitch, time wasting and any other stoppages. Extra time of two equal halves (usually of 15 minutes each) can be used to resolve a tied match, depending on a competition rules. An abandoned match is usually replayed.

Scoring/ goals/ tie-breaking
Scoring
A goal is scored when the whole of the ball crosses the goal line between the goal posts and under the crossbar – providing no rules have been broken in the scoring of the goal (i.e. a hand ball, the fouling of the goal keeper, a player being in an off-side position, etc.). Many controversial goals have been given and goals that should have been disallowed – England's third goal in their 4-2 victory over West Germany in the World Cup in 1966 continues to vex professional and armchair commentators alike after 40 years – and has led to a growing call for video technology to monitor goal line decisions.

Winning, Tie-Breaking, Goal Difference
The winning team is the one who scores the most goals at the end of the match. If the same amount of goals are scored (or none are scored by either team) then it is a draw. How a win or draw is treated depends on the competition.

League Matches, Points
In a league match a team is usually awarded 3 points for a win and 1 for a draw. Over a season teams play each other twice at both team's grounds or "home" and "away". The league winner is the team with the most

LAWS OF THE GAME

points when all games are completed. If teams are tied on points, at any point in the season, then the amount of goals scored is compared to goals conceded during the season to produce a goal difference (i.e. Quarrymen Rovers score 89 goals but concede 62 goals, this equals a goal difference of +27. Equal on points are 101ers United

who have scored 23 but let in 47 and thus have a goal difference of -24. Quarrymen Rovers are therefore placed higher in the league than 101ers United). If teams are tied on points and goal difference, then the team who has scored more is placed higher.

Knockout competitions

In a knockout competition, a winning team progress to the next round or if it is the final wins the tournament. However, a drawn game can be resolved in a number of ways to see who progresses. Sometimes a match is replayed at the opponent's ground - as ties could take many matches to resolve, usually nowadays if the replay is drawn the game moves into extra-time and then a penalty shootout to decide the winner. Most often, however, extra-time is played after the first draw, with 30 minutes split into two halves with a short break in between. If the game is still tied then a penalty shootout settles the tie.

Penalty Shootouts

At the end of extra-time each team takes 5 penalties alternately, the winner being the team who scores the most. While the penalties take place all other players must wait in the centre circle, except the opposing keeper who waits at the edge of the penalty area on the goal line. Only players on the pitch at the end of the game may take a penalty and only one penalty may be taken by each player until all the players on their team have taken one. If one of the team is unable to score as many as their opponents before 5 have been taken, then no more penalties are necessary and the opposing team wins. However, if the game is still tied after 5 penalties then the tie moves into sudden death penalties where each team gets a penalty until someone misses and the other scores i.e. Quarrymen Rovers and 101ers United both score 4 of their first 5 penalties, the game then goes to sudden

LAWS OF THE GAME

death – first round: John (Rovers) scores, Joe (United) scores = teams still tied. Round two: Paul (Rovers) misses, Mick (United) misses = teams still tied. Third round George (Rovers) misses while Paul (United) scores = 101ers United wins.

Golden Goals
In an attempt to find another solution to break-tied matches a method called the Golden Goal was introduced. If a game is drawn in regulation time, extra time is played and the first team to score wins the game. If it is still tied at the end of extra time then penalties are used to decide the match.

Away Goals Rule
This is a tie-breaking method applied in knockout competitions that take place over two-legs (or two home and away matches). If a game is tied on an aggregate score at the end of both matches then the team who has scored the most goals "away from home" progresses. If the match is still tied then the game goes to a penalty shoot-out.

Ball in and out of play/ Throw-Ins/ Corners/ Goal kicks
A ball is out of play if it wholly crosses the touchline or goal lines either on the ground or in the air.

Throw-in
If it crosses the touchline, it is a throw-in to the opponent of whoever touched the ball last, from the point where it went out of play. The thrower must face the field of play, use both hands and throw the ball from behind and over their head. The player is not allowed to the touch the ball a second time until another player has touched it. A player is also not allowed to score directly from a throw-in.

Goal kick
If the ball crosses the goal lines (and is obviously not a goal) then a goal kick or corner is awarded depending who touched the ball last. If the attacking team last touched the ball a goal kick is awarded to the defending team. The ball is then kicked from any point in the goal area by a player of the defending team (usually the goal

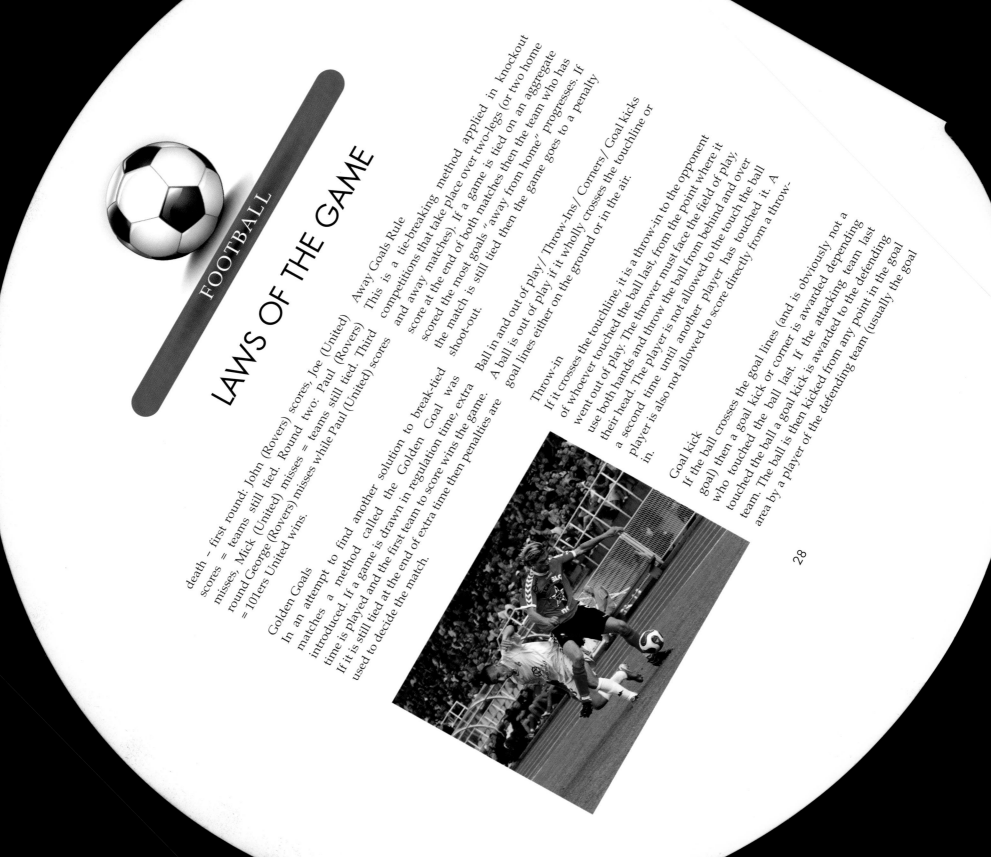

28

FOOTBALL

LAWS OF THE GAME

keeper), opponents must remain outside the penalty area until the ball is in play - which is when the ball is outside the penalty area. The kicker is also not allowed to touch the ball a second time until it has touched another player. A goal against the opposing team can be scored directly from a goal kick.

Corner
If it is the defending team who touched the ball last, then a corner is awarded to the attacking team. The ball is placed inside the corner arc, the corner flag is not moved, and opponents must be 10 yards (9.15 m) away from the ball. The ball is then kicked by an attacking player and cannot be touched a second time until touched by another player. A goal can be scored directly from a corner.

Foul play/ Misconduct/ Free kicks/ Penalties
Direct and indirect free kicks are awarded to penalise players who commit an infringement. The free kick is taken from where the misconduct took place. The ball must be stationary and all opponents must be 10 yards (9.15 m) from the ball – any infringement means the kick is retaken. Again the kicker cannot play the ball a second time until another player has touched the ball.

Direct free kick: Means a goal can be scored against an opponent directly from the free kick. They are used to punish a player who kicks, trips, jumps at, charges at, strikes, pushes, holds or spits at an opponent. Or tackles an opponent to get possession of the ball but makes contact with the player before the ball or handles the ball deliberately (except the goalkeeper in his own area). A penalty kick is awarded if any of these take place when the ball is in play in the player's own penalty area, regardless of where the ball is.

Indirect free kicks: Means a goal can only be scored after it touches another player. If a player scores from an indirect free kick without touching another player a goal-kick is awarded. They are also awarded to the opposing team if a goalkeeper in his own area takes longer than 6 seconds to release a ball while in his hands, touches the ball again with his hands if it has not been played by another player, touches the ball with his hands after being deliberately kicked to him by a team-mate, or touches it with his hands directly from a throw-in. It is also awarded to the opposing team if a player plays in a

LAWS OF THE GAME

dangerous manner (such as a raised foot above head height), impedes the progress of a player, prevents a goalkeeper from releasing the ball from his hands, or commits another offence which the game needs stopping for.

Penalty kick: During a penalty, the goalkeeper must remain on his line until the ball is kicked. All other players except the penalty taker must remain outside the penalty area and at least 10 yards (9.15 m) from the ball. Any player, including the goalkeeper, can take a penalty. When players are in position the ref signals for the kick to be taken, the player taking the penalty kicks the ball forward (and cannot play it a second time until it touches another player) – a goal is scored if the ball enters the net. If it is saved or rebounds off the frame of the goal then play continues (but not in a penalty shoot out).

Yellow/ Red Cards
Players can be cautioned and disciplined at the discretion of the referee. A player is shown a yellow card if they are guilty of unsporting behaviour, persistently infringes the laws of the game, delays the restart of play, does not comply with distances from free kicks/ corners, or leaves/ enters the field of play without the ref's permission. A player is shown a red card and sent off if guilty of serious foul play, violent conduct, spits at someone, denies the opposing team a goal or obvious goal scoring opportunity through deliberately handling the ball (except obviously the goalkeeper in his own area) or an offence punishable by a free kick or penalty,

uses abusive language or gestures, or receives a yellow cards. A sent off player must leave the pitch and technical area.
Players are allowed to take liquid refreshments during a match but only from the touchlines when there is a stoppage in the match.

Offside
It is not an infringement to be offside, but a player is in an offside position if they are nearer to their opponent's goal line than both the player and the second last opponent. A player is not offside if they are in their own half, level with the second last opponent or the last two opponents. A player is only penalised if they are in an offside position at the moment a ball is played or touched by one of their own team and they are in "active play". A relatively recent and controversial concept, "active play" is determined by the referee and is when a player is interfering with play or an opponent, or gaining advantage by being in that position. A player is not offside if they receive the ball directly from a goal kick, throw-in or corner kick. For any infringement an indirect free kick is awarded to the opposing team where the offside occurred.

Field of Play / Equipment

Kit

Players must wear a kit that includes a jersey, shorts, stockings, appropriate footwear and shin-guards (covered by stockings) for protection. They are also not allowed to wear anything that could injure themselves or another player (including any kind of jewellery). The goalkeeper is allowed to wear goalkeeping gloves and must wear a kit that distinguishes him from the other players and officials.

The Ball

The ball used should be spherical and must have a circumference of not more than 70 cm or less than 68 cm. It must be made of leather (or other suitable material) and weigh at most 450g and not less than 410g when the game kicks off.

The Pitch

An official football pitch is rectangular in shape with goals at either end. The minimum length for a pitch at club level is 90 metres and the maximum allowed is 120 m, while the minimum width is 45 m and is allowed up to 90 m. This gives some scope for difference; but in the UK most league pitches are roughly 105 m long by 68 m wide. FIFA recognised international pitches must conform to slightly more stringent dimensions, however (between 100-110 m long, and 64-75 m wide). 12 cm white lines mark out the boundary of the pitch. The two longer lines of the rectangle are called the touchline, the two shorter end ones (where the goals are) are goal lines.

The pitch with a goal on either side is divided into two halves by a halfway line with a centre mark at the midpoint of the halfway line, there is then a centre-circle marked around it of 10 yards (9.15 m). In each corner is a flag not less than 1.5 m high, with a quarter circle with a 1 m radius marked out.

Goalposts

The goals are placed at the halfway point on the goal lines, the uprights must be 2.44 m and the distance between the two (joined by the crossbar at the top) must be 7.32 m with the posts/ crossbar at the top being no bigger than 12 cm. Nets are attached at the back of the goals and a depth of 80 cm at the top and 2 m at the bottom) and a goal line runs between the posts. Around the goals is marked the goal area; this runs 5.5 m either side of the posts at right-angles from the goal line into the pitch for 5.5 m and is then joined by a line parallel to the goal line. Outside of this is the penalty area, its shape follows the

LAWS OF THE GAME

goal area but with the dimensions of 16.5 m, within this is the penalty spot (11 m from the centre of the goal) and an arc circle with a radius of 10 yards (9.15 m) is marked outside the penalty area.

Goalpost Safety

There has been growing concern recently about the number of serious injuries and deaths (31 since 1979 in America alone) caused by portable goals collapsing. Prompting organisations such as AnchoredForSafety.org to suggest that all portable goals should be securely anchored, regularly checked and dismantled when not in use.

Technical Area

As well as the pitch there is also a Technical Area, which is a designated seated area for technical staff (the manager, physio, etc.) and a team's substitutes. Their sizes vary in each stadium but extend roughly to a metre on either side of the seated area and can extend forward to a distance of a metre from the touchline. Players and staff in the area should remain in the area except in special circumstances (such as a physio coming on for an injured player, etc.) while staff and players are supposed to remain seated except one person who is allowed to give tactical instructions, after which is supposed to return to their position.

substitutes during the match, although if both teams agree and inform the referee before a game kicks off then this can be altered (i.e. for friendly or exhibition matches). In all games, potential substitutes names must be given to referees before the game starts as part of a team sheet. When a substitution is made, the referee is informed and the sub can only enter the pitch to play after the replaced player has left the pitch and the ref has signalled for them to come on. The sub has to come on at the halfway line during a stoppage in the match, as soon as they enter the field of play the replaced player takes no further part in the match. A goalkeeper can be substituted or replaced by an outfield player as long as the referee is told before the change is made and it happens during a stoppage. This only really happens if all 3 substitutions have been made and the keeper is injured.

Youth and women's football are allowed to alter some of these rules, depending on the competition and agreement between both teams prior to kick off.

Governing bodies

The world game is governed by a pyramid of organisational bodies, with FIFA at the top responsible for its overall operation. To oversee the game on each continent they have also created six regional confederations: the Asian Football Confederation (AFC), Confédération Africaine de Football (CAF), Confederation of North, Central American and Caribbean Association Football (CONCACAF),

Substitutions

An official match recognised by FIFA, regional confederations and national associations allows up to 3

36

LAWS OF THE GAME

Confederación Sudamericana de Fútbol (CONMEBOL), Oceania Football Confederation (OFC), and the Union of European Football Association (UEFA). These are member associations, made up of each nation that they represent (who also separately belongs to FIFA). They organise international tournaments at both club and country level.

The national associations then administer the game in their own country - the domestic league and cup competitions, as well as their national team. In total FIFA recognises 213 senior men's and 129 women's teams from their various national federations. All these organisations are responsible for the proper running, laws, and development of the game.

As the world's national boundaries have become increasingly fractured and contested – there are a number of territories and states who want a football team to represent them at international level. As many of these are not identified as sovereign states FIFA does not officially recognise them. In 2003 a world organisation was established, called the Nouvelle-Fédération Board, to promote and facilitate games between these teams. It currently has 21 members who can compete via their own alternative international competitions the Viva World Cup and the ELF (Equality, Liberty, Fraternity) Cup.

LINKS

FIFA web site: http://www.fifa.com

Asian Football Confederation web site: http://www.the-afc.com

Confédération Africaine de Football web site: http://www.cafonline.com

Confederation of North, Central American and Caribbean Association Football web site: http://www.concacaf.com

Confederación Sudamericana de Fútbol web site: http://www.conmebol.com

Oceania Football Confederation web site: http://www.oceaniafootball.com

Union of European Football Associations web site: http://www.uefa.com

Nouvelle-Fédération Board web site: http://www.nf-board.com

38

UEFA CHAMPIONS LEAGUE

The UEFA Champions League remains the most prestigious club competition in the world. It has also become incredibly lucrative with UEFA estimating that in 2005/06 it distributed Euro430 million between the 32 groups–stage finalists.

Gabriel Hanot, a journalist and editor for French daily sports paper, L'Équipe, had initially been inspired by the Mitropa Cup - an interwar tournament between clubs from Austria, Hungary, Czechoslovakia, Yugoslavia, Italy and Switzerland. However, for the former French player and national team coach, the catalyst for establishing the competition came after travelling to England to watch Wolverhampton Wanderers play Hungary's Honvéd and the USSR's Spartak Moscow. After winning both matches, the Daily Mail newspaper headline exclaimed: "Hail Wolves, Champions of the World Now." Hanot thought this was farfetched and suggested in his paper's editorial that a European competition should be organised to prove which team really was the best. The paper enthusiastically promoted the idea and lobbyed clubs. A competition between the continent's national league winning clubs was envisaged. With teams playing each other, home and away, in a knockout competition. The winner could then justly be able to claim to be the champions of Europe. A year later, the first game was played. Sporting Clube de Portugal and FK Partizan from Yugoslavia played out a thrilling 3-3 draw to a packed stadium. As Jacques Ferran, Hanot's colleague, who wrote up the competition's rules, said; "We knew at that moment we had created something very special."

Real Madrid took the Cup by storm, winning the first five competitions. The legendary team of Ferenc Puskás, Alfredo Di Stéfano, Raymond Kopa, Gento and José

Santamaría began its domination by beating French team, Stade de Reims Champagne 4-3 to win the first competition. It ended in 1960 with the demolition of West Germany's Eintracht Frankfurt 7-3 in Glasgow in front of 135,000 spectators. A sixth consecutive title was not to be though as Barcelona won the league and therefore qualified. They also made it to the final but lost 3-2 to an exceptional Portuguese side, Benfica – who had scored 24 goals in the previous 4 games! In the following season they also went on to be the first side to beat Real Madrid in the competition with a 5-3 victory in the final. Since then the competition has been relatively open with teams from ten countries winning the trophy. With the continent's top three leagues providing the most champions (11 both for Spain and Italy, 10 for England and Germany (6), Netherlands (6) and Portugal (4) all have significant success. While France, Romania, Scotland and Yugoslavia all providing one champion. Spain's Real Madrid remain the most successful club with an incredible 9 trophies, while Italy's AC Milan have 7 and England's Liverpool have won it 5 times. Ajax Amsterdam and Bayern Munich both had exceptional runs in the competition, with 3 consecutive titles each during the 1970s. Ajax inspired by Cruijff beat Panathinaikos, Internazionale and Juventus (1971-73), while Bayern led by Beckenbauer beat Atlético Madrid, Leeds United and St. Étienne (1974-76). Before English clubs dominated the trophy winning every trophy except one between 1977 and 1984 through Liverpool, Nottingham Forest and Aston Villa. Before the Heysel Stadium disaster in the 1985 final between Liverpool and Juventus led to English clubs being banned from European football for 5 years, it took another 10 years before an English team won the competition again with Manchester United's dramatic injury time 2-1 victory

Opposite: Roberto Baggio of Juventus in action during th UEFA Cup Final match between Juventus and Borussia Dortmund on May 19, 1993 in Turin, Italy.

40

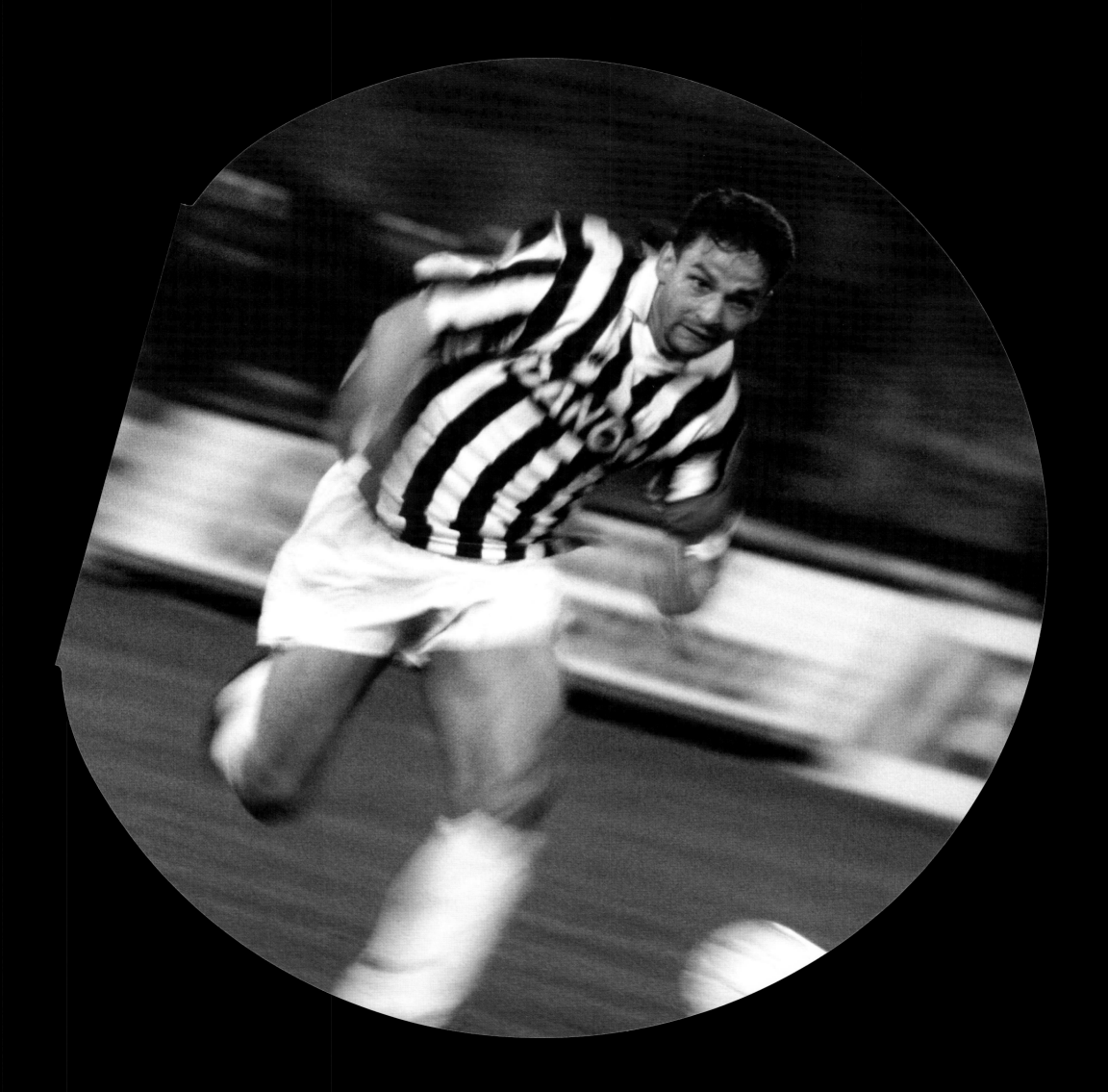

UEFA CHAMPIONS LEAGUE

over Bayern Munich. No nation has dominated the trophy since then, although you can be fairly confident in seeing a Spanish, Italian, German or English club competing in the finals. There have been a handful of upsets worth mentioning, however. In 1986 Romania's talented squad of Steaua Bucureflti beat Barcelona to be crowned champions, after goalkeeper Helmuth Duckadam saved all four of Barças penalties to become the first Eastern European team to win the trophy. The second was Yugoslavia's Crvena Zvezda (more commonly known as Red Star Belgrade), who beat France's Olympique de Marseille in 1991 also in a penalty shootout. While for many the biggest surprise in recent times came when FC Porto beat AS Monaco 3-0 to be crowned champions.

The European Champions Cup followed the original format until it was profoundly restructured and renamed the UEFA Champions League for the 1992/93 season. With French side Olympique de Marseille beating Italy's AC Milan 1-0 to win the inaugural competition. The competition now included a round-robin (home and away) league system and knockout stages. It also expanded to involve more than one team from each nation but with the greater number of European national leagues producing champions (after the emergence of the Baltic countries, former Yugoslavian countries, etc.) UEFA introduced a "coefficient" system in an attempt to maintain the strength and integrity of the competition. This means that a country's national league and clubs are ranked depending on their performance over the previous five seasons with bonus points added for success in European competitions. From this UEFA allocates the number of places each country has in the Champions League and also the UEFA Cup. It then seeds the teams to decide at what point they enter the competition. Winners of every league enter the competition but "weaker" clubs have to play qualification rounds to progress before eventually making it to the group stages, where they meet the continent's elite of clubs.

For the 2007/08 UEFA Champions league 76 teams take part with four places granted to Spain, England and Italy; three places granted to France, Germany, and Portugal; two teams each for Netherlands, Greece, Russia, Romania, Scotland, Belgium, Ukraine, Czech Republic, and Turkey; while the winners of the rest of Europe's leagues qualify. There are three qualifying rounds, with the losers of the third round entering the 3rd round of the UEFA Cup, and the winning 16 teams entering the final group stages of the competition. They join 16 more teams who automatically qualify: the previous years winners as defending champions, the winners and runners-up of the top 6 ranked national leagues (Spain, Italy, England, France, Germany and Portugal) and the winners of the next three ranked nations (Netherlands, Greece and Russia). This stage witnesses all teams split into 8 groups of 4 clubs who play each other home and away, the winner and runner-up then progress to a knockout stage through a 2nd round, quarter and semi finals through to the final. Critics argue this favours the "big" nations too strongly and only consolidates their power. While supporters point to the recent qualification of Maccabi Tel-Aviv (of Israel) in 2004/05, Artmedia Bratislava (of Slovakia) in 2005/06, and Levski Sofia (of Bulgaria) in 2006/07 to prove that "smaller" teams are still able to make it to the final group stages.

Such a glorious competition has also witnessed great tragedy also at the Heysel Stadium and Munich Air Disaster but each year also continues to provide plenty of dramatic emotion-packed games and many of the iconic moments in modern football's history.

Opposite: Kaka of Milan celebrates with the trophy following his teams 2-1 victory during the UEFA Champions League Final match between Liverpool and AC Milan at the Olympic Stadium on May 23rd, 2007 in Athens, Greece.

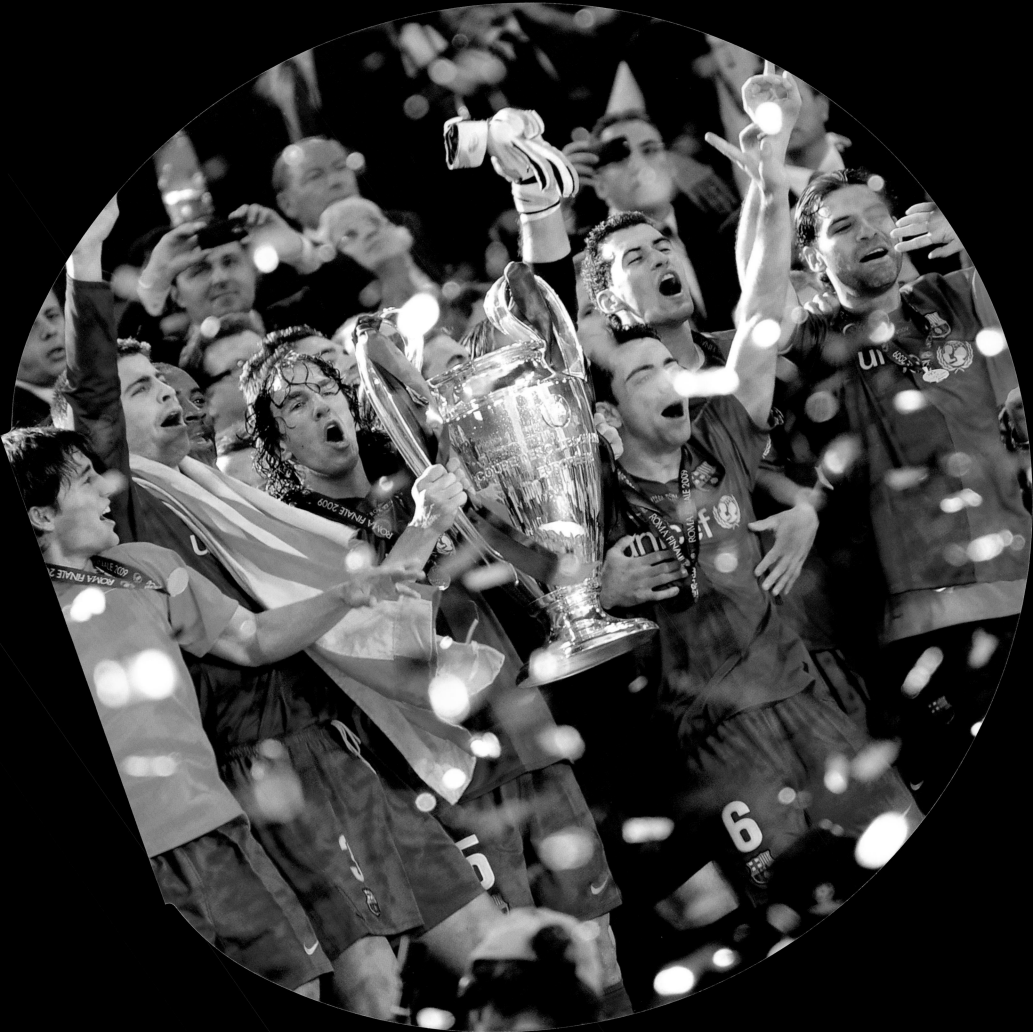

AFRICAN CUP OF NATIONS

Africa's raw talent has long been recognised, beginning in earnest with the arrival of players in Portugal from Mozambique and Angola during the 1950s. However, a continent's optimism at the dawn of its post-colonial era has been shattered by years of war, ethnic conflict, instability, military coups, corruption and dictatorship. This has been combined with chronic poverty, debt, famine and inequality, as well as recently been further compounded by an AIDS/ HIV+ pandemic of truly terrifying magnitude. Despite its depressingly enduring problems, Africa's passion for football is undiminished and the continent's potential continues to shine through. Pelé predicted that an African country would win the World Cup by 2010 and although this has yet to happen, over the last twenty five years the strength, power and skill of its national teams from Cameroon, Nigeria, Senegal, Ghana and Côte d'Ivoire have lit up the World Cup finals. That is not to forget teams from Northern Africa, traditionally the strongest on the continent, such as Tunisia and Morocco qualifying for four World Cup's each, while Egypt and Algeria also both appearing twice. African players have also become integral to many of the world's top clubs including the top leagues of England, Spain and Italy.

The continent's own football competition, the African Cup of Nations, can be traced back to 1956 and a FIFA meeting in Lisbon, Portugal with the formation of Confédération Africaine de Football (CAF). The first continent wide competition was proposed for the following year in Khartoum, Sudan. Four of CAF's founding members – Ethiopia, Sudan, Egypt and South Africa - planned to compete but as South Africa refused to send a multi-racial squad, due to its system of apartheid, they were disqualified. This handed Ethiopia a bye to the final where they met Egypt. Egypt had already beaten Sudan 2-1 in the semi-finals and went on to demolish Ethiopia 4-0 to claim the first African champions title. The tournament held every two years continued to grow as more teams from around Africa (such as Ghana, Nigeria and Tunisia) started to compete. By 1968, the 6th tournament held, twenty-two teams were eligible to qualify and the finals expanded to include eight teams in two groups, with the top two progressing to the semi-finals. The semis saw hosts Ethiopia beaten 3-2 by Congo-Kinshasa, today known as Congo DR, and Ghana beat Côte d'Ivoire 4-3 The final saw Congo-Kinshasa win 1-0. This format operated until 1992 when the finals expanded to include 12 teams.

In 1970 FIFA guaranteed a place for an African team at the World Cup for the first time and Morocco became the first team from the continent to compete in 1970. Zaire (as Congo-DR was known) followed in 1974 and in some ways can be used as a yardstick for just how far football in Africa has come. They lost all three matches in West Germany against Scotland (2-0), Brazil (3-0) and included a record 9-0 defeat to Yugoslavia. In the 2006 World Cup, five African sides are able to qualify and even "minnows" like Togo managed to give a decent account of themselves, while Côte d'Ivoire, Ghana, and Angola provided thrilling entertainment and were unlucky not to progress further. While the 1970s witnessed six different teams winning the African Cup of Nations (Sudan, Congo Brazzaville, Zaire, Morocco, Ghana and Nigeria) the 1980s saw the emergence of two of Africa's stars, Cameroon and Nigeria. In only one of

Opposite: Ivory Coast Elephants defender Arthur Boka vies with Madagascar's Randrianarisoa during their African Nations Cup 2008 qualifying match in Bouake 3rd June 2007. Ivory Coast won 5-0.

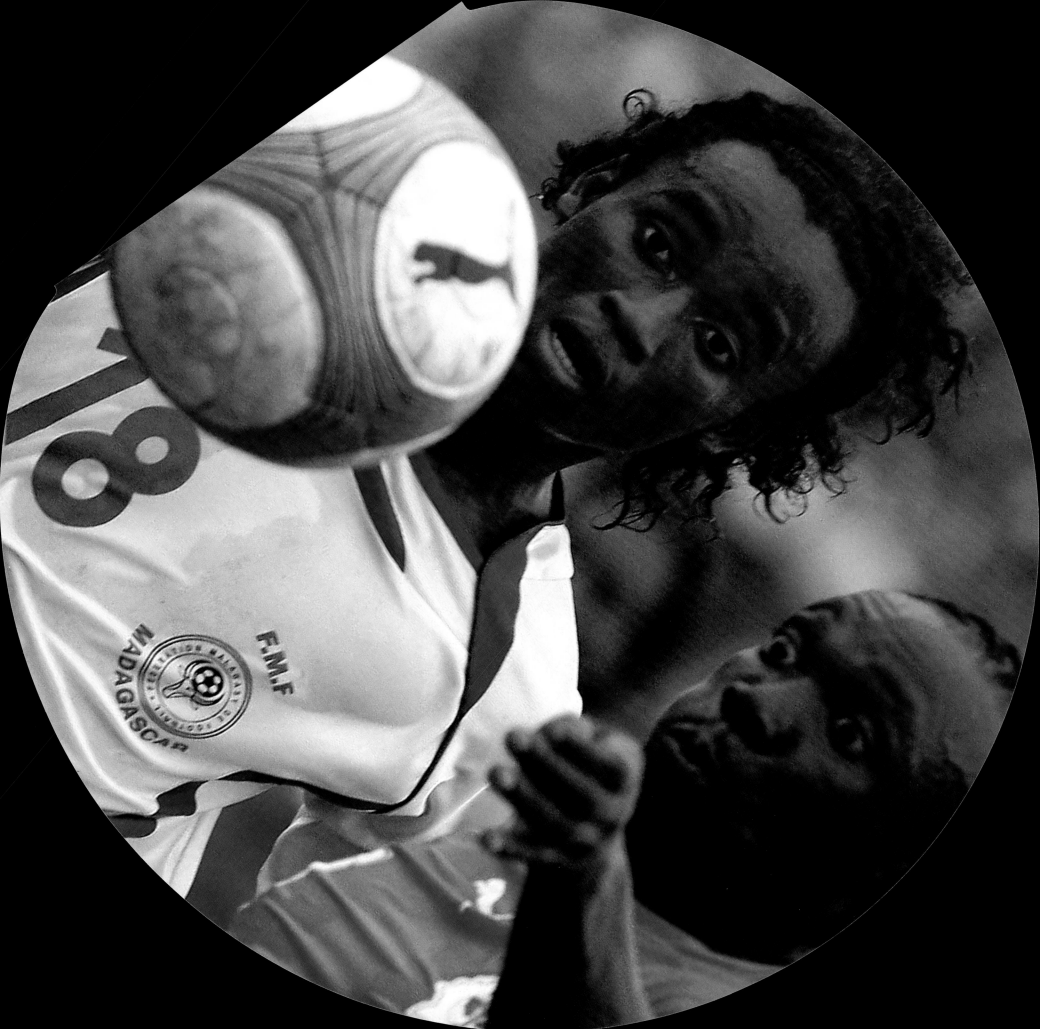

AFRICAN CUP OF NATIONS

six finals (Ghana's penalty shoot out victory over Libya in 1982) were neither team present during the decade with Cameroon beating Nigeria twice to lift the trophy in 1984 and 1988. The 1990s saw both teams continue to be play a major role in the tournament and with the long overdue end to apartheid South Africa was welcomed back to the tournament as hosts in 1996. The competition was expanded again this time to 16 teams. The Bafana Bafana playing on home soil were in inspired form; beating Cameroon (3-0) and Angola (1-0) in the group stage, before dispatching Algeria (2-1) and Ghana (3-0) in the quarter and semi finals, to finish champions after beating Tunisia 2-0 in the final in front of 80,000 fans. In the following competition, in Burkina Faso in 1998, they came close but had to make do with runners-up as Egypt ran out 2-0 winners. Cameroon again re-emerged as a dominant force winning both the 2000 and 2002 championships (against Nigeria and then Senegal) before an explosive 2004 derby final in Tunisia between the hosts and Morocco ended 2-1. North African glory continued in 2006 as Egypt beat Côte d'Ivoire in a penalty shoot-out to become the all-time title record holder with their fifth championship (putting them one ahead of Cameroon

and Ghana). They extended their lead in the 2008 tournament, beating Cameroon 1-0 in the final.

Egypt is the most successful nation in the cup's history, winning the tournament a record seven times. Ghana and Cameroon have won four titles each. Three different trophies have been awarded during the tournament's history, with Ghana and Cameroon winning the first two versions to keep after each of them won a tournament three times. The current trophy was first awarded in 2002 and with Egypt winning it indefinitely after winning their unprecedented third consecutive title in 2010. On 31 January 2010, Egypt set a new African record, not being defeated for 19 consecutive Cup of Nations matches, since a 2-1 loss against Algeria in Tunisia in 2004, and a record 9 consecutive win streak. Egypt also set another record on that day, where it became the first African Cup nation to win three consecutive cups joining Mexico, Argentina, and Iran who won their continent cup 3 times in a row.

As from 2013, the tournament will switch to being held in odd-numbered years so that it does not clash with the FIFA World Cup.

Opposite: Egyptian team members celebrate after their team won against the Ivory Coast Elephants 4-2 in penalties in the final game of the African Nations Cup (CAN), held in Cairo 10th February 2006.

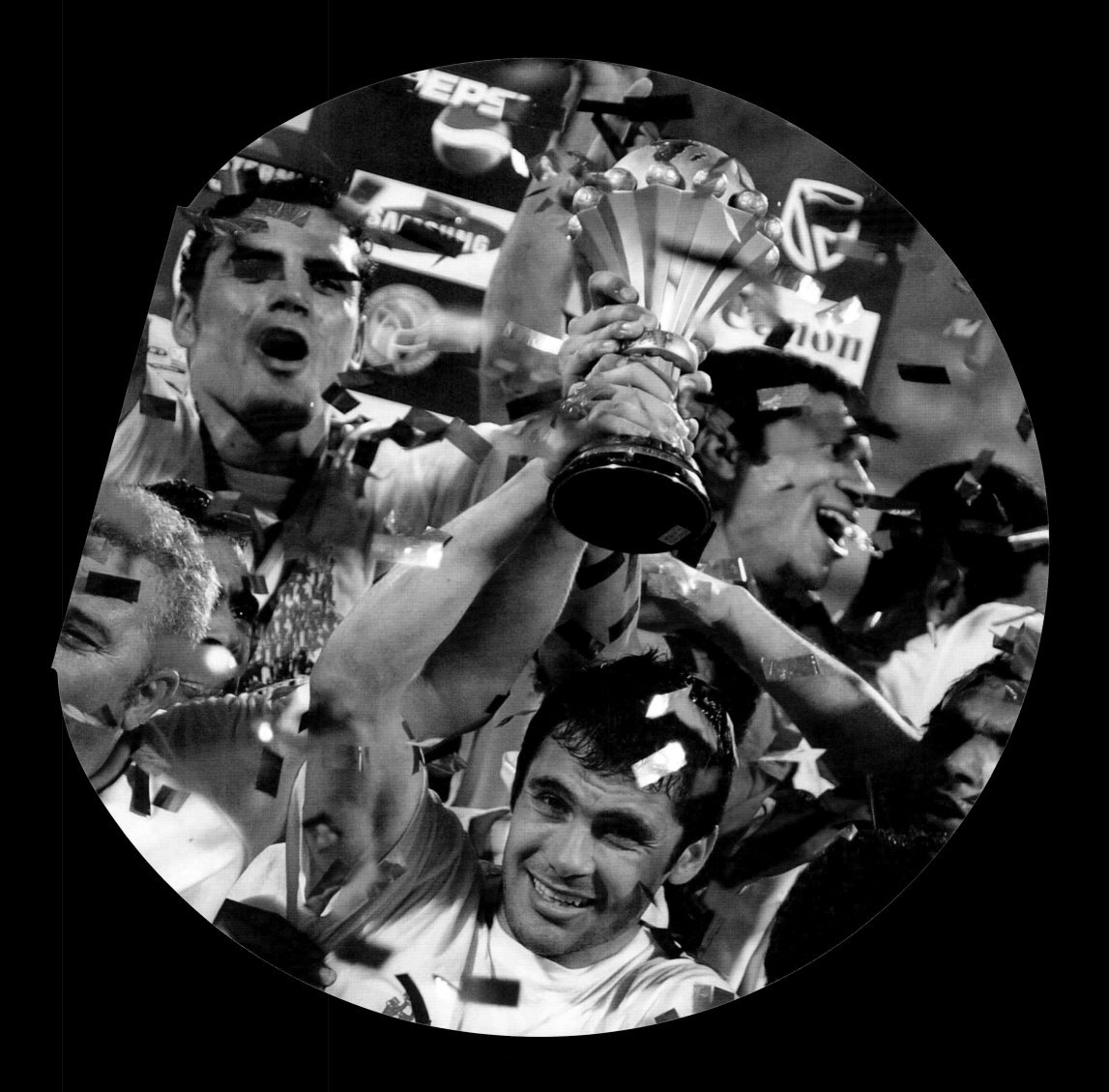

AFC ASIAN CUP

With the formation of Asian Football Confederation in Manila in 1954 hopes of a regional tournament became a reality. Before this Asia's national football teams met at the Asian Games (a regional multi-sport competition under auspices of the Asian and international Olympic committees). Held at four-year intervals in between the Asian Cup finals, it continued until 2002 after which it became an Under-23 tournament. Of the twelve original members of the AFC seven competed two years later in the inaugural AFC Asian Cup. Qualifiers Israel, Vietnam and South Korea played each other and hosts Hong Kong in a league format. South Korea were crowned champions after two wins and a draw with Israel as runners-up. The following competition they would go one better as hosts and win all 3 games to retain the trophy, Israel again as runners-up. However, in 1964, Israel as hosts turned the tables to win all 3 games and be win the Asian Cup for their first and last time.

From the late 1960s through the 1970s Iran emerged as the regions strongest team winning three consecutive titles. The competition enlarged in 1972 - with Bahrain, Iraq, Jordan, Kuwait, Lebanon and Syria all attempting to qualify – and saw the final stages change to a knock-out format. Israel, however, had also begun its withdrawal from Asian football (1968 being its last Asian Cup appearance) before they eventually found their home in European football, becoming an official UEFA member in 1994. The Gulf States continued to dominate the competition with Kuwait victorious in 1980 and Saudi Arabia twice crowned champions in 1984 and 1988. However, Saudi Arabia were surpassed by Japan in the 1990s and early 2000s as the regions most powerful football force. Japan battled there way to three titles (in 1992, 2000 and 2004 – twice defeating Saudi Arabia) but were eliminated by Kuwait in 1996 to leave the way open for the Saudi's to win the trophy again. However, in 2004 with the competition expanded to 16, the Saudi's had a surprisingly underwhelming tournament. After appearing in the last five finals, they only managed 1 point in a 2-2 draw with Turkmenistan before finishing bottom of their first round group and elimination. The finals also showed that the gap between the region's "minnows" and traditionally strong nations had narrowed with plucky Bahrain finishing 4th and Jordan only losing on penalties to Japan in the quarter-finals.

The AFC has grown from 12 to 46 members and now covers a huge region of profound social and cultural diversity, from Laos to Australia, Qatar to Mongolia, Hong Kong to Tajikistan, all meeting to play football. A mark of the the region's growing respect in the international community was the awarding of the 2002 World Cup to South Korea and Japan, during which South Korea excelled to finish 4th. Today with the entrance of Australia into the Asian Football Confederation and the dynamic growth of Chinese football its reputation continues to grow with the future looking bright indeed. The 2007 finals were held in Indonesia, Malaysia, Thailand and Vietnam, and Iraq emerged the winner for the first time, beating Saudi Arabia 1-0 in the final. The next event will be held in Qatar in 2011.

Opposite: Iraq players celebrate winning the AFC Asian Cup 2007 final between Iraq and Saudi Arabia at Gelora Bung Karno Stadium on July 29th, 2007 in Jakarta, Indonesia.

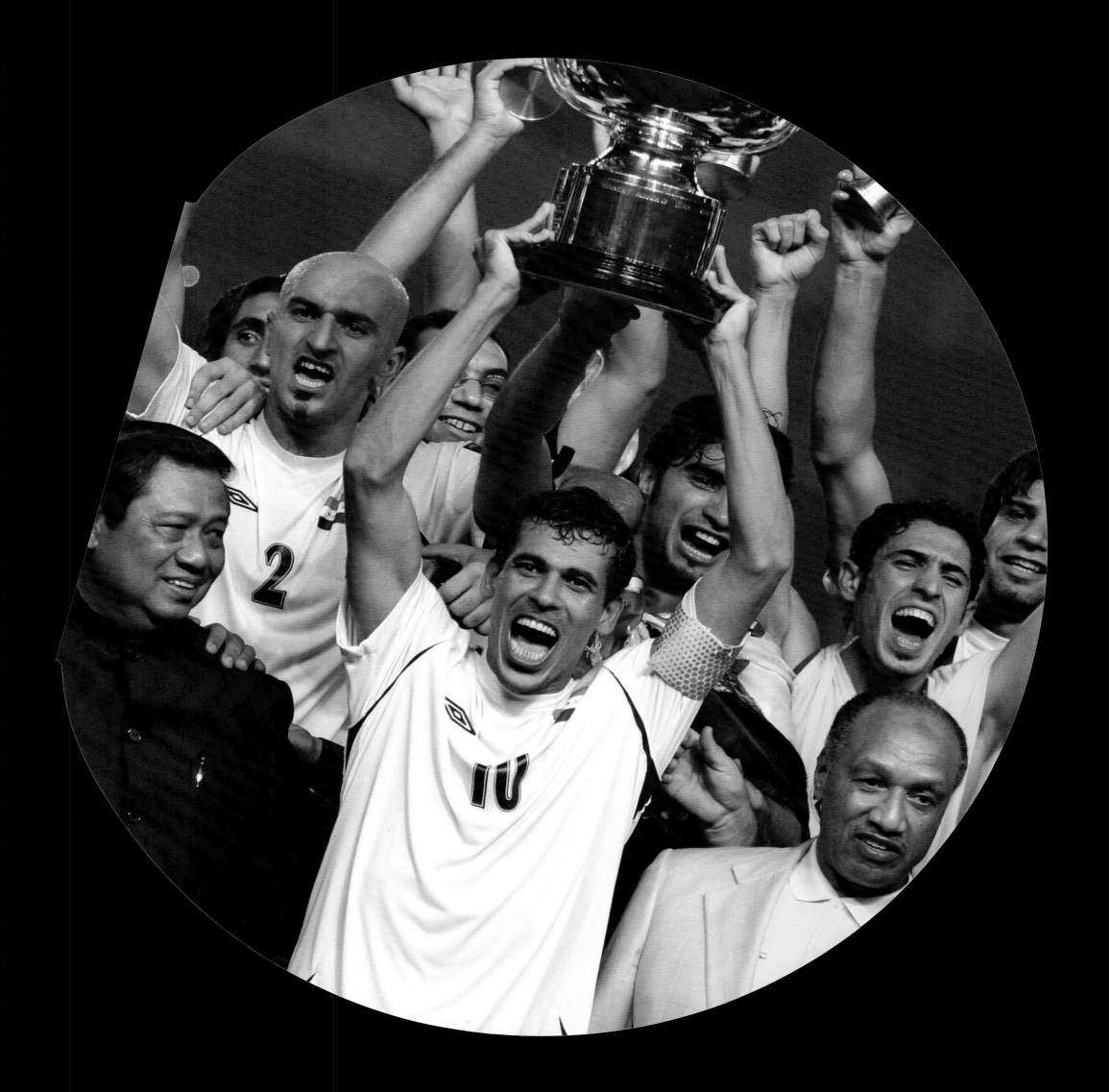

FOOTBALL AT THE OLYMPICS

Despite there being demonstration football matches at both the second and third modern Olympic games in 1900 and 1904, which have had medals awarded retrospectively, football really began at the Olympics in 1908. Since then football has been included in every Olympics, except 1932, with women's football being added in 1996, and can be seen as a precursor to the World Cup. In 1932 with the Olympics hosted in America, where the sport was unpopular, football was dropped. Without an international competition, despite football's increasing popularity at the Olympics in the 1920s, the World Cup was established – although some claim that FIFA disallowed its member nations to play. It coincided with the development of professionalism in the game, which contradicted the Olympics commitment to "amateur" sporting and as nearly all the best players were professionals and therefore could not play at the Olympics the football tournament lost its significance.

The ethos that athletes should be amateur "gentlemen" not professionals was maintained until the 1970s despite it becoming increasingly outdated and sidestepped through endorsements, indirect payment through trust funds, and by communist bloc teams. It was claimed that the latter's team's athletes played for industry and institutional clubs rather than profit-making clubs that they were "amateurs". Of course this was somewhat academic (and disingenuous), as they

were state sponsored and able to train full-time. It also meant that, after the Second World War, the football tournament was dominated by Eastern Bloc countries - Hungary, Soviet Union, Yugoslavia, East Germany and Czechoslovakia – who provided a great deal of excitement to the games and, between 1948-80, won all but 5 of 28 medals awarded. By the time the Olympics had changed its Charter to include professionalism the World Cup had become not just the biggest football tournament in the world but the biggest sporting competition in the World.

In 1984 the International Olympic Committee (IOC) wanted to revive interest in Olympic's football and started to readmit professionals. FIFA were concerned, however, that it could detract from the World Cup as the premier competition. In a compromise teams from Africa, Asia, Oceania, North America, Central America and the Caribbean were allowed to field their strongest teams while teams from Europe and South America were allowed to field teams of players who had not yet played in the World Cup. With teams such as France fielding young teams (and winning in 1984) the idea of making the competition a youth team tournament began to gain support in both FIFA and the IOC. Since 1992, therefore all players must be under 23 years old, with the allowance of three older players in each squad, and now effectively operates as the Under-23 World Cup.

50

Opposite: The Argentinian team celebrate gold during during the Men's Final between Nigeria and Argentina at the National Stadium on Day 15 of the Beijing 2008 Olympic Games on August 23, 2008 in Beijing, China.

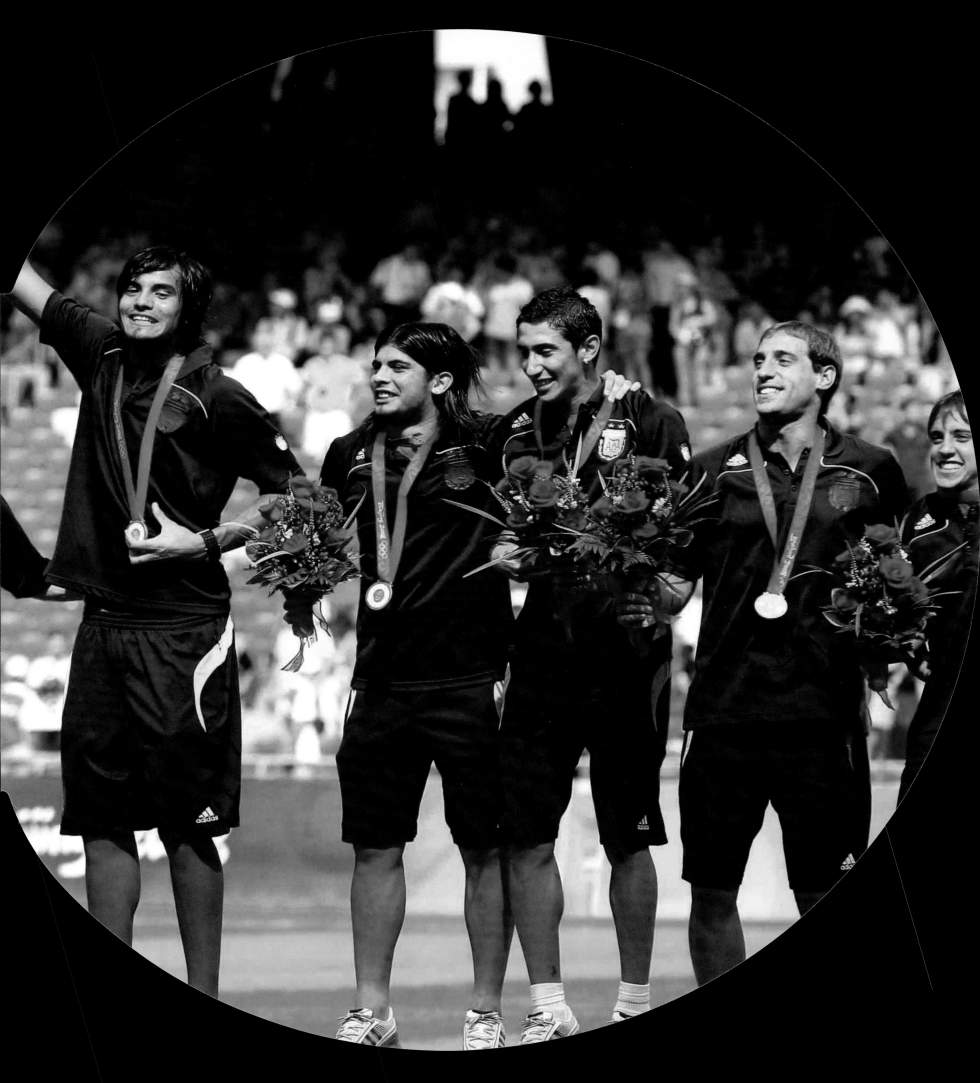

COPA AMÉRICA

The Copa América is the oldest remaining international football competition in the world. The first tournament was held in 1916, during Argentina's centenary celebrations of its independence. The South American football federation, CONMEBOL, was established during the competition and the competition became a regular biannual tournament (until 2007 after which it will now be held every four years) known as Campeonato Sudamericano de Selecciones (South American Championship of National Teams). The competition is an approximate equivalent to UEFA's European Championship. As there are only 10 members of CONMEBOL though since 1993 two non-federation members, usually from the CONCACAF federation, have been invited. Mexico has appeared in every competition since, with the USA and Costa Rica both appearing three times, as well as once for Honduras and Japan. In a confederation that includes Brazil, Argentina, Uruguay, Colombia, Paraguay, Ecuador, and even Chile and Perú are currently thought of as "weaker" teams it is a passionately contested competition between some of the finest teams in the world, followed by their colourful and fanatical supporters. However, it has faced problems in recent years with both Argentina and Canada pulling out of the 2001 Colombian finals due to security concerns, teams saving their strongest teams for the World Cup qualification campaigns

instead, and overseas players pulling out due to club commitments.

Perhaps to many, Brazil – as five times world champions - would naturally be thought of as the dominant force in the region. However, it is Argentina and Uruguay who currently both hold the record for championships. Both have won the title 14 times during the competition's long history, over Brazil's 8 trophies. Ominously for the rest of the region, however, four of these trophies have come during the last four Copa Américas. This run has only been broken by Colombia with a 1-0 victory in the finals over Mexico on home soil in 2001, after Brazil had been knocked out by surprise third place Honduras. Only Argentina has managed to win the tournament for 3 consecutive competitions (1945, 1946 and 1947) under the excellent coaching of Guillermo Stábile. While four other nations have also managed to win the competitions: Paraguay and Perú twice, and Bolivia and Colombia once each. While Chile (4 times runners-up), Ecuador and Venezuela are yet to win the trophy.

The 2007 Copa América was the 42nd edition of the Copa América. The competition was held in Venezuela, who hosted the tournament for the first time, between June 26 and July 15, 2007. The competition was won by Brazil who went on to beat Argentina 3-0 in the final. Mexico took third place by beating Uruguay 3-1 in the third-place match.

Opposite: Brazilian players celebrate with the trophy after they won the Copa America 2007 final match against Argentina at the Pachencho Romero stadium in Maracaibo, Venezuela, 15 July 2007 . Brazil defeated Argentina 3-0 and won the Copa America.

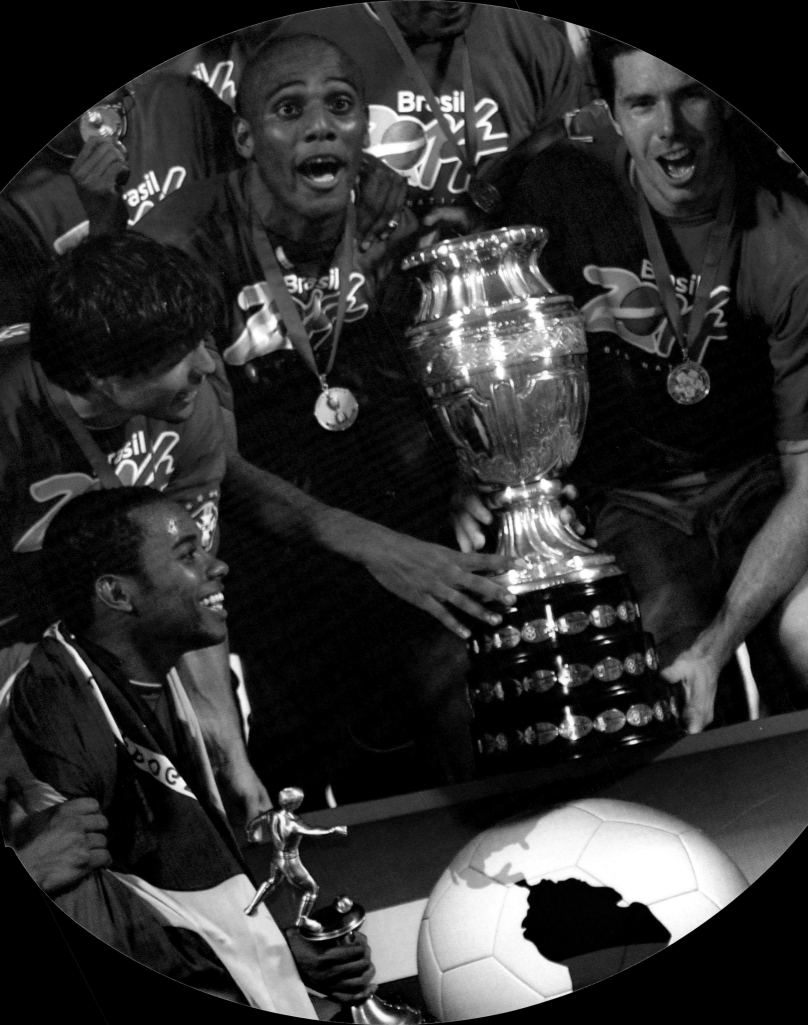

CONCACAF GOLD CUP

Often viewed as one of the weaker confederations, especially when compared with CONMEBOL its South American neighbour, CONCACAF is responsible for 40 member associations in North America, Central America and the Caribbean as three small South American territories (Guyana, Suriname and French Guiana). Many of these nation's teams can best be described as "minnows", small teams from tiny countries (often Caribbean Islands) with little hope of making progress on the World Stage. However, CONCACAF was guaranteed three places at the 2006 World Cup with a further place available through a play-off against the fifth place Asian confederation team. There is a belief amongst critics that this gives too much weight to the federation. In 2006, it meant qualifiers United States, Mexico and Costa Rica were also joined by Trinidad and Tobago. When the Soca Warriors beat Asia's Bahrain 2-1 on aggregate to send the Caribbean nation into raptures and begin another World Cup fairy tale. The debutants also did the region's and their own reputation no harm performing above everyone's expectations with a creditable 0-0 draw against Sweden and brave performances against England and Paraguay.

The region itself was originally split into two separate confederations: the NAFC (North American Football Confederation) including Mexico, USA, Canada and Cuba; and the CCCF (Confederacion Centroamericana y del Caribe de Futbol) whose strongest team by far were Costa Rica. The CCCF organised a regular competition beginning in 1941 (which Costa Rica won 7 out of 10 times), while the NAFC's competition was only held twice during this era. The region's football was restructured with both organisations merged into the CONCACAF confederation. With it came a reinvigorated CONCACAF championship as Costa Rica finally had some real competition from Mexico (both managing to win twice) before the competition was dissolved. The confederation's qualification rounds for the World Cup then became the de facto regional championship. The first competition in 1973 produced an upset when Haiti qualified over Mexico to head to West Germany for their only World Cup Finals in 1974. In 1981 Honduras followed their example by also winning and qualifying for the World Cup in Spain 1982.

This system was replaced by the CONCACAF Gold Cup, a revitalised regional competition established in 1991. An expanded tournament with greater participation from the North American teams meant the competition became more competitive and therefore taken more seriously. The 2000 Gold Cup saw Colombia, Peru and South Korea compete with South Korea returning in 2002 alongside Ecuador. The last nations to be invited were Colombia and South Africa. The 2000 Gold Cup reverted back to a full CONCACAF confederation tournament in 2007 (that included a fabulous run by Guadeloupe to reach the semi-finals). Since its beginning the Gold Cup has been dominated by Mexico and their biggest regional rivals the USA, with Canada the only team to rock the boat by beating Colombia 2-0 in the final. The 2009 Gold Cup took place July 3 to July 26, 2009 with Mexico claiming the title after beating the United States by a 5-0 score.

The future of the Gold Cup will greatly depend on how seriously the big CONCACAF teams of Mexico, the USA and to a lesser extent Costa Rica take the competition. All three teams have been regularly appearing as invited guests to the South American Copa América since 1993. With many American and Mexican soccer fans calling for CONCACAF to merge with their South American neighbour CONMEBOL and top Mexican clubs already also competing in the Copa Libertadores there seams to be a certain inevitability about it.

...ica's most successful in the competition winning the trophy 21
...competition. times, with both Independiente and Boca Juniors being
...s contested the most successful teams as champions 7 ti...
...outh America's respectively. Peñarol are their nearest challengers...
...ons Cup. Initially titles, while Estudiantes (Argentina)...
...nation's league could (Uruguay), Olimpia (Paraguay) and São P...
...expanded to include 38 have all been crowned champions 3...
...from Mexico Brazilian clubs reachi...
... . The teams are as many times a...
... stage playing each Brazil's clubs b...
...ay before the top two times, with...
...ockout stage. Historically Brazil's...
...ent did not use the away goal other...
...her teams were awarded points (C...
...a win, 1 for a draw) for each leg.
...erefore, if both teams won (regardless
...of the aggregate score) the game went to
...a replay at a neutral venue. This carried
...on until 1988 when games were decided
...to a penalty shootout. Finally in 2005 the away goal r...
...was used to break tied games.

The first tournament in 1960 was played...
...countries and teams including Argentina's C...
...de Almagro, Bolivia's Jorge Wilsterman...
...Chile's Universidad de Chile, Colo...
...Paraguay's Olimpia, and Urugu...
...finals were played over two l...
...Olimpia 2-1 on aggregate. P...
...be the first of five titles a...
...the competition. Arg...

COPA
TOYOTA
LIBERTADO...

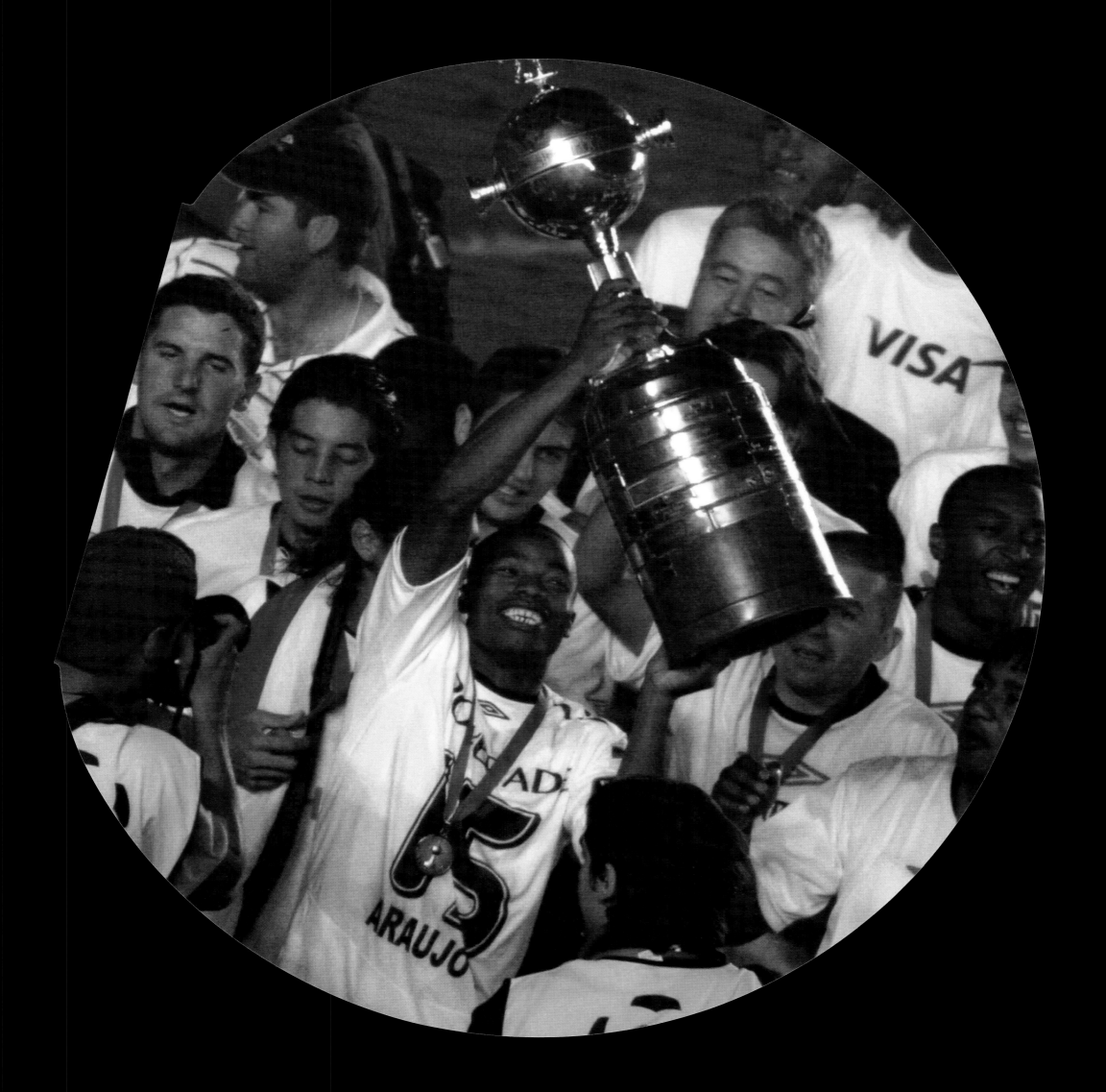

UEFA'S EUROPEAN CHAMPIONSHIP

The European Championship is the pinnacle of national team football in Europe. In fact there are plenty of football fans who view it as a more difficult trophy to win than the World Cup, as the overall quality of opposition is better. For example, there are no small teams like Togo, Haiti, Trinidad and Tobago, or Zaire to beat. This of course ignores the romance of Cup tournaments and how "minnows" have occasionally risen above expectations to produce upsets. Who can forget unfancied Senegal's incredible defeat over defending world champions France? There has also never been a "small" team making it to the final of the World Cup, whereas the European Championship has had two fabulous underdog champions with both Denmark and Greece lifting the trophy. Correct or not, the Euro Championships has produced some stunning football and is one of the highlights of football's calendar.

The idea for a continent-wide national team competition was first suggested by Henri Delauney, a French member of FIFA, as early as 1927. He became UEFA's first General Secretary when the federation was formed in 1954 but died a year later before his brainchild became a reality. In honour the trophy is still named after him. Even with the popularity of the European club competition, it would take another 5 years until the first national team tournament was held. The inaugural competition was nearly cancelled after an initial lack of interest from national football associations meant there were not enough teams to compete. In the original format, qualifiers took place over two years with teams playing each other in knockout home and away games, before the four winning teams took part in the finals of the European Nations Cup. Hosts were only chosen after the places in the semi-finals had been decided, so hosts also had to qualify. 17 teams took part in the first tournament with West Germany, Italy and the British countries all absent. There was further trouble when Franco refused to allow the Spanish team to travel to the USSR in the quarter-finals and withdrew.

Despite its teething troubles, over 100,000 people watched the first qualifying match as the USSR beat Hungary 3-1 in Moscow. Czechoslovakia, France, the Soviet Union and Yugoslavia all progressed to the first final in France in 1960. The Soviet Union, led by the inspirational Lev Yashin, beat Yugoslavia 2-1 after an extra-time header by Viktor Ponedelnik proved to be the winner. Four years later, 29 teams entered the qualification round, this time Greece withdrew when it was drawn against Albania. In the end Denmark, Hungary, Spain (chosen as hosts), and the Soviet Union all made it to the finals. Ironically Spain and the Soviet Union faced each other in the final. In energy-sapping heat Spain prevailed 2-1 to win their only major trophy

UEFA'S EUROPEAN CHAMPIONSHIP

to date. In 1968, the qualifying knockout stages were replaced by qualification groups and the Cup was renamed the European Championship. The Soviet Union were unlucky not to make a third consecutive final. After their game against hosts Italy ended 0-0 after extra time, and as of yet no penalty shootouts, they lost to a coin toss to decide who should go through. In the other semi-final world champions England were beaten by Yugoslavia. Italy drew the initial final 1-1, before beating Yugoslavia 2-0 in the replay. The 1972 final in Belgium saw the hosts beaten by a classy West German side. While the Soviet Union, after beating Hungary 1-0, made the final again. The Soviets were again runners-up as Gerd Müller scored twice in a 3-0 West German victory. The last tournament in the original format came four years later in Yugoslavia. Where West Germany again progressed to meet underdogs Czechoslovakia. Having beaten the Netherlands (3-1 in extra time) they went onto a 2-2 draw with West Germany before winning a penalty shootout 5-3, after Uli Hoeneß missed his spotkick. Euro '80 witnessed a major overhaul of the competition. The hosts Italy automatically qualified to join seven other qualifiers: Belgium, Czechoslovakia, England, Greece, Netherlands, Spain and West Germany. The tournament split the teams into two groups of four who played each other before the top team went directly into the final and the two group runners-up played a third place match. The finals were something of a failure though as overly defensive teams played out dull matches. Off the pitch football hooliganism hit the

headlines again, especially after both teams had to leave the pitch during a game when police used teargas to suppress a riot when England met Belgium. Another disappointment was spectators only really turning out in force for Italy's matches. Bright spots though included an offensive minded Belgium team making it to the final where they lost 2-1 to West Germany (who also had a team of young new stars in the making). At Euro '84 in France, with a slight change in format (group winners and runners-up met in a semi-final), the tournament was a great success with little trouble. Michel Paltini's exhilarating form lit up the competition and France beat everyone including title contenders Belgium 5-0. They met Spain in the final – who had needed to beat Malta by 11 goals to qualify and won 12-1 in their final match – but were beaten 2-0 for the French deservedly to win the championship.

In a shock, however, the French failed to qualify for the following Euro '88 in West Germany – finishing behind the Soviet Union and East Germany in their group. The hosts had a strong team (with Jürgen Klinsmann, Jürgen Kohler, Lothar Matthäus, Pierre Littbarski, and Thomas Berthold) and were favourites to win on home soil. England as well were expected to challenge strongly with an excellent qualification campaign and a team including Glenn Hoddle, Bryan Robson, Chris Waddle, John Barnes, Peter Beardsley and Gary Lineker. However, the English were knocked out after three defeats (including losing 1-0 to the Republic of Ireland). While Italy also had an excellent young including Paolo Maldini, Riccardo Ferri, Gian

UEFA'S EUROPEAN CHAMPIONSHIP

and Roberto Mancini. However, it was the Soviet Union, with the core of its team built around an excellent Dynamo Kiev side, who progressed to the finals where they lost 2-0 to the Netherlands. Ruud Gullit, Marco van Basten, Frank Rijkaard, Ronald Koeman, Gerald Vanenburg and veteran Arnold Mühren.

Euro '92 in Sweden produced one of the biggest shocks in the tournaments history. After Yugoslavia had descended into a tragic civil war, their fabulously talented team was withdrawn under United Nations sanctions and their place handed to Denmark (who had been runners-up in their qualification group). Reunited Germany, Sweden and the Netherlands were the teams to beat yet it was Denmark, recalled from their summer holidays, who made it to the final. Danish goalkeeper, Peter Schmeichel, was in exceptional form and kept the German attack at bay, while John Jensen scored after 18 minutes and a classic strike from Kim Vilfort's won the game with 12 minutes remaining.

Euro '96 in England also produced some memorable moments. Pre-tournament favourites Italy and Netherlands were plagued by infighting and exited early. The hosts, recovered from a 1-1 draw with Switzerland, to produce some excellent form with Paul Gascoigne scoring one of the goals of the tournament in a 2-0 victory over Scotland, before beating the Netherlands 4-1. They beat Spain in the next round on penalties but once again were knocked-out by penalties in a major tournament. Exiting to Germany again in the semi-finals, after a tense 1-1 draw and a 6-5 penalty shootout when Gareth Southgate's penalty was saved. It left the country in mourning for weeks. The Czech

Republic had progressed through a tough group with Germany, Italy and Russia, before defeating Portugal and France in the knockout stages. In the final Germany beat them with the first Golden Goal to decide a major tournament; scored after a mistake by Czech keeper, Petr Kouba, following a miss-hit shot by Oliver Bierhoff to win the trophy for a record third time.

France are one of only three teams, the others being Germany and Spain, to win the trophy more than once and also hold the honour of being the only reigning World Cup champions to also hold the European Championship. It came in 2000 during an excellent tournament, co-hosted by Belgium and the Netherlands. Whereas Platini had been the inspiration for France's previous title it was Zinedine Zidane who proved the inspiration to take France to the final, where they met Italy. David Trezeguet blasted home a Golden Goal on 103rd minute to give France a 2-1 victory. Euro 2004 in Portugal went onto produce possibly an even bigger upset than Denmark's triumph in 1992. The tournament, another excellent spectacle of high-quality football, confirmed something that had been becoming apparent during recent World Cup results also – that the world's smaller teams have significantly closed the gap between themselves and the traditional super-powers. As a hard-working pragmatic Greek team knocked out France and the Czech Republic to beat the hosts with an Angelos Charisteas header in a memorable 1-0 victory to be crowned champions.

The 2008 tournament, hosted by Austria and Switzerland marked the second time that two nations co-hosted, and the first edition where the new trophy was

62

Opposite: Captain Iker Casillas of Spain lifts the trophy after winning against Germany in the UEFA EURO 2008 Final match between Germany and Spain at Ernst Happel Stadion on June 29, 2008 in Vienna, Austria.

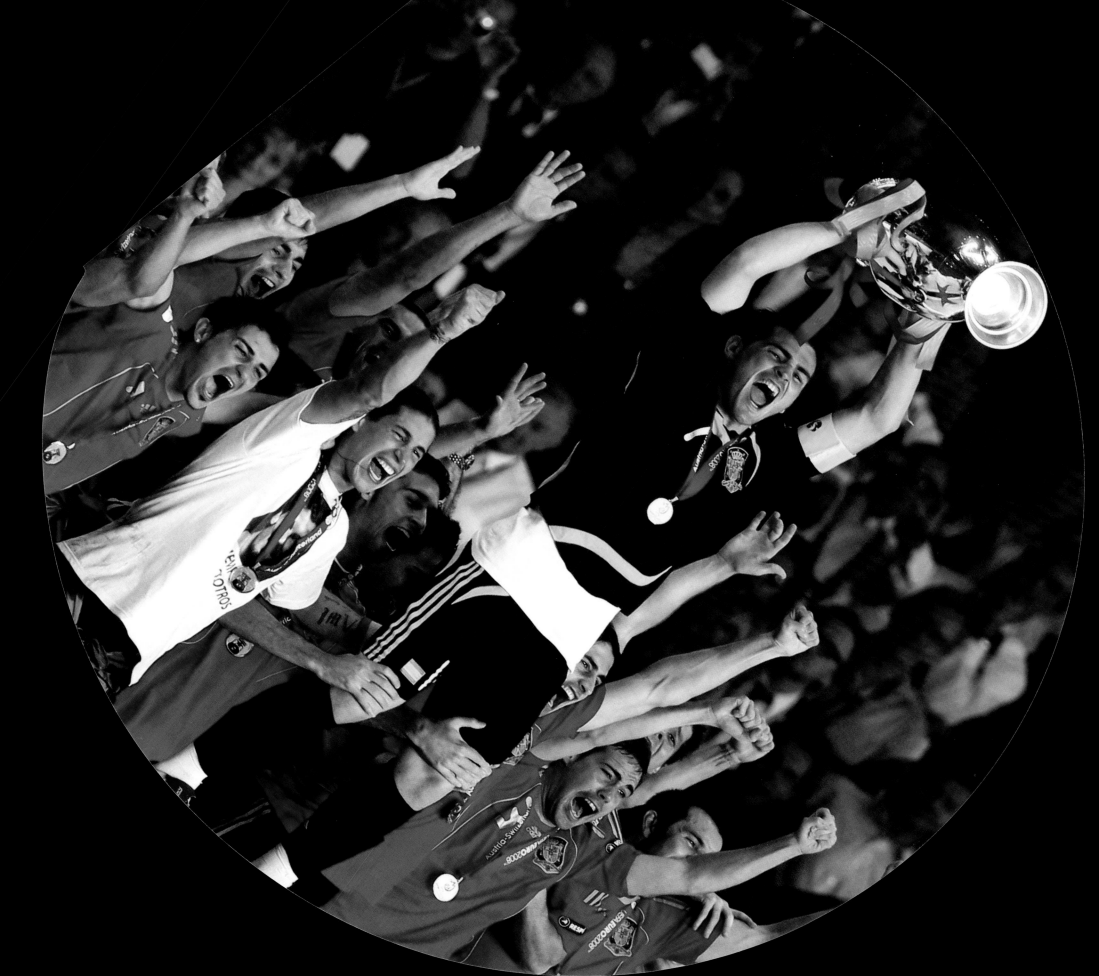

THE WORLD CUP

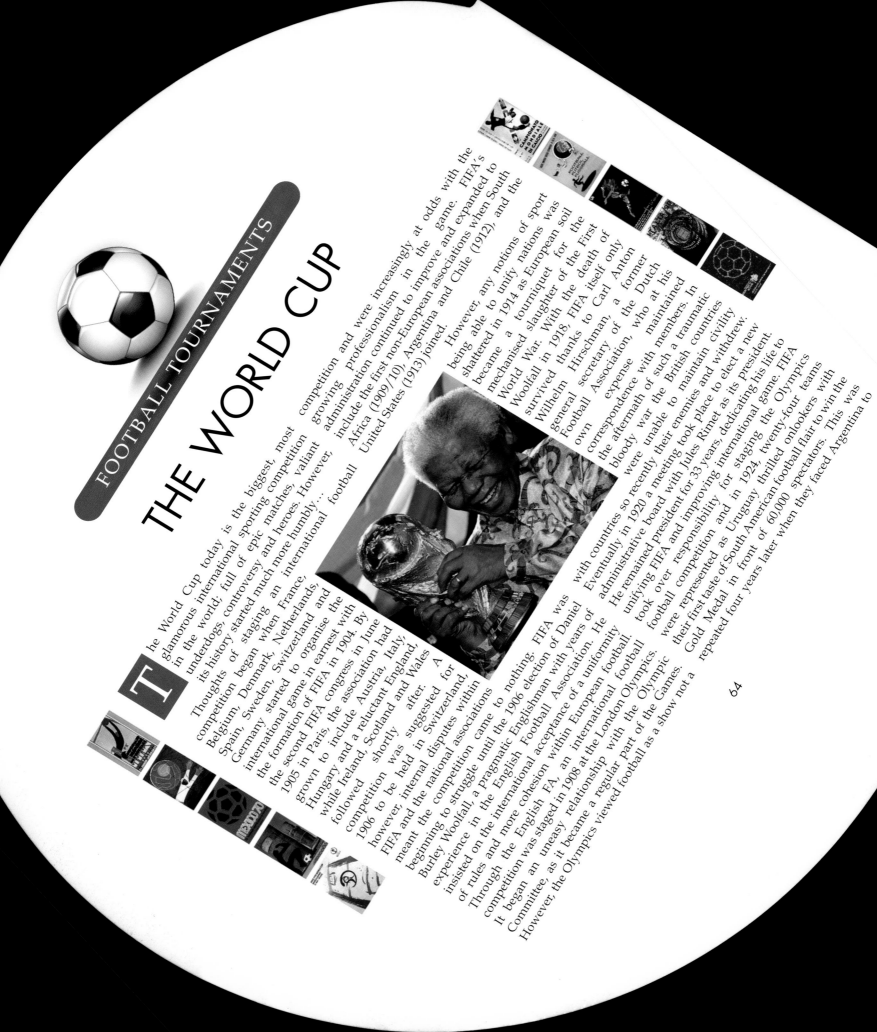

The World Cup today is the biggest, most glamorous international sporting competition in the world; full of epic matches, valiant underdogs, controversy and heroes. However, its history started much more humbly..

Thoughts of staging an international competition began when France, Belgium, Denmark, Netherlands, Spain, Sweden, Switzerland and Germany started to organise the international game in earnest with the formation of FIFA in 1904. By 1905 in Paris, the association had grown to include Austria, Italy, Hungary and a reluctant England, while Ireland, Scotland and Wales followed shortly after. A competition was suggested for 1906 to be held in Switzerland, however, internal disputes within FIFA and the national associations meant the competition came to nothing. FIFA was beginning to struggle until the 1906 election of Daniel Burley Woolfall, a pragmatic Englishman with years of experience in the English Football Association. He insisted on the international acceptance of a uniformity of rules and more cohesion within European football. Through the English FA, an international football competition was staged in 1908 at the London Olympics. It began an uneasy relationship with the Olympic Committee, as it became a regular part of the Games. However, the Olympics viewed football as a show not a competition and were increasingly at odds with the growing professionalism in the game. FIFA's administration continued to improve and expanded to include the first non-European associations when South Africa (1909/10), Argentina and Chile (1912), and the United States (1913) joined.

However, any notions of sport being able to unify nations was shattered in 1914 as European soil became a tourniquet for the mechanised slaughter of the First World War. With the death of Woolfall in 1918, FIFA itself only survived thanks to Carl Anton Wilhelm Hirschman, a former general secretary of the Dutch Football Association, who at his own expense maintained correspondence with members. In the aftermath of such a traumatic bloody war the British countries were unable to maintain civility with countries so recently their enemies and withdrew. Eventually in 1920 a meeting took place to elect a new administrative board with Jules Rimet as its president. He remained president for 33 years, dedicating his life to unifying FIFA and improving international football. FIFA took over responsibility for staging the Olympics football competition and in 1924, twenty-four teams were represented as Uruguay thrilled onlookers with their first taste of South American football flair to win the Gold Medal in front of 60,000 spectators. This was repeated four years later when they faced Argentina to

THE WORLD CUP

successfully defend their Gold Medal and status as world champions. The popularity of these competitions intensified FIFA's desire to stage its own international championship. It came at a time when there was increasing conflict with the Olympic Committee over the professional and amateur status of teams. When it became known that football was being dropped for the 1932 Olympics in Los Angeles, the World Cup became a reality.

Defending world champions, Uruguay, were also about to celebrate its centenary of independence in 1930 and offered to pay for all costs of the competing nations including travel and accommodation. After which they were unanimously chosen to host the inaugural World Cup. However, the long distance sea-crossing meant many teams from Europe withdrew and it was only through Rimet's maneuvering that four teams made the long journey to South America to play the competition - Belgium, France, Romania, and Yugoslavia. The competition was a huge success with massive crowds and thrilling football. The hosts and European teams were joined by eight more teams from the Americas – Argentina, Bolivia, Brazil, Chile, Mexico, Paraguay, Perú, and the United States. Uruguay went on to confirm its place as world champions, defeating Perú, Romania (4-0) before demolishing Yugoslavia 6-1 in the semi-finals to face Argentina in the finals. Uruguay won 4-2 and ushered in a new era in modern football.

Despite its success the World Cup still faced significant problems. With the distance involved in intercontinental travel and politically as the world, stumbling through a severe economic recession, was heading towards political polarisation and the most destructive war the planet has ever witnessed. Two more tournaments took place before the Second World War, however. The first was held in Italy in 1934, with 32 teams entering the qualification rounds before 16 teams emerged to compete in the finals. Uruguay still angered about the lack of European participation in the previous tournament snubbed the finals in retaliation. They remain the only holders not to defend the trophy. Three teams from the Americas made the long journey across the sea (Argentina, Brazil and the USA), while Egypt represented Africa (the last team to do so until Morocco in 1970). The rest of the teams were European with Austria, Belgium, Czechoslovakia, France, Germany, Hungary, the Netherlands, Romania, Spain, Sweden, and Switzerland all joining the hosts. As it was a knockout competition, Argentina, Brazil and the USA, only played one game before having to return home. Politics began to cast a shadow over the World Cup as Benito Mussolini used the final, held at the Stadio Nazionale del Partito Nazionale Fascista in Rome, as a propaganda tool to broadcast his views on nationalism and fascism. Many of the referees were also later banned from officiating again after skewing games in Italy's favour. It was the first final to be broadcast live on radio as Italy beat a great Czechoslovakian side 2-1 in extra-time, with powerful striker Angelo Schiavio scoring the winner 5 minutes into extra-time.

As Europe's political climate continued to deteriorate the last World Cup for 12 years was hosted in France. Spain were forced to withdraw due to its Civil War, while Uruguay and Argentina – angry at the

Opposite: First World Cup 30th July 1930: Uruguayan captain Jose Nazassi (left) shakes hands with his Argentinian counterpart 'Nolo' Fereyra before the final of the first world Cup competition in Montevideo, which Uruguay won . With them is referee John Langenus and linesmen Saucedo and Henry Christophe. Uruguay won 4-2.

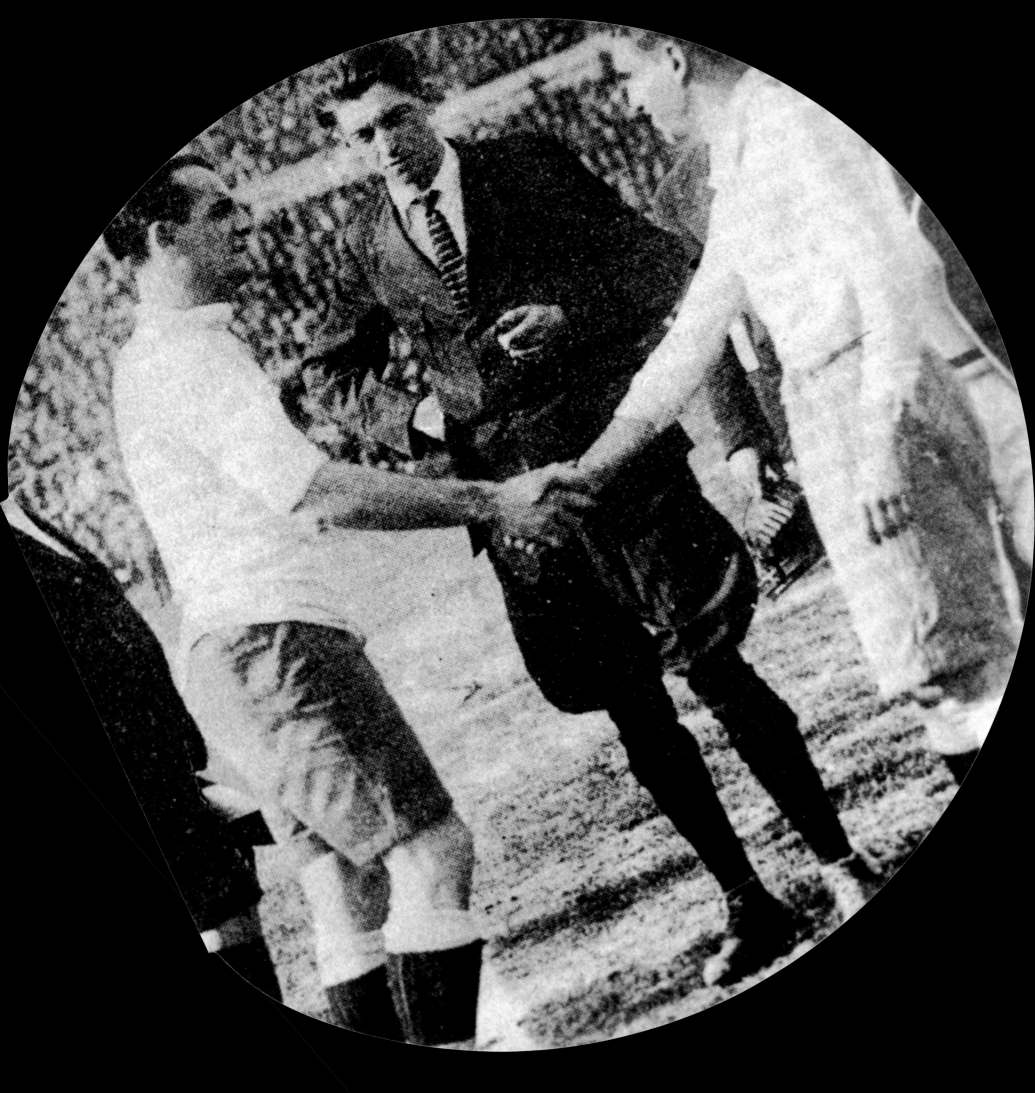

THE WORLD CUP

tournament's hosting not returning to South America – boycotted the finals. They were replaced by the Dutch East Indies (today's Indonesia was Asia's first representative) and Cuba (who surprised everybody by progressing to the quarter-finals after holding Romania to a 3-3 draw and then winning the replay). Again external forces impacted on the game as 16 teams became 15 after Austria was annexed by Hitler's Germany. On the pitch, the finals included an all-time classic match between Brazil and Poland. Brazil were leading 3-1 at half-time, before the Poles pulled level in the second half only for Brazil to take the lead again through Peracio, however, with a minute to go Ernest Wilimowski equalised again for the game to go Ernest Wilimowski equalised again for the game to finish 4-4. In extra time Leônidas completed his hat-trick with goals on the 93rd and 104th minute, however, Wilimowski scored again (for his fourth goal) with two minutes to go but Poland were unable to score again: Brazil 6, Poland 5. In the next round Brazil progressed after a fractious tie with Czechoslovakia descended into an all-out brawl with 5 players injured, 2 Brazilians and 1 Czech player sent-off. The replay was somewhat more subdued as Brazil came from behind to win 2-1. Brazil then made, arguably one of the worst manager decisions in World Cup history. The coach, Adheniar Pimenta, confident of reaching the finals, rested star-player and tournament top scorer Leônidas during the semi-finals. Overconfidence would be the Achilles Heel for many teams over the World Cup's history and would meet Italy. However, the Italians knocked Brazil out with a 2-1 victory. In the final they would meet the kings of flowing football, Hungary. However, the final ended Italy 4, Hungary 2 for Italy to be the first nation to successfully defend the

title. The final has begun to enter into football folklore, as rumours emerged that Mussolini had telegrammed the Italian team with the words: "Vincere o morire!" A typical fascist slogan roughly translated, some say misunderstood, as "to win or to die". After losing the game Hungarian goalkeeper, Antal Szabó, expressed relief stating; "I may have let in four goals, but at least I saved their lives." Whether this is true, a black-humoured joke, or an excuse for losing is not known but certainly gives an indication of the fear underpinning the times.

It would take twelve tumultuous years before the World Cup would be held again. With much of Europe still in ruins Brazil was unanimously backed to hold the finals in 1950. To mark his 25th year as FIFA president and his role in establishing the World Cup the cup was renamed the Jules Rimet Trophy. Again more teams withdrew after qualifying, including Scotland, Turkey, and most endearingly India – who requested to play barefoot; when FIFA refused they pulled out. England made their first competition appearance, while Uruguay returned for the first time since they won the cup in 1930. The English were pre-tournament favourites but after a 1-0 defeat to the USA (one of the World Cup's biggest upsets) and a 1-0 loss to Spain were eliminated. The tournament's format returned to the 1930's version whereby the teams played the first round in a group stage before the winner of a second group decided the world champions. In the final group Brazil thrashed Sweden 7-1 and Spain 6-1 before meeting Uruguay who had drawn 2-2 with Spain and narrowly beaten Sweden 3-2. The Brazilian's were hot favourites to win and only needed a draw to lift the trophy. In front of an official

Opposite: Swedish goalkeeper Kalle Svensson dives to block the ball in front of Brazilian forward Ademir on 9th July 1950 in Rio de Janeiro during their World Cup final pool soccer match. Ademir scored four goals as Brazil beat Sweden 7-1. Ademir finished the competition as the leading scorer with 8 goals, but Brazil lost in the final to Uruguay (1-2) in front of 200,000 fans at Maracana stadium in Rio de Janeiro on 16th July.

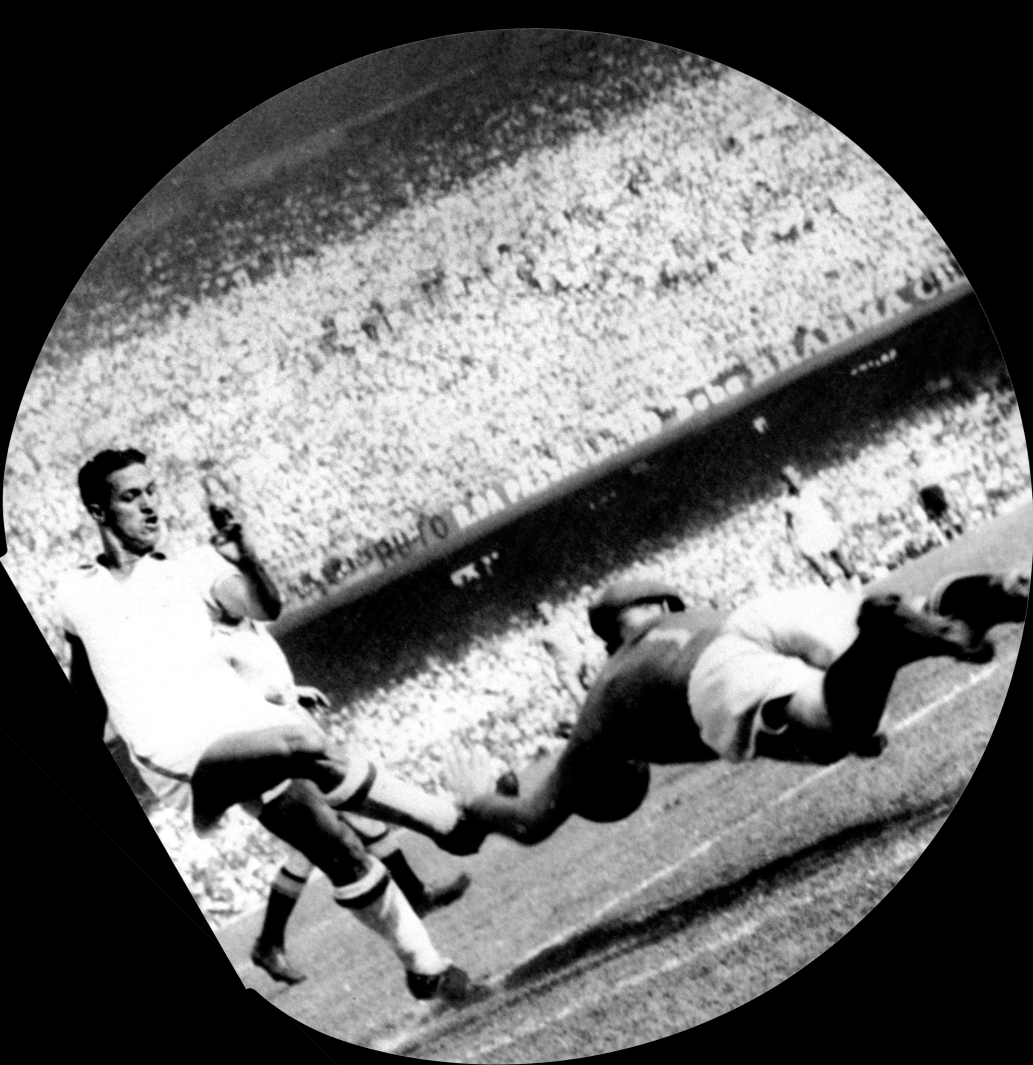

THE WORLD CUP

174,000 spectators (although is really believed to be over 200,000) the home side took a 47th minute lead through Friaça and had one hand on the trophy. Uruguay though had other ideas, as the weight of the home crowd's expectations began to unsettle the team, they equalised through Schiaffino in the 56th minute. 3 minutes later Ghiggia scored the winner as Uruguay broke Brazilian hearts to dramatically clinch the title.

In 1954 the World Cup finals returned to Europe with Switzerland as hosts. The Mighty Magyars were expected to win, as they were unbeaten since 1950, and faced Brazil in their group stages World Cup game after scoring 17 goals in another infamous World Cup game dubbed the Battle of Berne. Both teams were excellent skillful teams but what could have been an all time classic match descended into brutal tackling, niggling fouls, and retaliatory tit-for-tat before full-scale punch ups left 3 players sent-off. This was just a prelude though before things went berserk after the Brazilians believed Ferenc Puskás, who was on the sidelines injured, had thrown a bottle at Pinheiro causing a 3 inch cut (later reports blamed a spectator). The game almost ended in the mayhem ended with a 4-2 Hungarian victory. However, that was not the end as a livid Brazil team (including coach and delegation) invaded the Hungarian changing room after the match where a full-scale battle began including fists, boots and bottles. Despite being shaken by events they went on to a thrilling semi-final match with Uruguay that ended 2-2, but in extra-time 2 goals by Sándor Kocsis put Hungary in to the final. They met underdogs West Germany for a second time having already beaten them 8-3 in the first round. Everything insisted on playing despite being injured.

went to script as Hungary stormed into a 2 goal lead within 8 minutes, however, West Germany quickly fought back to 2-2. Then the unthinkable happened as Helmut Rahn scored to put the West German team into the lead. Puskás equalised with two minutes to go but the goal was disallowed to the fury of the Hungarians and the celebrations of the West German team and fans.

In 26 games an amazing 140 goals were scored, a goal ratio that remains a World Cup record.

1958 in Sweden witnessed Brazil's ascent to the pinnacle of the world game and the arrival of a legend in the making, Pelé. It was the first tournament to receive widespread international television coverage as the public was mesmerised by the brilliance and flair of Raymond Kopa, Just Fontaine, John Charles, Lev Yashin, Tom Finney, Uwe Seeler, Garrincha, Vavá and Pelé.

Although it was France's Just Fontaine who scored a record 13 goals (which still stands today), the world fell in love with the 17 year old Pelé who inspired a great Brazilian side to their first World Cup title. He scored a sublime goal to beat Wales 1-0 in the quarter-finals, a hat-trick against a great French side for a 5-2 win, and two more goals in the finals to help Brazil also beat Sweden 5-2. Brazil secured their second World Cup title in style in 1962 in Chile, even though Pelé only played in their opening 3-1 victory over Czechoslovakia. However, the brilliance of Garrincha and his teammates overcame the tournament's descent into over-physical play that many of the teams used. The "ugly side" of football culminated in another infamous match, the "Battle of Santi... which saw Italy and Chile coming to blo... remarkably only two red cards. In the ... defeated surprise package Czechoslovakia ...

70

Opposite: Brazilian football star Pele (Edson Arantes do Nascimento) and Swedish goalkeeper Kalle Svensson jump for the ball during the 1958 World Cup Final in Swe...

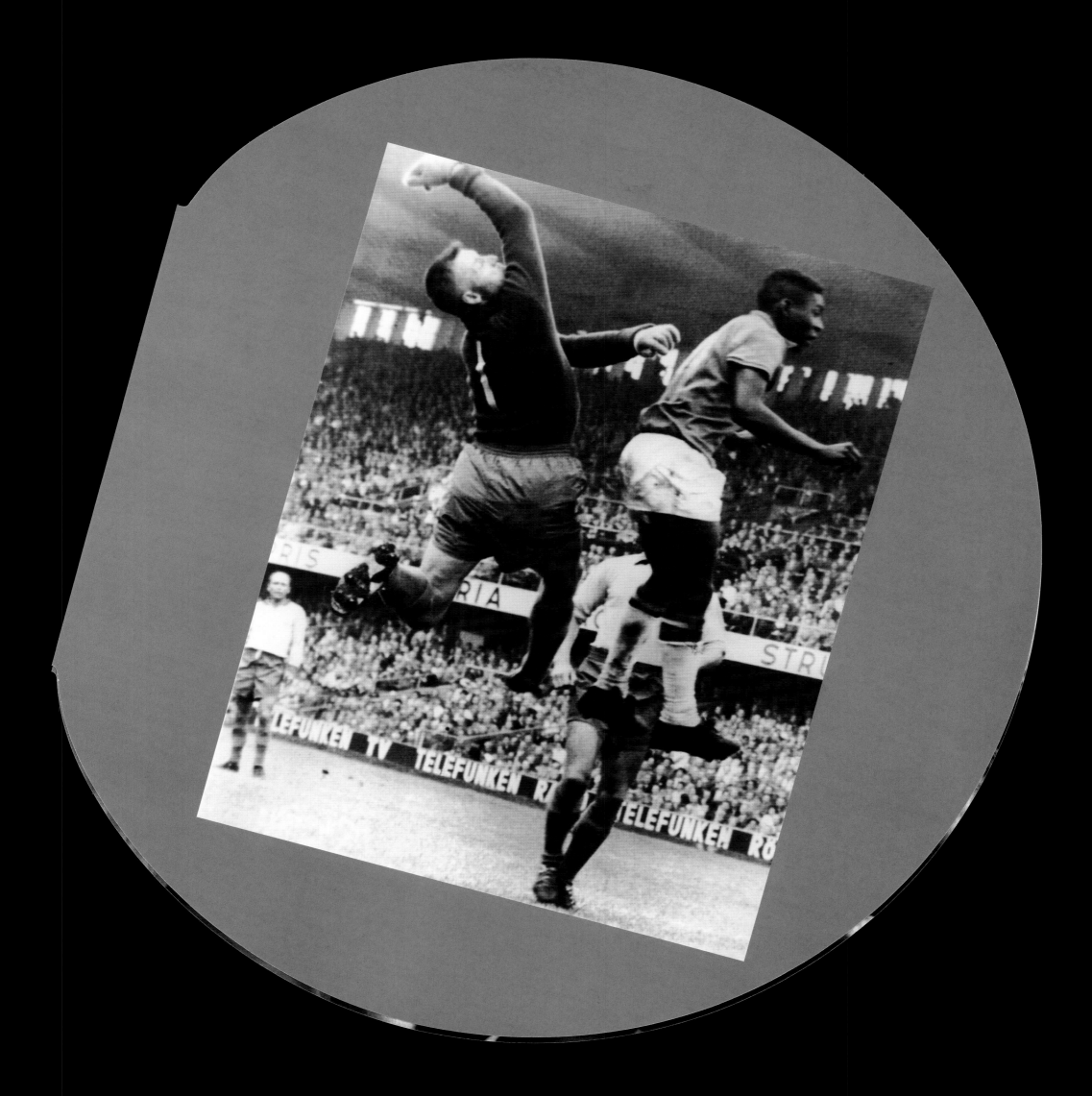

THE WORLD CUP

played a part in England's exit. The quarter-finals saw a rematch of the 1966 final, with arch-rivals West Germany (who had cruised through their group with victories over Morocco, Bulgaria and Perú). The game started off at a great pace, with Alan Mullery scoring in the 31st minute and Martin Peters seeming to have scored the winner in the 49th minute. Bobby Charlton was at his best, controlling the midfield and containing the runs of Franz Beckenbauer from deep. Just after Beckenbauer had pulled a goal back, manager Alf Ramsey wanted to rest the ageing Charlton, who was beginning to tire and substituted him with 20 minutes to go, to save him for the rest of the competition. Many see this as a tactical mistake by Ramsey that cost England the game as West Germany began to impose themselves on the game. Missing Gordon Banks, who was too sick to play, Chelsea keeper Peter Bonetti was his last minute replacement. In extra time, Geoff Hurst had a goal disallowed, before Gerd Müller pounced and completed another of West Germany's fantastic comebacks. Another epic match followed in the semi-finals as they drew 1-1 with Italy, before a thrilling extra-time as they scored three times to overcome Gerd Müller's two goals and end the match 4-3 winners. The tournament, however, belonged to the Brazilians. A fabulous team, possibly one of the best ever, that included Pelé, Jairzinho (the only player to score in every game in every round of the competition), Tostão, Rivelino, Carlos Alberto, Gerson and Clodoaldo who thrilled spectators with a string of excellent performances before a sublime performance to dance past Italy in the final with a 4-1 victory. With it

as Uwe Seeler and had an uncharacteristically poor game hesitated.

came a third World Cup and the right to retain the Jules Rimet Trophy permanently. Sadly the trophy was stolen in 1983 while on display in Rio de Janeiro and has never been recovered. It was not the first time the trophy has been stolen though. In 1966 it was pinched during a public exhibition in London four months before the finals started but was found wrapped in newspaper a week later by a dog called Pickles under a bush.

After such an exciting World Cup could easily have been an anti-climax. However, with the arrival of the 1974 World Cup, spearheaded by the enigmatic Johan Cruijff Football, there were plenty of memorable matches. The Netherlands exploded onto the international scene beating Argentina 4-0, East Germany and Brazil 2-0. Hosts, West Germany had a shaky start to the finals with a highly-politically and emotionally charged match against East Germany – with the East winning 1-0. They went on to beat Brazil 1-0 to finish third, with Italy.

Poland were the dark-horses of the tournament, including beating Argentina (3-2) and Italy (2-1). They pitched Lato the tournaments top scorer with 7 goals. The final was billed as Total Football versus German efficiency, exceptional Cruijff against the Dutch irrepressible West German team who triumphed by an the hosts against the Netherlands versus German technical start the Dutch were beaten by Beckenbauer. After an World Cup were still a powerful force in the 1978 Argentina striker, Johan Cruijff. The team picked up form through Dutch but were missing their talismanic mercurial competition to face hosts Argentina in the final. Controversy remains to this day though as Argentina, needing to win by 4 goals to progress at the expense of

Opposite: West German midfielder Franz Beckenbauer (l) fights for the ball with Moroccan Benkhrif Boujemaa as Mohammed El Filali (back) looks on during the World Cup first round soccer match between West Germany and Morocco 3rd June 1970 in Leon. West Germany won 2-1.

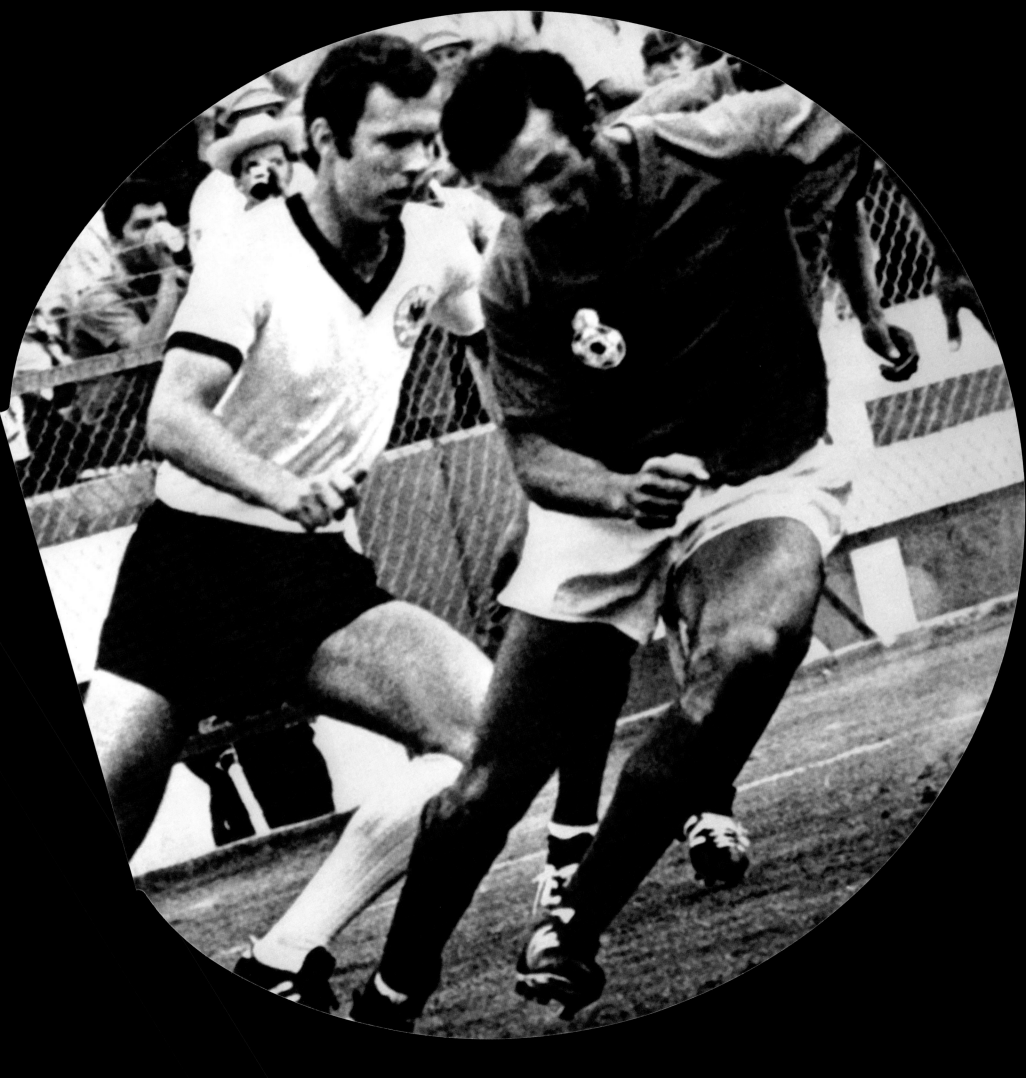

THE WORLD CUP

Brazil to the final, beat a good Perú side 6-0. In the previous 5 matches Argentina had only scored 6 goals and Perú had only conceded 7. Collusion was widely suspected with the team either bought off or threatened by the military junta, further suspicion arose after it became known the Peruvian goalkeeper Ramón Quiroga had been born in Argentina. However, to this day both teams vehemently deny any foul play. In the end it was the brilliance of Argentinean striker Mario Kempes that will most likely be remembered as he finished top scorer with 6 goals – scoring twice in a vibrant final against the Netherlands, which Argentina won 3-1 in extra time in front of 78,000 fanatical partisan supporters.

By Spain in 1982 the World Cup had grown to include a 109 teams attempting to qualify. 24 teams went on to compete in what many believe is one of the best finals held. The competition had expanded to open up the World Cup for teams from North America, Africa and Asia – with Algeria, Cameroon, Honduras, Kuwait, and New Zealand all competing for the first time. Cameroon were desperately unlucky to not qualify for the next round as were Algeria (who beat West Germany 2-1).

Fellow group teams West Germany and Austria already knew Algeria's result before kicking off and knew that a 1 or 2 goal victory would give both German speaking nation's a place in the next round. West Germany started on the attack, piling on the pressure until Horst Hrubesch scored after 10 minutes – the two teams then kicked the ball around aimlessly for the next 80 minutes much to the disgust of the onlookers and even their own fans. After this controversy FIFA reorganised the finals so that all final group games are played simultaneously.

Another "small" team to do remarkably well was Northern Ireland who topped a group including

Yugoslavia, Spain and Honduras but were knocked out after France beat them 4-1 in the second stage. Brazil were pre-tournament favourites, with a team including Zico, Sócrates, Falcão, Serginho, Junior and Éder and fulfilled expectations as they cruised through the first group round to be drawn in a second group stage. They destroyed Argentina 3-1, a score line that flattered the defending world champions, and went on to meet Italy in the "Group of Death" decider. A classic match with Brazil leading twice and twice Italy equalising before Paolo Rossi scored a hat-trick to send Italy into the semi-finals. Where they met Poland (again a revelation), who had had to play a highly politically charged meeting with the Soviet Union only months after Poland had cracked down on dissent and introduced martial law to avoid a Soviet invasion. Needing a draw Poland gave as good as they got and held out for a 0-0 draw. Paolo Rossi again supplied the goals as Italy ran out 2-0 winners. The other semi-final witnessed another classic as West Germany met France. Tied 1-1 after regulation time (and Harald Schumacher's unpunished assault on Patrick Battiston), France stormed into a 3-1 lead in extra-time before Germany managed to score twice and level the game. The game went to a penalty shoot out with Schumacher saving the penalties to send West Germany into the final. Drained from the epic semi-final appearance West Germany were easily beaten by Italy with Rossi scoring the opener before it finished 3-1 and Dino Zoff at 40 years old lifted the trophy. Rossi's achievements were even more remarkable considering his career had been destroyed during the first Italian match fixing scandal in 1980. He repeatedly protested his innocence and his three-year suspension was cut to two,

Opposite: Gentile (number 6) of Italy holds aloft the World Cup with team captain and goalkeeper Dino Zoff (right) after Italy's victory over West Germany by 3-1 in the 1992 World Cup final at the Bernabau Stadium in Madrid, Spain.

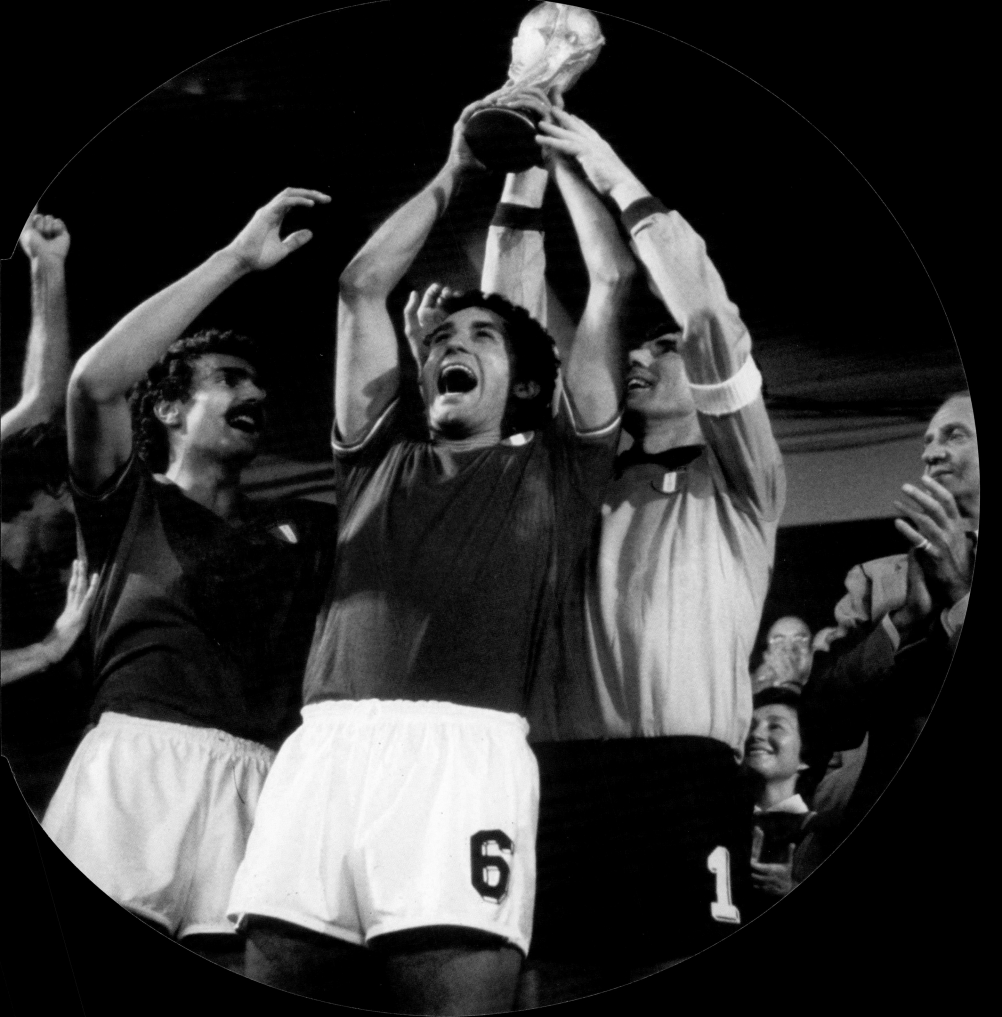

THE WORLD CUP

just in time for the finals. He became the tournament's top scorer (even after not scoring in the opening 4 matches), as well as an Italian and World Cup hero. If question marks had hung over Argentina's victory in 1978 they were more than worthy champions in Mexico 1986. Driven by the maverick genius of Maradona in sensational form, Argentina had to overcome two of its archrivals, Uruguay and then England (in an infamous match that included the "Hand of God" goal), to reach the semi-finals where they met and with two Maradona goals defeated Belgium, one of the surprise teams of the tournament. Another team to rock the boat was Morocco who topped a group that included England, Poland and Portugal before narrowly losing to West Germany in the knockout stages. West Germany went on to knockout the host nation in a penalty shootout, before again knocking France (who had just eliminated Brazil and won the accolades for their dazzling football) in the knockout. The finals, in front of a crowd of 114,600, saw Maradona double-man-marked through the game, but Argentina still managed to force their way into a 2-0 lead. However, with 16 minutes left West Germany fought back first with a goal by Karl-Heinz Rummenige and equalised on the 82nd minute through Rudi Völler. It was Argentina's tournament though, as Maradona created enough space to set-up Jorge Burruchaga to snatch the winner with only 2 minutes left, and spark wild national celebrations in the streets of Argentina.

The 1990 World Cup was low on goals and in general is regarded as the least exciting of recent finals. After the over-defensive tactics of many teams FIFA attempted to change the point system and encourage more attacking football with 3 points awarded for a win instead of 2.

This, however, does not mean it was not a final without drama and excitement. It began with the opening match when Cameroon beat Argentina 1-0 with a header from François Omam-Biyik. They went on to become one of the highlights of the tournament and the first African team to make the quarter-finals where they were unlucky to lose to England, with 2 Gary Lineker penalties, and a final score of 3-2 in extra-time Another surprise quarter-finalist was the Republic of Ireland who were narrowly edged out by the Italy 1-0. The hosts then failed to defeat Argentina and were knocked out in a penalty shootout after Sergio Goycochea saved penalties by Roberto Donadoni and Aldo Serena. The other semi-final was a tense match between West Germany and England, famous for Paul Gascoigne's tears when he received a yellow card that would have menat an automatic suspension had England progressed to the finals. However, England's dream, despite a great performance, was cut short in another penalty shootout. Bodo Illgner was the keeper who saved Stuart Pearce's spotkick before Chris Waddle blasted his over the bar. The final that followed was an ugly niggling match with Argentina unable to find rhythm and the West German team (in their last tournament before reunification) winning through an Andreas Brehme penalty 5 minutes from time.

Despite the United States' reputation as a barren country for football it staged a hugely successful World Cup finals in 1994 with a record average attendance of 69,000. There were more surprises in this competition before the traditional superpowers of Brazil and Italy met in the final. The Republic of Ireland beat Italy 1-0 in the group stage after a great looping shot from veteran Ray Houghton and finished 2nd (above the Azzurri).

Opposite: Lothar Matthaeus and Rudi Voeller of Germany celebrate victory over Argentina in the World Cup final in the Olympic Stadium on July 8, 1990 in Rome, Italy.

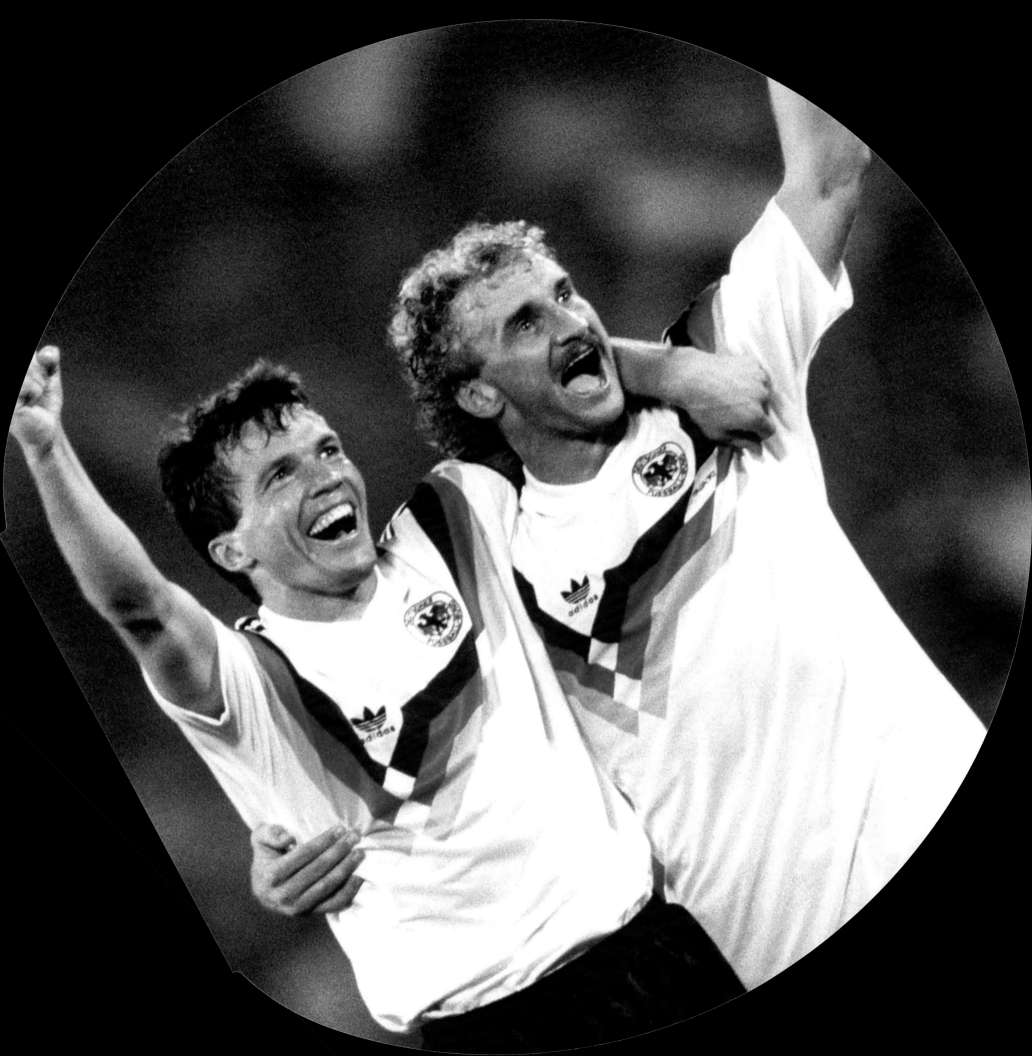

Saudi Arabia also performed above expectations, with two victories (against Morocco and Belgium) to also progress before being knocked out by Sweden 3-1. Nigeria finishing top of their group (that included Argentina, Bulgaria and Greece) before being 90 seconds away from knocking 10 man Italy (who had only progressed as a best third place team) out in the second round, before Roberto Baggio equalised and then scored a penalty in extra time. There was also Bulgaria, inspired by Hristo Stoichkov, to become one of the teams of the tournament, smashing Greece 4-0, before beating Argentina 2-0. They then defeated Mexico (in a penalty shootout) before knocking out Germany in the quarter-finals. They were halted by Italy as Roberto Baggio scored the all-important goals again; with two in a 2-1 victory and progress to the finals. With Roberto Baggio as its heartbeat Romania knocked out Gheorghe Hagi being knocked out by Sweden on penalties in the quarter-final. The hosts also won many admirers before being beaten 1-0 by Brazil. They themselves continued in steady, if unspectacular, form to beat the Netherlands (3-2) and Sweden (1-0) and progress to the final. The final game went to the first penalty shoot in the World Cup's history. Cruelly it was Roberto Baggio, the star and saviour of Italy's World Cup, who missed the crucial penalty, lifting it high over the crossbar, to give Brazil their fourth championship. Tragically Andrés Escobar a Colombian defender was shot dead when he returned home to Medellín. It is not entirely clear why he was killed but it was suggested that he had been killed after scoring an own goal during a 2-1 defeat to the USA (angering powerful Colombian gambling syndicates) but could also have been linked to a bar fight that left several people wounded.

The following World Cup was also a great success. The competition now had 174 teams entering with the finals in France expanded to include 32 teams, divided into eight groups of four, with the top two teams progressing to the knockout stage. In general the traditional football teams progressed much as expected. However, Nigeria again delighted the footballing world with powerful performances to beat Spain 3-2 and Bulgaria 1-0 before unexpectedly crumbling in a 4-1 second round Denmark defeat. Although it would be too strong to suggest that Croatia were an unknown force (as they made it to the European Championship finals two years earlier) they still caused an upset by finishing third (1-0) and West Germany in the knockout stages against Romania after great wins in the semi-finals by the hosts. Brazil had been in great form with Ronaldo setting the finals alight before a strangely subdued Brazil faced France – who with Zinedine Zidane's magic won 3-0 to win its first World Cup title. Its team was representative of modern France, a multi-racial team that unified a nation as it celebrated long into the night.

Asia hosted its first World Cup in 2002 when Japan and South Korea co-hosted the finals. The tournament opened with another major upset as the relatively unknown Senegal thrilled their own fans and many neutrals by defeating the world champions 1-0 with a scrambled Pape Bouba Diop goal in the opening game. It was the beginning of a great tournament for the Senegalese team who made it to the quarter-finals only to lose 1-0 in extra time to Turkey, another surprise team who finished third after being knocked out by Brazil.

Opposite: Brazilian forward Denilson controls the ball during the Brazil/Belgium second round match of the FIFA 2002 Soccer World Cup, 17th June 2002 in Kobe. Brazil won 2-0 and qualified for the quarterfinal against England.

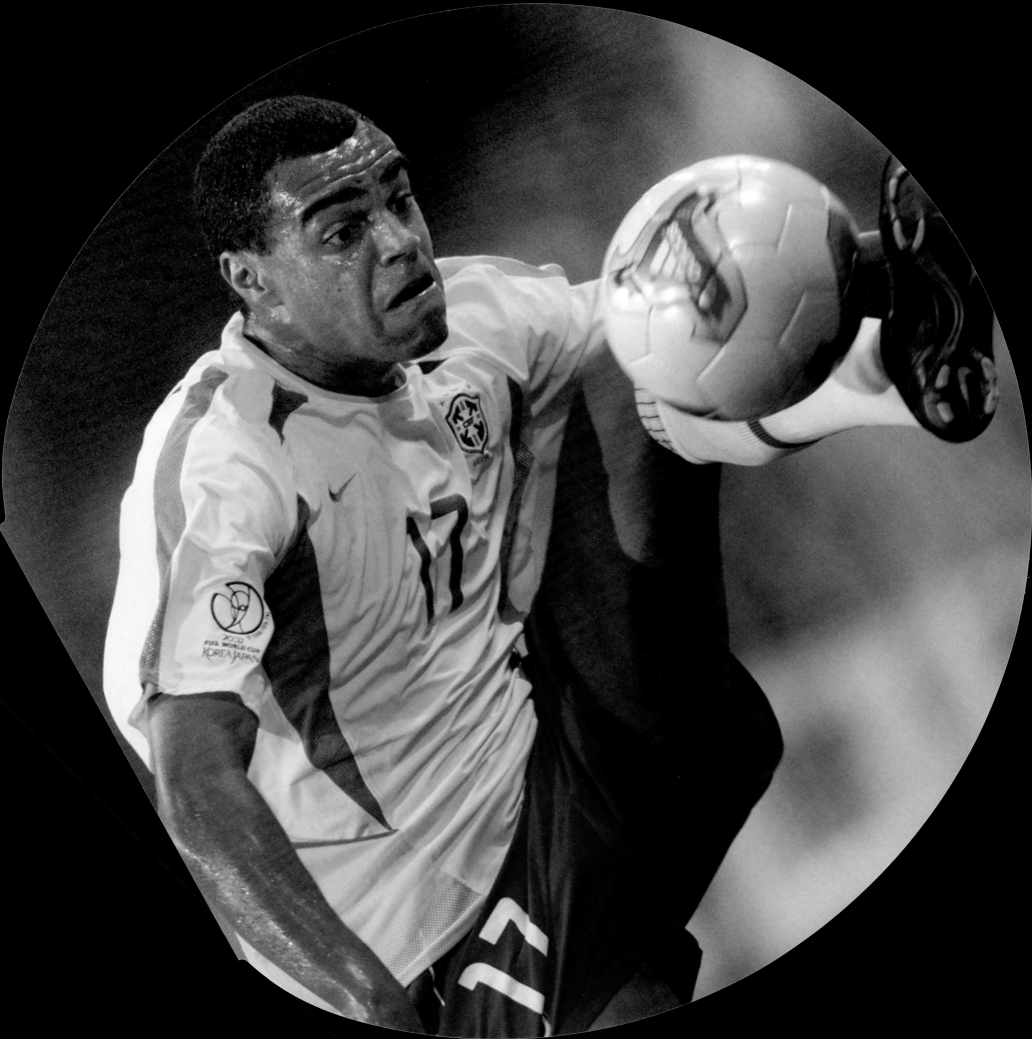

THE WORLD CUP

While Japan were knocked out in the second round by Turkey, the other hosts South Korea, with Guus Hiddink using all his management expertise to bring the best out of the team and urged on by fantastic home support, went on a great run to make it to the semi-finals – a record achievement for an Asian team. There they met Germany, who for a change were expected to achieve little (after a 5-1 defeat by England in the qualifiers and needing a play-off victory against the Ukraine to qualify), however, only someone with amnesia would underestimate any German national team. They had progressed through a relatively easy group (Cameroon 2-0, Republic of Ireland 1-1, and Saudi Arabia 8-0) before negotiating there way through the knockout rounds with three 1-0 wins against Paraguay, the USA and South Korea before meeting Brazil. Ronaldo was in great form with a classy Brazilian team and banished his own personal and Brazil's collective demons from four years ago, as top scorer with 8 goals, and scoring twice in the final itself to defeat Germany 2-0. Brazil were crowned champions for a record fifth time.

The 18th World Cup was held in Germany with 32 teams qualifying for the final from a total of 198 entrants – it was estimated that over the course of the finals 28.29 billion non-unique viewers watched the games at some point, with an estimated 715 million people tuning in for the final. It was another successfully organised tournament with excellent facilities, transport and an enthusiastic and hospitable home nation. Good fighting performances from many of the teams written off prior to the finals including Australia, Ecuador, Côte d'Ivoire, Ghana, Angola and even Trinidad and Tobago brought excitement to the group stages. While in the second round Australia were desperately unlucky to be knocked out by eventual winners Italy and the 3-0 scoreline in Ghana's defeat by Brazil was not reflective of a much more even game. The latter stages were dominated by the traditional powers, as Italy defeated Germany 2-0 and Zinedine Zidane, in his last tournament, galvanised the French side in the knockout stages to become probably the best team in the tournament, beating Spain 3-1, Brazil 1-0 and an unpopular Portuguese side 1-0 to meet Italy. The final was full of drama that centered around two men; French midfielder Zinedine Zidane and Italian defender Marco Materazzi. France took the lead through a Zidane penalty conceded by Materazzi, who then headed an equalizer. As the game entered extra time, Zidane then shocked the world by powerfully head butting Materazzi, who had been verbally antagonising the Frenchman through the match. With France down to ten men, the game went to penalties. Materazzi scored Italy's second, while France missed Zidane's second, penalty taking technique and captain's influence, as the French went on to lose after David Trézéget hit the crossbar. It gave Italy their fourth title, one more than Germany and one less than Brazil.

The 2010 World Cup will be held on the African continent with South Africa, so long the international pariah because of apartheid, chosen as hosts. Since its beginning 78 teams have appeared at least once with 7 nations winning the trophy. The competition has been won 9 times by European teams (England, France, Germany and Italy) equalled by the South American teams (Argentina, Brazil and Uruguay). Will this be the year, as Pelé predicted, that will finally see an African team win the World Cup? Only time, and no doubt a series of thrilling matches full of drama, will tell…

Opposite: Italian defender Fabio Cannavaro celebrating with the trophy after the World Cup 2006 final Italy vs. France, at Berlin stadium 9th July 2006.

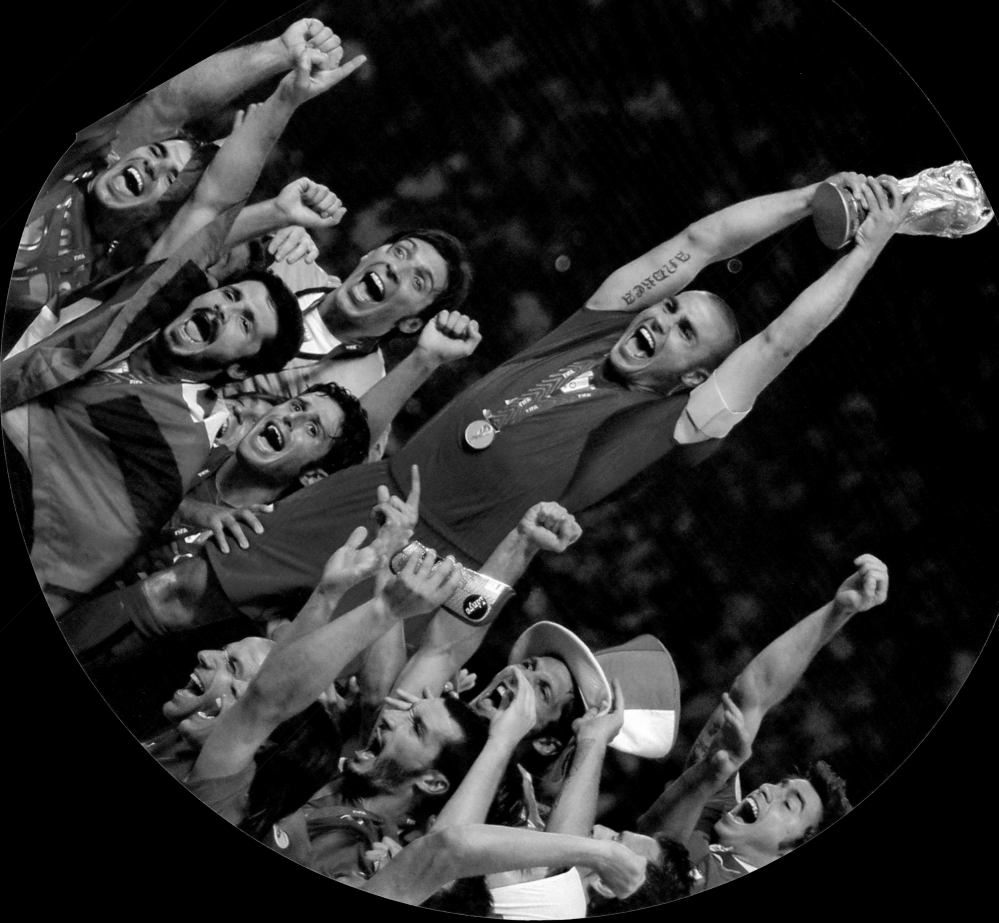

THE 2010 WORLD CUP SOUTH AFRICA

Africa was chosen as the host for the 2010 World Cup as part of a short-lived policy, abandoned in 2007, to rotate the event among football confederations. Five African nations placed bids to host the 2010 World Cup: Egypt, Morocco, South Africa and a joint bid from Libya and Tunisia.

Following the decision of the FIFA Executive Committee not to allow co-hosted tournaments, Tunisia withdrew from the bidding process. The committee also decided not to consider Libya's solo bid as it no longer met all the stipulations laid down in the official List of Requirements.

The winning bid was announced by FIFA president Sepp Blatter at a media conference on 15 May 2004 in Zürich; in the first round of voting South Africa received 14 votes, Morocco received 10 votes and Egypt no votes. South Africa, which had narrowly failed to win the right to host the 2006 event, was awarded the rights to host the tournament.

During 2006 and 2007, rumours circulated in various news sources that the 2010 World Cup could be moved to another country. Franz Beckenbauer, Horst R. Schmidt and, reportedly, some FIFA executives, expressed concern over the planning, organisation, and pace of South Africa's preparations. FIFA officials repeatedly expressed their confidence in South Africa as host, stating that a contingency plan existed only to cover natural catastrophes, as had been in place at previous FIFA World Cups.

The qualification draw for the 2010 World Cup was held in Durban on 25 November 2007. As the host nation, South Africa qualified automatically for the tournament. As happened in the previous tournament, the defending champions were not given an automatic berth, and

had to participate in qualification.

There were several controversies during qualifications. In the second leg of the play-off between France and the Republic of Ireland, French captain Thierry Henry, unseen by the referee, handled the ball in the lead up to a late goal, which enabled France to qualify ahead of Ireland, sparking widespread controversy and debate. FIFA rejected a request from the Football Association of Ireland to replay the match and Ireland later withdrew a request to be included as an unprecedented 33rd World Cup entrant. As a result, FIFA announced a review into the use of technology or extra officials at the highest level, but decided against the widely expected fast-tracking of goal-line referee's assistants for the South African tournament.

Costa Rica complained over Uruguay's winning goal in the CONMEBOL-CONCACAF playoff, while Egypt and Algeria's November 2009 matches were surrounded by reports of crowd trouble. On the subject of fair play, FIFA President Sepp Blatter said: "I appeal to all the players and coaches to observe this fair play. In 2010 we want to prove that football is more than just kicking a ball but has social and cultural value ... I appeal to the rest of the world." So we ask the players 'please observe fair play', as we will be an example to the rest of the world."

The first round, or group stage, saw thirty-two teams divided into eight groups of four teams. Each group was a round-robin of six games, where each team played one match against each of the other teams in the same group. Teams were awarded three points for a win, one point for a draw and none for a defeat. The teams finishing first and second in each group qualified for the Round of 16.

In a first for a World Cup, the host team did not advance beyond the initial stage. Defending champions

84

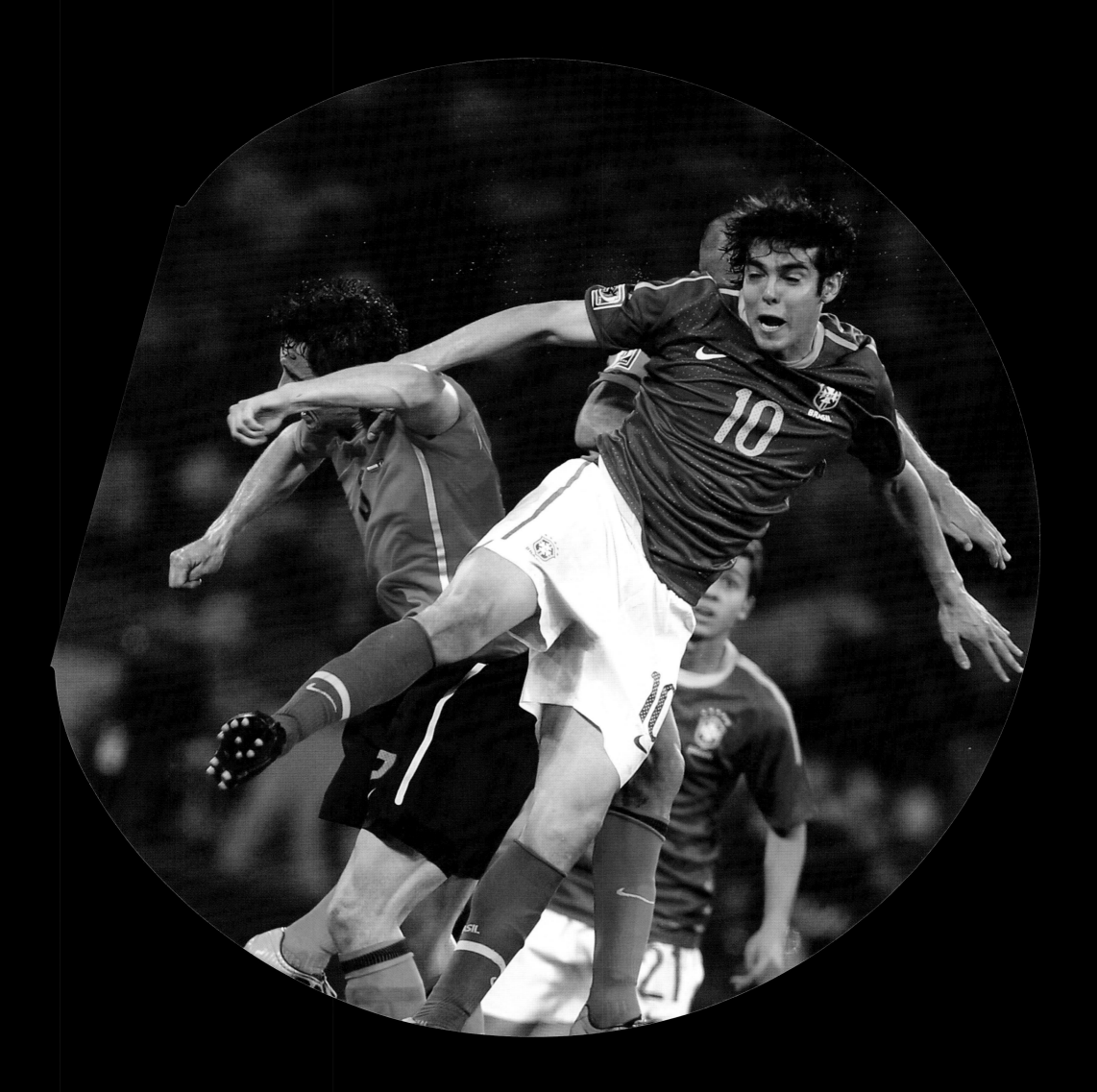

THE 2010 WORLD CUP SOUTH AFRICA

Italy and 2006 runners-up France finished last in their respective groups. Only six UEFA teams progressed to the last sixteen, a record low in the 32-team era.

In the round of 16, each group winner (A-H) was paired against the runner-up from another group. South American teams again performed strongly in the round of 16, with four teams advancing to the quarter-finals including Brazil who defeated fellow South American team Chile, the largest number of South American teams in the final eight since 1930.

England's 4–1 loss to Germany marked their worst ever defeat at a World Cup finals.

Ghana defeated the United States to become the third African team to reach the last eight (after Cameroon in 1990 and Senegal in 2002). Paraguay and Ghana reached the quarter-finals for the first time

The round was marked by some controversial referees' calls, including a disallowed goal by England in their 4–1 loss against Germany, where the shot by Frank Lampard was seen to cross the goal line when shown on television broadcast replays and an allowed goal scored by Argentina in their 3–1 win over Mexico, where Argentine striker Carlos Tévez appeared to be offside when shown on television broadcast replays.

FIFA President Sepp Blatter took the unusual step of apologizing to England and Mexico for the decisions that went against them, saying "Yesterday I spoke to the two federations directly concerned by referees' mistakes. I apologised to England and Mexico. The English said thank you and accepted that you can win some and you lose some and the Mexicans bowed their head and accepted it." Blatter also promised to re-open the

discussion regarding devices which monitor possible goals and make that information immediately available to match officials, saying "We will naturally take on board the discussion on technology and have the first opportunity in July at the business meeting." Blatter's call came less than four months after FIFA general secretary Jerome Valcke said the door was closed on goal-line technology and video replays after a vote by the IFAB.

The three quarter-finals between European and South American teams all resulted in wins for Europeans. Germany had a 4-0 victory over Argentina, Netherlands came from behind to beat Brazil 2–1, while Spain reached the final four for the first time since 1950 after a 1–0 win over Paraguay. Uruguay, the only South American team to reach the semi-finals, overcame Ghana in a penalty shoot-out after a 1–1 draw in which Ghana missed a penalty at the end of extra time.

The main topic of discussion was the match ball for the 2010 World Cup, manufactured by Adidas. The Jabulani, which means "bringing joy to everyone" in Zulu, was introduced to the event after trials in Germany giving the German team a distinct advantage. Several footballers complained about the new ball, arguing that its movements were difficult to predict. Brazilian goalkeeper Júlio César compared it to a "supermarket" ball that favored strikers and worked against goalkeepers. Argentinian coach Diego Maradona said "We won't see any long passes, in this world cup because the ball doesn't fly straight." However, a number of Adidas-sponsored players responded favourably to the ball.

86

Opposite: France's Djibril Cissé reacts after South Africa's defender Bongani Khumalo scored the first goal during the Group A first round 2010 World Cup football match France vs. South Africa on June 22, 2010 at Free State Stadium in Mangaung/Bloemfontein.

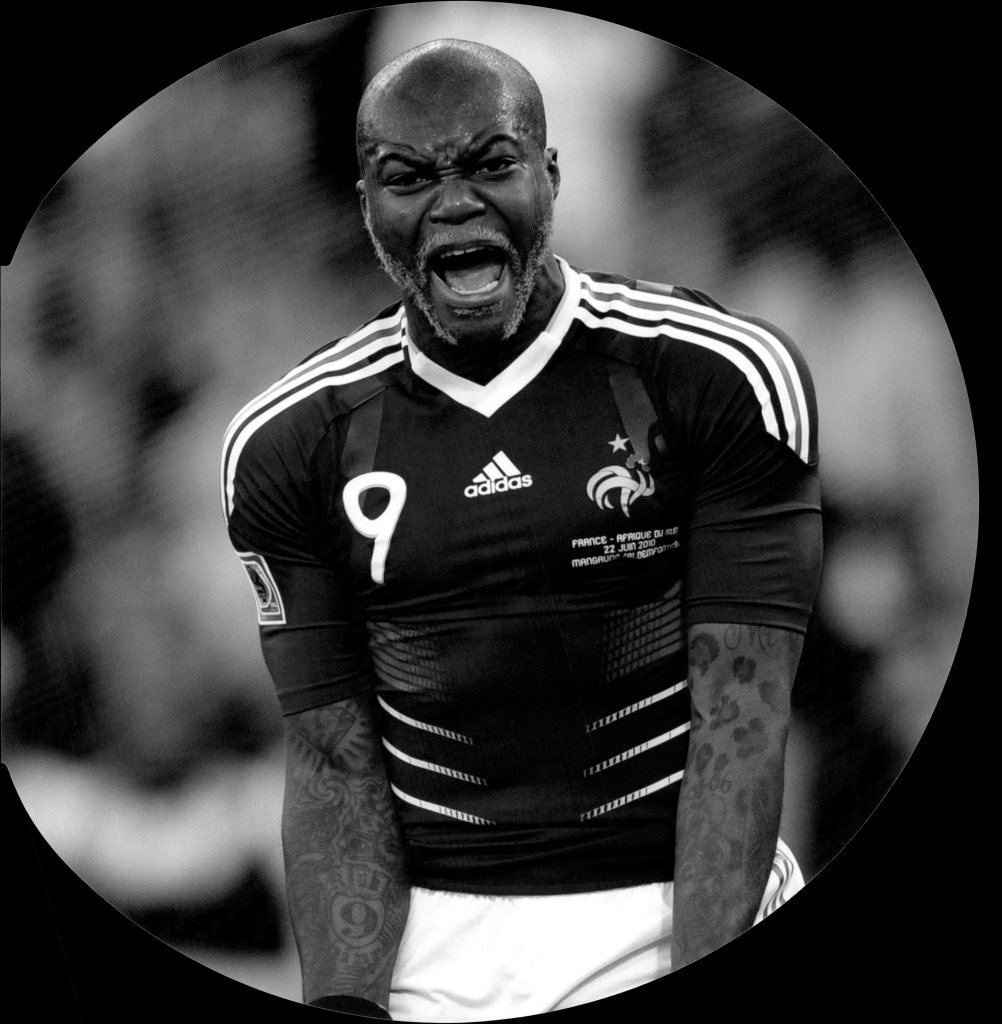

THE 2010 WORLD CUP SOUTH AFRICA

It was the eleventh World Cup match ball made by the German sports equipment maker and featured eleven colours, representing each player of a team on the pitch and the eleven official languages of South Africa. A special match ball with gold panels, called the Jo'bulani, was used in the final in Johannesburg.

The ball is constructed using a new design, consisting of eight thermally bonded, three-dimensional panels. These are spherically moulded from ethylene-vinyl acetate (EVA) and thermoplastic polyurethanes (TPU). The surface of the ball is textured with grooves, a technology developed by Adidas called GripnGroove that is intended to improve the ball's aerodynamics. The design has received considerable academic input, being developed in partnership with researchers from Loughborough University, United Kingdom. The balls are made in China, using latex bladders made in India, thermoplastic polyurethane-elastomer from Taiwan, ethylene vinyl acetate, isotropic polyester/cotton fabric, and glue and ink from China.

Another major concern for the organisers was the vuvuzela, a long horn blown by fans throughout matches. Many World Cup competitors criticised and complained about the noise caused by the vuvuzela horns, including France's Patrice Evra, who blamed the team's poor performance. Other critics included Lionel Messi, who complained that the sound of the vuvuzelas hampered communication among players on the pitch, and broadcasting companies, which complained that commentators' voices were being drowned out by the sound.

Others watching on television complained that the ambient audio feed from the stadium only contained the sounds of the vuvuzelas and the natural sounds of people in the stands were drowned out.

As the group stages were completed, half of the 32 teams that began the 2010 FIFA World Cup, were progressing onwards, it was all about winning each game now. The second round (last 16) approached, and there were some intriguing encounters lined-up to really set the competition buzzing.

Uruguay faced a South Korean side full of energy and spirit; Suarez scored an early goal after eight minutes. In a rain-soaked game, South Korea fought back in the second half, giving themselves hope with a Lee Chung-Yong leveller on 68 minutes. Suarez would seal the 2-1 win with a stunning 80th minute curler.

The USA had a tough fixture with Ghana, proving FIFA rankings count for nothing in tournaments. Ghana took the lead after five minutes, from a spectacular shot from Kevin Prince-Boateng. Rattled by this, the USA struggled to match the Ghana team in the first half. Taking advantage of half-time, the Americans forced a penalty later, after a theatrical dive from Clint Dempsey, enabling Landon Dovonan to slot the 62nd minute kick away. Matched evenly at 1-1 going into extra-time, Asamoah Gyan ripped off a stunning winner on 93 minutes to seal a deserved win.

Germany and England was set to be a classic, but only one team showed up. Early goals from Miroslav Klose (20 minutes) and Lukas Podolski (32 minutes)

88

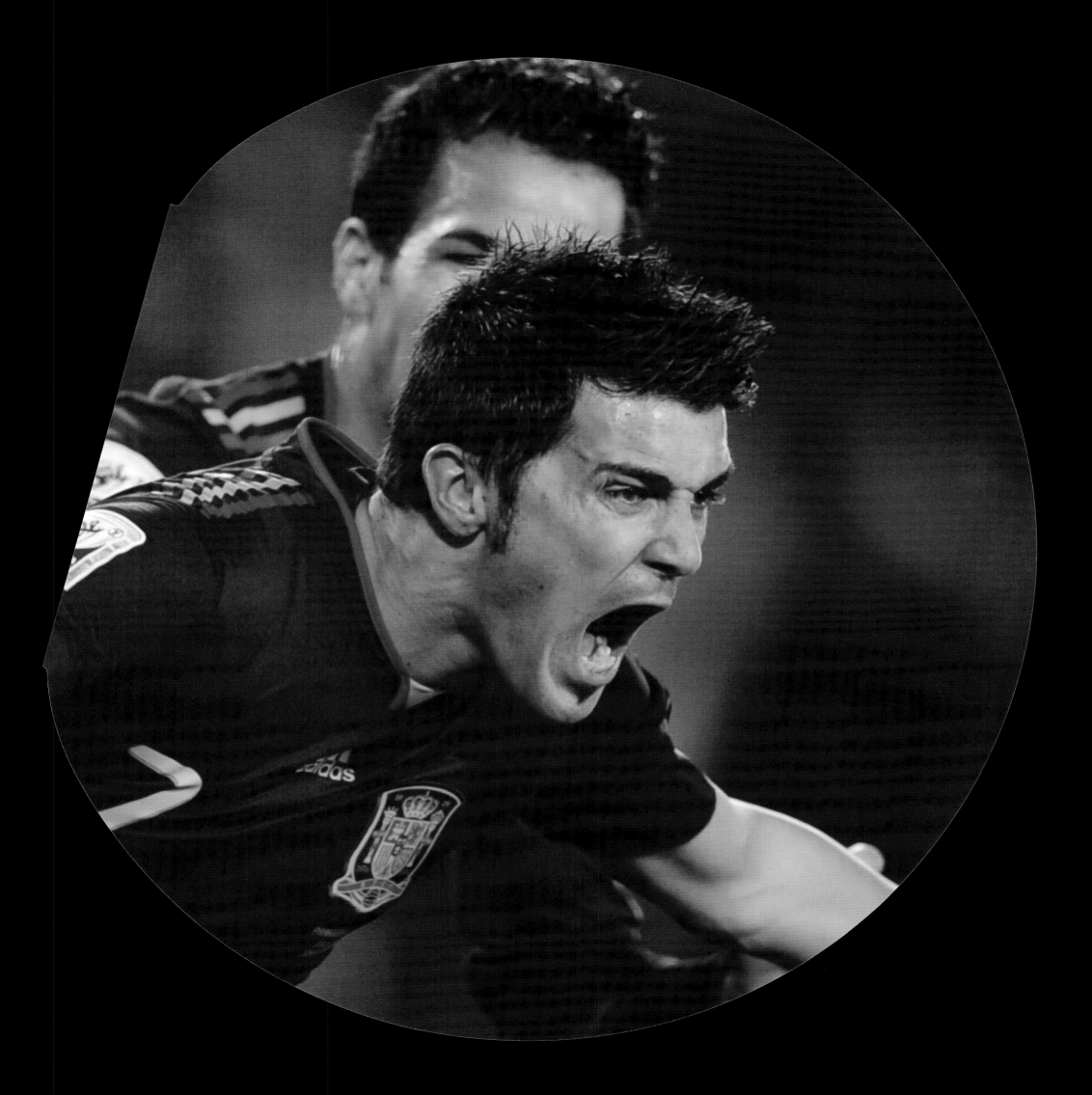

THE 2010 WORLD CUP SOUTH AFRICA

rocked England. Matthew Upson glanced a headed-goal in on 37 minutes to make it 2-1, then a chip-shot by Frank Lampard was shockingly disallowed, despite being well inside the goal. It accounted for little as Germany strolled through the goal; Thomas Mueller added two more goals after the 67th and 70th minute to win easily, 4-1.

Argentina and Mexico met, in a rematch of a 2006 FIFA World Cup match. This time it was a far more comfortable win as Argentina cruised to a 3-1 victory. Goals from Carlos Tevez (26th and 52nd minute) sandwiched a Gonzalo Higuin effort on 33 minutes. Consolation for Mexico came in the form of a well-taken goal by Javier Hernadez in the 71st minute. Argentina cruise to the quarter-finals.

Holland never defeated Slovakia 2-1, the result never seemed in doubt; the clinical play of the Dutch was too strong for the first-timers (at this stage of the World Cup). A long-range Arjen Robben strike after 18 minutes settled the game down. Wesley Sneijder touch-of-the-game penalty to restore some pride to a beaten Slovakia side. Robert Vittek ended the game as a contest after 84 minutes.

Brazil faced an old regular foe in fellow South American side, Chile. Brazil overmatched a hard-working opponent and rode out 3-0 winners. Goals from Jaun (35th minute), Luis Fabiano (38th minute) and Robinho (59th minute) paved their way to the next round.

Paraguay and Japan were a somewhat unlikely match-up; the game failed to live-up to the standard already set in the second round earlier. Chances were limited and extra-time couldn´t separate the two teams. Following the drab 0-0, it came down to penalties to decide the contest. Paraguay held their nerve and moved on after a 5-3 decision.

Spain and Portugal faced a tough match early in the knockout stages. There were a fair number of chances for both teams as the game unfolded. David Villa (for Spain) and Cristiano Ronaldo (Portugal) both had opportunities to open the scoring. Eventually Villa made the breakthrough with a second-chance stab at shooting, it proved to the winning goal on 62 minutes, taking Spain through 1-0.

The second round games were entertaining and livened up a tournament, which had been accused of lacking goals and many memorable moments, into something very watchable indeed.

The 2010 FIFA World Cup has seen most of the big teams and favourites crash out of the Cup dramatically in a series of missed penalties, own goals and poor defence. As World Cup favourites England, Brazil, Argentina and France crashed out of the world cup amidst the tears and anger of their fans, Uruguay, the Netherlands, Germany and Spain broke through to face each other for a contest to kiss to cup.

The July 6, 2010 semi-final match kicked off at Cape Town Green Point Stadium, and saw the Netherlands edge past Uruguay to secure a seat in the finals with a win of 3 goals to 2. Giovanni Van Bronckhorst, Wesley Sneijder and Arjen Robben slammed the ball past Uruguay to face

Opposite: Opposite: Spain's defender Carles Puyol celebrates with team mates after scoring Spain's opening goal during the 2010 World Cup semi-final football match Germany vs. Spain on July 7, 2010 at Moses Mabhida stadium in Durban.

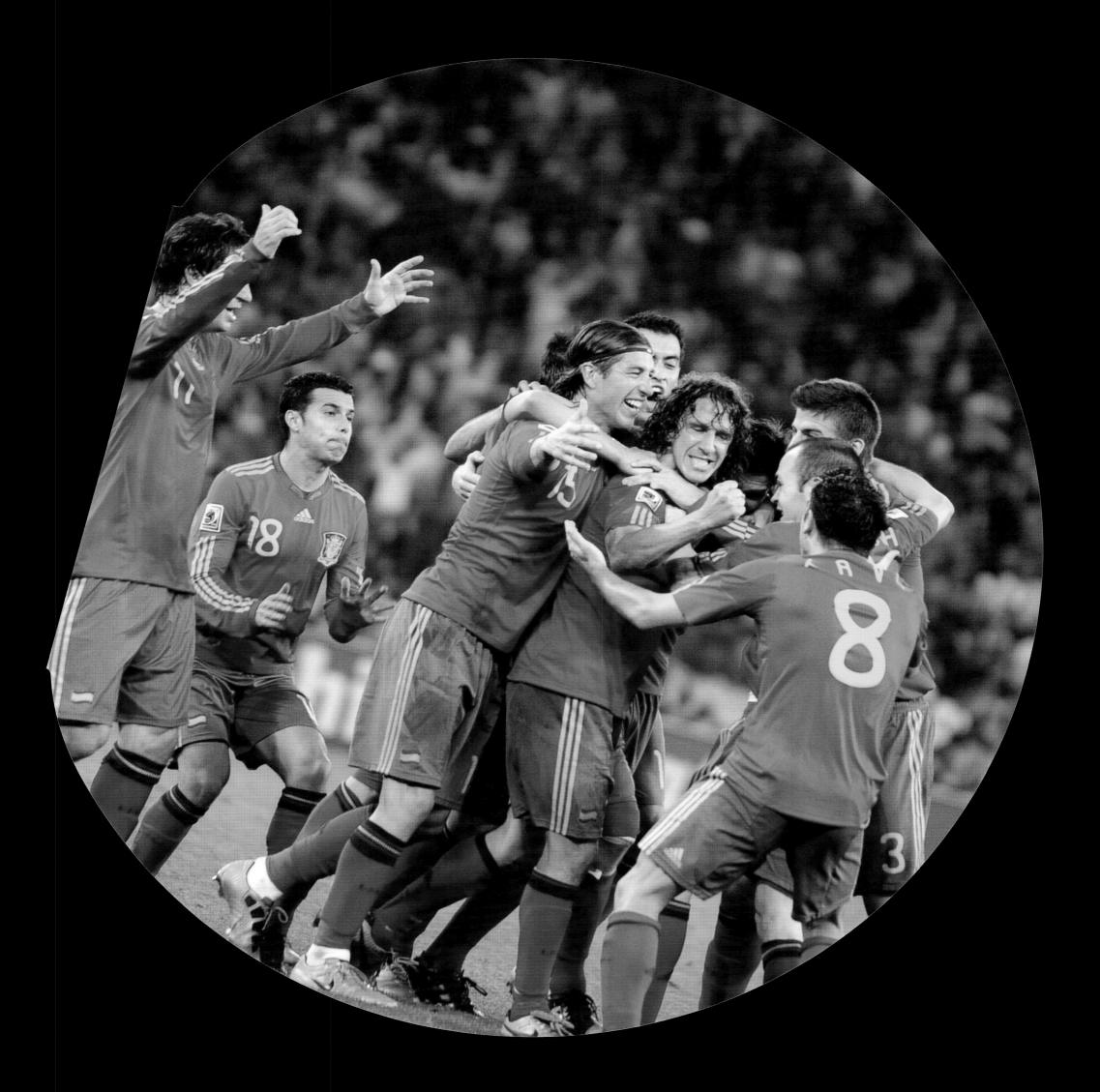

THE 2010 WORLD CUP SOUTH AFRICA

Spain for an opportunity to win the cup.

Despite the Netherlands win, the Dutch were kept on their toes as Uruguay's other leading scorer Diego Forlan, who replaced top goal scorer Luis Suárez; after Suárez's handball in Uruguay's quarter final match against Ghana, and Maximiliano Pereira scored two outstanding goals against Bert Van Marwijk's side, which, at the end of ninety minutes and five minutes of extra time, proved to be too little too late, dashing the dreams of Uruguay's place in the final.

In the second semi-final, Spain won through to the Final of South Africa 2010 with a 1-0 victory over Germany in Durban. Carles Puyol's 74th-minute header repeated the single-goal triumph over Germany that secured La Roja the European title two years ago and now only the Netherlands stood between them and a first FIFA World Cup title.

While Germany were playing in their 12th FIFA World Cup semi-final, this was Spain's first, although it was business as usual for Vicente del Bosque's side, who dominated possession. Indeed Spain might have had an early goal when Pedro, making his first start of the finals in place of Fernando Torres, slipped a through-ball to David Villa after just six minutes. Clear of the Germany defence, Villa produced a sliding finish but Manuel Neuer was out of his goal fast to deny the Spaniard.

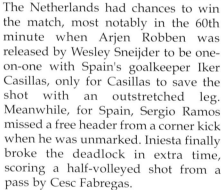

The Final was held on 11 July 2010 at Soccer City, Johannesburg. Spain defeated the Netherlands 1–0, after an extra time goal by Andrés Iniesta. The win gave Spain their first World Cup title.

Spain had the better of the first half with complete possession. Like every match in this World Cup, there were deliberate fouls and several unwanted displays of acting in and near the square.

The match was affected by a large number of fouls, particularly from the Netherlands. 13 yellow cards were given, and John Heitinga of the Netherlands was sent off.

The Netherlands had chances to win the match, most notably in the 60th minute when Arjen Robben was released by Wesley Sneijder to be one-on-one with Spain's goalkeeper Iker Casillas, only for Casillas to save the shot with an outstretched leg. Meanwhile, for Spain, Sergio Ramos missed a free header from a corner kick when he was unmarked. Iniesta finally broke the deadlock in extra time, scoring a half-volleyed shot from a pass by Cesc Fabregas.

A closing ceremony was held before the Final, featuring singer Shakira. Afterwards, the former South African President Nelson Mandela made a brief appearance on the pitch, wheeled in by a motorcart.

Opposite: Spanish players celebrate with the trophy following the 2010 World Cup football final between the Netherlands and Spain on July 11, 2010 at Soccer City stadium in Soweto, suburban Johannesburg.

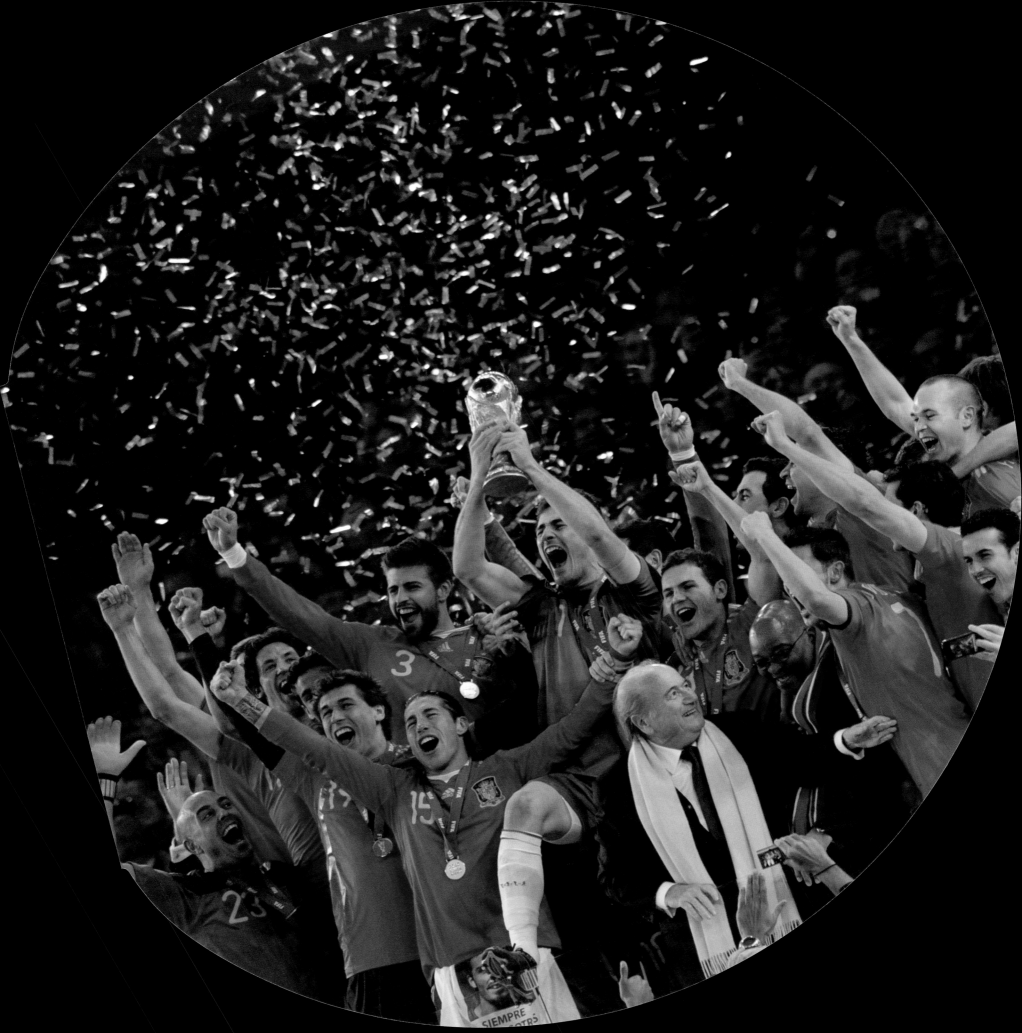

FRANZ BECKENBAUER

Der Kaiser (or The Emperor) as Franz Beckenbauer was nicknamed is a football legend having won the World Cup as both a player and manager. In his prime, his vision and ability to read the game on a different level made him appear like he played the game on a different level to everybody else as he defined and invented the attacking defensive position of sweeper. Even in the highest pressure games, he remained calm to play with a style and touch of arrogance that oozed confidence as he ran out of defence to score or instigate an attack with precise passing. His technical brilliance and qualities as a leader meant he was the focal point of both Bayern Munich and West Germany as they dominated domestic and international matches from the mid-1960s to the mid-1970s. A great thinker of the game he also masterminded West Germany's World Cup victory in 1990.

Franz Anton Beckenbauer was born on the September 11th, 1945 in München (or Munich) in West Germany, growing up in the working-class district of Giesing. His father, a postman, was dismissive of the game, yet Franz started playing football for his local youth side SC Munich 1906 at the age of 8. He started out as a centre-forward and dreamt of playing for his favourite team 1860 Munich. About to make this a reality, he and his friends planned to join after playing an under-14s tournament, where fate drew his youth team against 1860 Munich in the final. It was an ill-tempered game with 1860 playing dirty and involved a scuffle between Franz and the opposing centre-half. The experience left such a bad taste in his mouth that he refused to join the more popular 1860 and went instead to the city's smaller club (at the time), and fierce rivals Bayern Munich in 1959. Three years later he gave up his job as an apprentice insurance salesman to become a professional footballer. Bayern were a league below the Bundesliga when he made his debut in June 1964, playing on the left-wing against FC St. Pauli, but later that season won promotion.

As Beckenbauer established himself in the team, Bayern also consolidated their position in the Bundesliga. They also won the DFB-Pokal (West German Cup) in 1966 (defeating Meidericher SV 4-2) and 1967 (beating Hamburger SV 4-0), and the following season led the team to their first championship in 37 years. During this time he had also begun experimenting with watching attacks from the centre of defence after watching Italian left-back Giancinto Facchetti's forward runs down the flank in a similar way to today's wing-

lifted the European Cup Winners' Cup (defeating Glasgow Rangers 1-0 after extra time). By the 1968/69 season, Beckenbauer had been promoted to captain and had also begun experimenting with launching attacks from the centre of defence after watching Italian left-back Giancinto Facchetti's forward runs down the flank in a similar way to today's wing-

In his prime, his vision and ability to read the game made him appear like he played the game on a different level to everybody else as he defined and invented the attacking defensive position of sweeper.

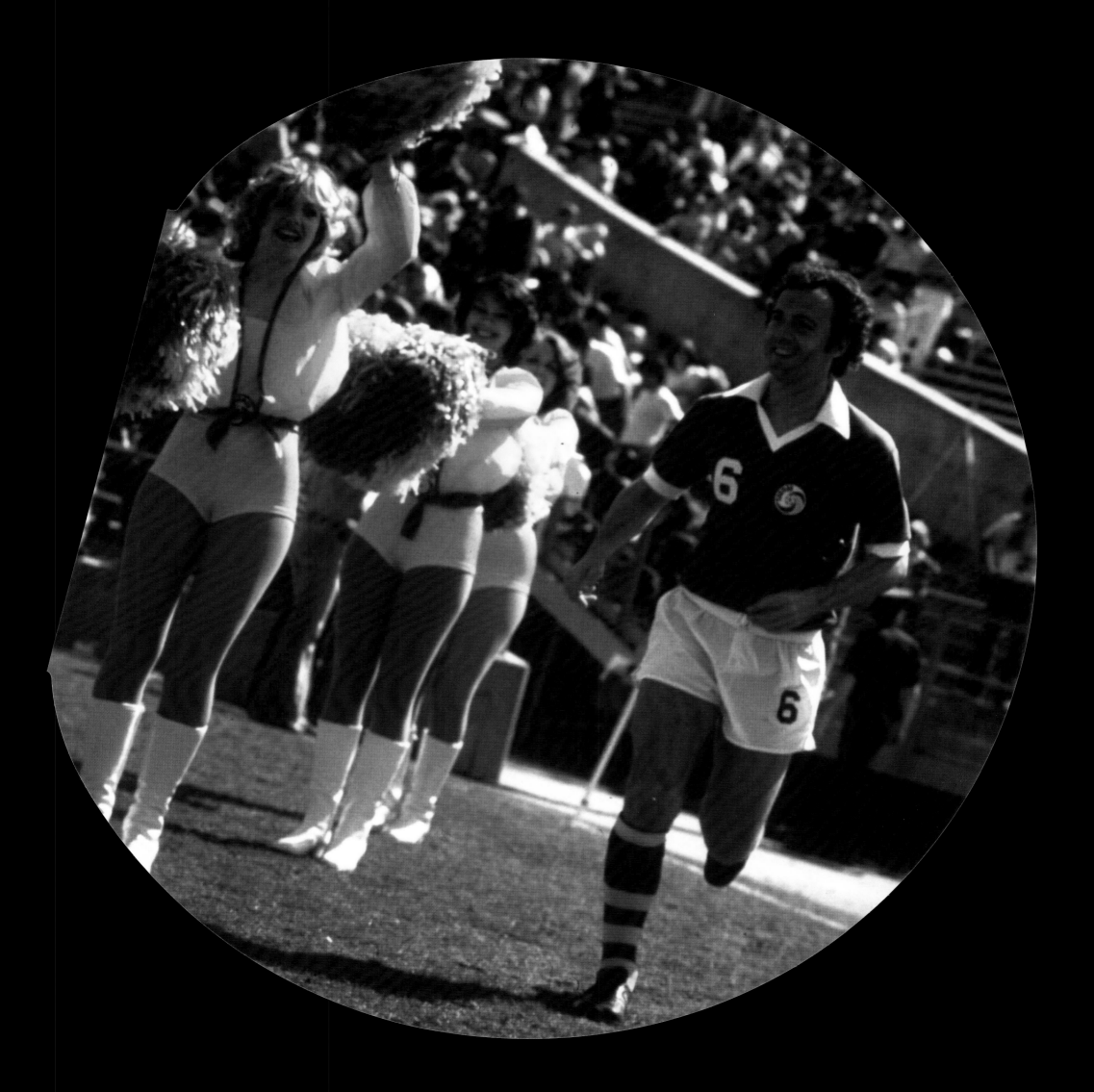

FRANZ BECKENBAUER

backs are used. Beckenbauer wanted to adapt this role into central defence also. This role as sweeper or libero, as it became known, is a more flexible centre-back or deep defensive midfield role, whereby they "sweep" up an attack that has broken through the defence or midfield (depending on exactly how far up the pitch they are positioned), they also play a key role in building attacking moves – therefore the ability to read the game, strong tackling and good passing are essential, as well as the stamina to maraud up and down the field throughout the game. With Beckenbauer at the heart of the team, prolific goal scoring of Gerd Müller leading the attack and an excellent keeper in Sepp Maier, Bayern began a period of German and European domination – winning the Bundesliga in 1972, 1973 and 1974, as well as three consecutive European Champions Cups (winning 4-0 against Spain's Athletic Madrid in 1974, 2-0 against England's Leeds United in 1975, and 1-0 against France's St. Etienne in 1976), which also lead to victory in the Intercontinental Cup 2-0 against Brazil's Cruzeiro (1976). In 1977, Beckenbauer accepted a lucrative deal to play for New York Cosmos in the North American Soccer League (along with other stars such as Pelé), he stayed for four seasons winning the Soccer Bowl three times. He returned to Germany to play 2 seasons and 28 games for

Hamburger SV between 1980-82 (winning the league again in 1982), before returning to Cosmos for a final season and 27 more games.

Beckenbauer's first of his record 103 caps for West Germany came in September 1965 against Sweden in an important World Cup qualifier, where he remained undaunted despite being only 20 years old. He played every game in the 1966 World Cup in England, scoring 4

times on the way to a dramatic final defeat against England, where he was given the unenviable job of man marking Bobby Charlton. West Germany were famously able to avenge their defeat in the 1970 World Cup in Mexico, when they knocked England out at the quarterfinals stage 3-2 in extra time after an amazing fight back from 2 nil down. Another dramatic game followed, one of the best in the history of the World Cup finals, when Italy beat West Germany 4-3, again in extra time. As Germany had used its two permitted substitutes, Beckenbauer refused to leave the pitch even after his collarbone (clavicle) was broken under a heavy Italian challenge, playing the remainder of the match with his arm in a sling. In the 1972 European Championship in Belgium, West Germany now led by Beckenbauer stormed to victory beating the hosts 2-1 in the semis, before

Franz enjoyed only the briefest of retirements before returning to the game as coach of West Germany in 1984, surprising everybody by guiding a fairly average team to the World Cup finals in 1986, where they lost 3-2 to Argentina.

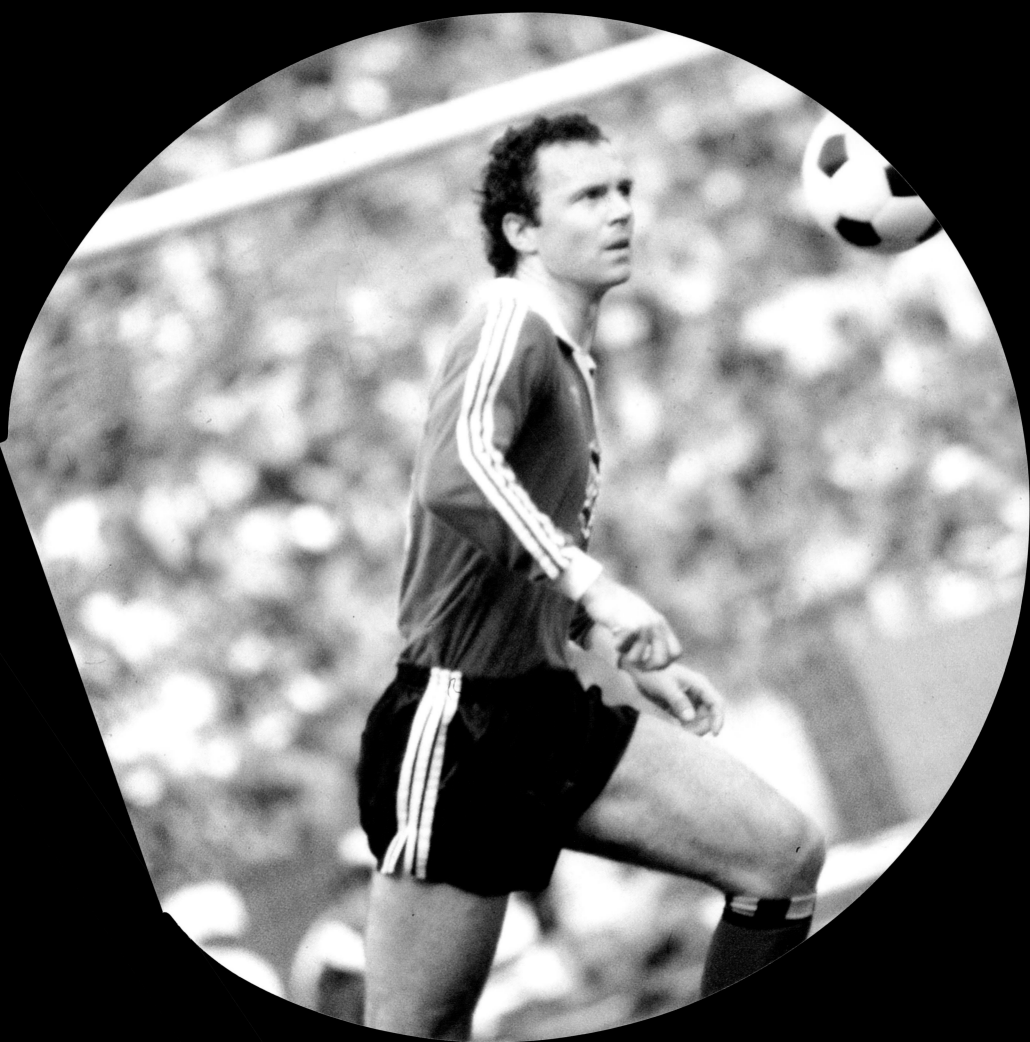

FRANZ BECKENBAUER

troucing the USSR 3-0 in the final. As hosts in the 1974 World Cup, West Germany faced a difficult politically charged group stage game as they faced East Germany for the first and only time, they lost 1-0 but with victories over Chile (1-0) and Australia (3-0) progressed to the knockout stages. With victories over Yugoslavia (2-0), Sweden (4-2), and Poland (1-0) they progressed to the final to face the "Total Football" of the Netherlands. The Netherlands started the game passing the ball around between themselves, before Johan Cruijff sped into the box on a solo run, only to be fouled. Johan Neeskens scored from the penalty spot for the favourites as The Netherlands took the lead before West Germany had even touched the ball. However, the German team is renown for their never-say-die attitude, personified by players like Beckenbauer, and came back to win 2-1. This same determination was witnessed in the 1976 European Championship held in Yugoslavia, where they came back from being 2-0 down to beat the hosts 4-2 in extra time, but lost to Czechoslovaki in the final, after the game finished 2-2 and the penalty shoot-out finished 5-3.

Franz enjoyed only the briefest of retirements before returning to the game as coach of West Germany in 1984, surprising everybody by guiding a fairly average team to the World Cup finals in 1986, where they lost 3-2 to Argentina. In the 1988 European Championships, after a good group stage (that included a 1-1 draw with Italy, and victories over Denmark 2-0 and Spain 2-0), it was eventual winners the Netherlands who this time staged a come back to knock West Germany out in the semi-finals 2-1. However, in Italy, during the 1990 World Cup Beckenbauer managed to complete a remarkable double as the only person to win both the World Cup as a captain and a manager, and only the 2nd to win as a

player and manager - the other being Brazilian Mário Zagallo (1958 and 1962 playing and 1970 coaching). The tournament is generally regarded as one of the poorer World Cups, with most teams playing defensively in an attempt to not get beaten rather than win, but even so still created plenty of drama and numerous memorable moments: Cameroon's 1-0 victory over defending champions Argentina followed by victory over Colombia and an unlucky defeat to England, the Republic of Ireland's draws against England and the Netherlands before penalty victory over Romania, as well as Scotland's humbling defeat to Costa Rica all remain in football fans memories. West Germany was one of the few teams to play attacking football with good victories in their group stage against Yugoslavia (4-1) and the United Arab Emirates (5-1), and a draw against Colombia (1-1). In the round of 16 knockout stage they beat arch-rivals the Netherlands 2-1, and narrowly beat Czechoslovakia 1-0 in the quarterfinals, to face one of their other great football rivals England (who they beat in a tense penalty shoot out, after extra time finished 1-1). It was a forgettable niggling final, decided by an 85th minute penalty to finish West Germany 1 Argentina 0 and see West Germany crowned world champions in their last tournament before reunification.

Beckenbauer went on to briefly manage Olympique Marseille in France but returned to Bayern Munich to twice become coach briefly (during which he won the Bundesliga in 1994 and UEFA Cup in 1996) before becoming club president. He has remained an influential figure in international football, as he also became vice-president of the DFB (German football association) helping to successfully bid for and organise the 2006 World Cup in Germany.

Beckenbauer's first of his record 103 caps for West Germany came in September 1965 against Sweden in an important World Cup qualifier, where he remained undaunted despite being only 20 years old.

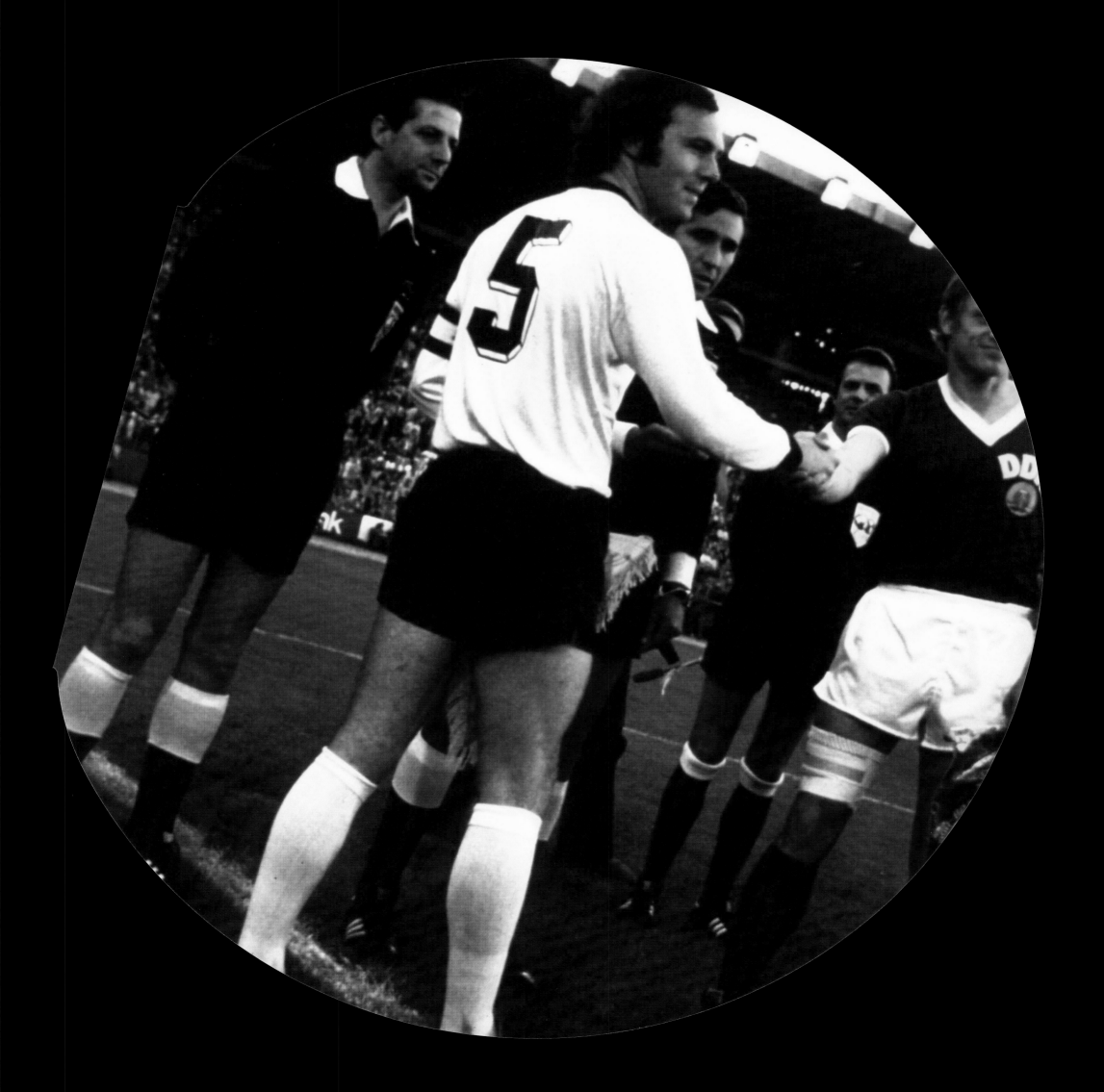

CRISTIANO RONALDO

With an awesome array of tricks and skills to dazzle spectators and bewilder defenders, combined with a growing maturity, Cristiano Ronaldo has blossomed into a global football super star. The precociously talented midfielder can play with either foot and has the ability to play on the left, right or through the middle. But he is at his most devastating for Manchester United and Portugal on the wing where his ability to run at defenders, trade-mark multiple step over, dummies, flicks, outstanding dribbling, combined with exhilarating pace, and an exceptional eye for goal have made him one of the world's most dangerous and exciting players.

Cristiano Ronaldo dos Santos Aveiro was born on 5th February 1985 in Funchal the capital of Madeira, a Portuguese island off the north African coast. It is rumoured his second name came from former US president Ronald Reagan, although not as a political tribute but rather his father's appreciation of his acting. He grew up in a poor family, with a brother and two sisters; his mother was a cook, his father a gardener and a heavy drinker. He began playing football against older players in a local amateur team, Andorinha, and even by the age of ten his exceptional 'innate talent' was being recognised. Manager of local side Maritimo arranged to meet the coach of his team to discuss signing him but failed to show up – which gave Nacional, the other big local team, an opportunity to step-in and quickly sign him but player. Two years later, still owing £15,000 for a youngster, they had already signed, Nacional offered Cristiano (now valued at £54 million) to Sporting Lisbon in exchange. Within minutes of a trial Sporting instantly knew they had a bargain. Only 12 years old Cristiano made the trip to the mainland, living with 9 other boys

in the Sporting Lisbon stadium. It was a traumatic time though for young Cristiano, who was homesick and regularly in fights after being picked on because of where he was from and his accent. Recognising his unhappiness Sporting eventually paid for his mother to join him. His ability to overcome this difficult time gave him a certain toughness and a fighting spirit that can be seen today when facing aggressive players on the pitch or a stadium full of thousands of hostile fans. At times it also works against him though with occasional impetuous behaviour on the pitch getting him into trouble. Working his way through the youth teams he also starred for the Portuguese in the UEFA Under-17 championship. Gérard Houllier, as manager of Liverpool wanted to sign him, but the club believed him too young, needing time to develop. He made his first team debut at 17, scoring two goals against Moreirense, before going on to make 23 appearances for the first team.

In the changing room and on the plane home, after Sporting beat Manchester United 3-1, with Ronaldo playing on both wings, United's players raved about the player telling Sir Alex Ferguson they would much rather play with him than against him in the future – confirming what Ferguson had already seen with his own eyes. Ferguson, looking for a replacement of United and England icon David Beckham on the right wing, signed Cristiano still a teenager for a fee of £12.24 million in 2003. Although he asked for the same number he had worn at Sporting (#28), he was handed the number 7 shirt worn by club legends George Best, Bryan Robson, Eric Cantona, and most recently Beckham. What for many would seem enormous shoes to fill proved to be an inspired signing. His skills and trickery made an immediate impact on the Premiership, with 31 appearances and 8 goals in his first season, endearing

With an awesome array of tricks and skills to dazzle spectators and bewilder defenders, combined with a growing maturity, Cristiano Ronaldo has blossomed into a global football super star.

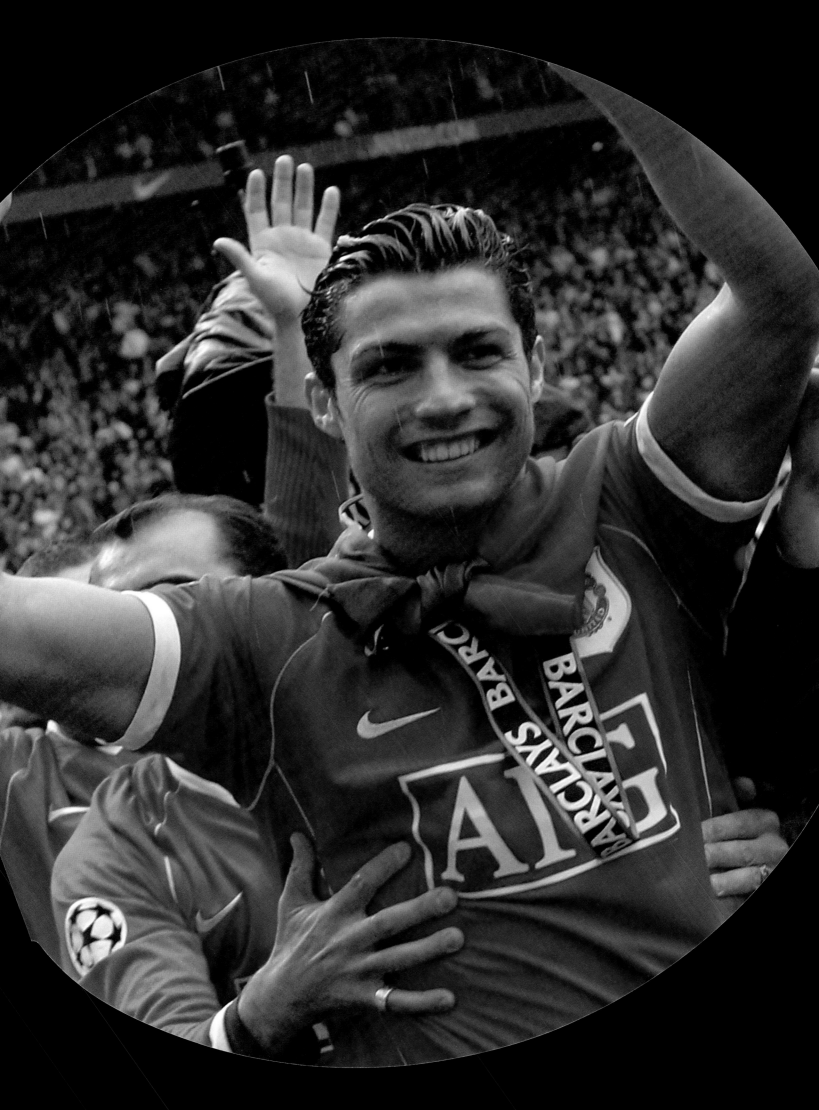

FOOTBALL CHAMPIONS

him to United fans and infuriating opponent players and fans alike. Ronaldo also earned a call-up to the Portuguese national team, making his debut against Kazakhstan in August 2003. He went on to be one of the stars in the European Championship in 2004, as the hosts made it to the final only to lose 1-0 as Greece shocked the football community winning their first ever major tournament. His second season (2004/05) for United began slowly, as he lacked consistency in his performances, was criticised for going to ground too easily to win free-kicks and his step-over lost its novelty, but improved as he made 50 appearances overall with 9 goals in a relatively mediocre season for United. In 2005/06, although off-field troubles and relationship difficulties affected his form, he continued to entertain crowds with his trickery as he also improved his crossing and ball delivery, scoring one of the goals of the season against Portsmouth from 30 yards, as he played 47 times and added 12 goals to his tally. In 2005, his father also died, badly affecting the youngster.

At the 2006 World Cup, Portugal finished 4th but were widely criticised by fans and commentators for what was perceived as a lack of sportsmanship and cynical tactics under the wily guidance of manager Luiz Felipe Scolari. Their second round match against the Netherlands, which saw a brutal foul injuring Ronaldo by Khalid Boulahrouz in the 7th minute, produced a record 16 yellow cards and 4 red (Costinha and Deco for Portugal, Boulahrouz and van Bronckhorst for the Dutch). In the quarter-finals against England, in 62nd minute with the game tied at 0-0, Wayne Rooney – a United team mate of Ronaldo - tried to gain his balance under the weight of two challengers and was judged to have deliberately stamped on Carvalho's groin. With Ronaldo and then pushed Rooney angrily away. After his dismissal Cristiano was seen winking at the manager – as if to say "job well done", confirming what many believe was a deliberate game plan to get Rooney (a player renowned for a short-fuse) sent off. The game

went to penalties which England lost. In the media furore that followed, Cristiano became public enemy number one in England; with tabloid paper The Sun even printing a dartboard of his face. Cristiano denied any wrong-doing, saying he had only pointed out that it was a foul not that he wanted him sent-off, but with threats pouring in he then stated he could see no future at United and would be ready to move, preferably to Real Madrid. This further angered fans in England and at United. Rooney insisted his own actions were accidental and that he bore no ill feeling to Ronaldo, even though he was disappointed that he had chosen to get involved and at later he would help ensure Ronaldo stayed. Portugal were knocked out in the semi-finals by France 1-0, with English and French fans loudly booing every touch by Ronaldo. It says much about the quality of Sir Alex Ferguson's managerial ability that he was able to calm the situation and convince Ronaldo to stay at all, never mind forge a team with him and Rooney at its core that would set the league for the first time since 2003. Despite continuing rumours of being unsettled, often originating from the board of Real Madrid, Ronaldo signed a 5 year extension to his deal, rumoured to be worth £120,000 a week in 2007. It also illustrates Ronaldo's strength of personality and growing maturity, that he was able to turn the vitriol aimed at himself to produce his best form ever – to rip defences apart game after game, finishing with 14 assists and as joint top scorer with, you guessed it, Wayne Rooney on 23 goals. In recognition of this he also finished the season with a clean sweep of individual awards for 2006/07: PFA Fans' Player of the Year, Barclay's Player of the Season, PFA Player of the Year, PFA Player's Player of the Year, as well as Portuguese Footballer of the Year. Football Writers' Association Footballer of the Year, PFA Young Player of the Year, and the PFA Team of the Year, named a member of the His goal in the 2007-08 Champions League final against Chelsea helped push the game to penalties. United won 6-5 and Ronaldo picked up the fans' Man of

Cristiano was named PFA Fans' Player of the Year, Football Writers' Association Footballer of the Year, Barclay's Player of the Season, PFA Young Player of the Year, PFA Player's Player of the Year, named a member of the PFA Team of the Year, as well as Portuguese Footballer of the Year.

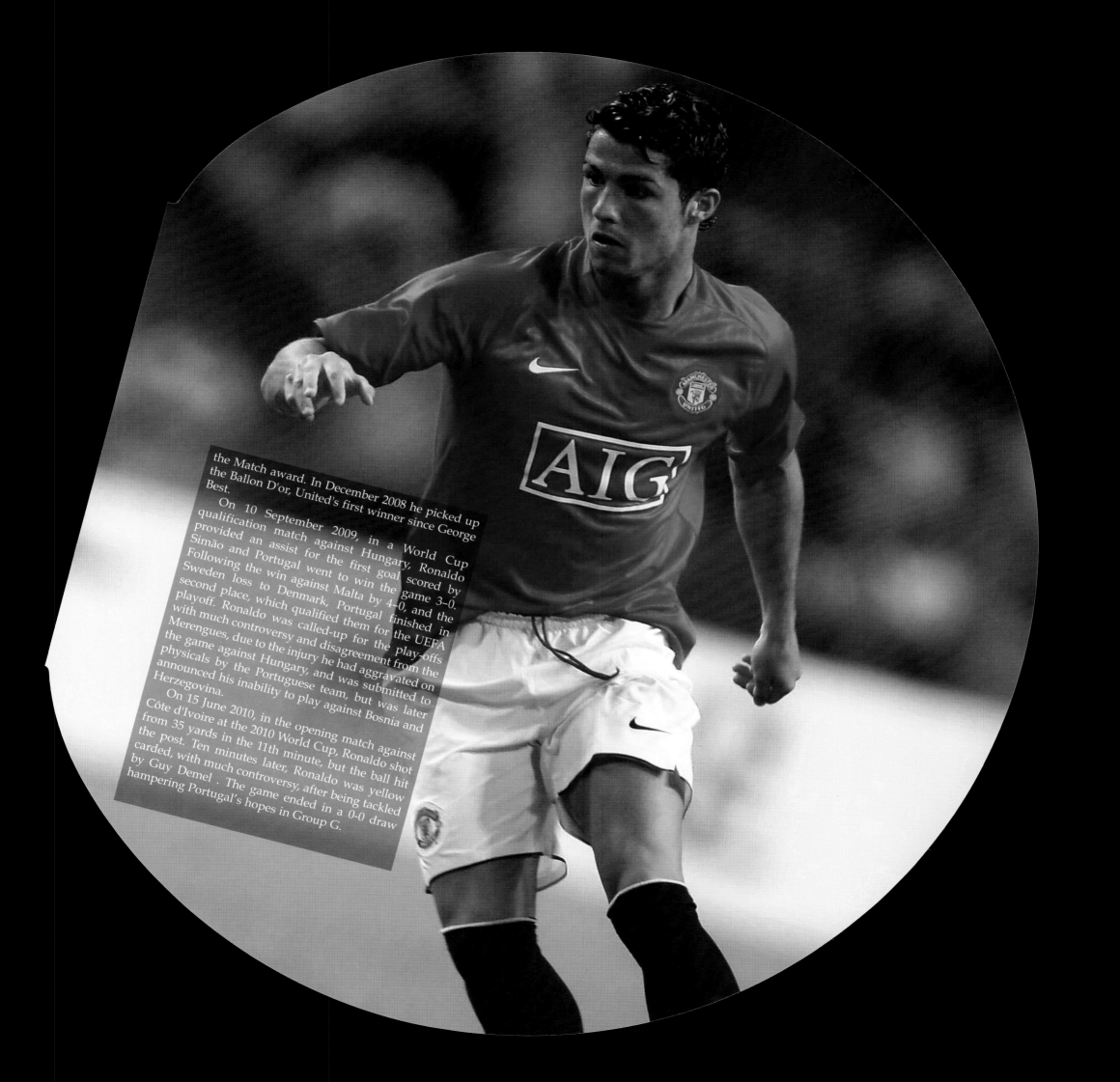

the Match award. In December 2008 he picked up the Ballon D'or, United's first winner since George Best.

On 10 September 2009, in a World Cup qualification match against Hungary, Ronaldo provided an assist for the first goal scored by Simão and Portugal went to win the game 3–0. Following the win against Malta by 4–0, and the Sweden loss to Denmark, Portugal finished in second place, which qualified them for the UEFA playoff. Ronaldo was called-up for the play-offs with much controversy and disagreement from the Merengues, due to the injury he had aggravated on the game against Hungary, and was submitted to physicals by the Portuguese team, but was later announced his inability to play against Bosnia and Herzegovina.

On 15 June 2010, in the opening match against Côte d'Ivoire at the 2010 World Cup, Ronaldo shot from 35 yards in the 11th minute, but the ball hit the post. Ten minutes later, Ronaldo was yellow carded, with much controversy, after being tackled by Guy Demel . The game ended in a 0-0 draw hampering Portugal's hopes in Group G.

JOHAN CRUYFF

Widely regarded as one of the world's most gifted footballers, Johan Cruyff, spearheaded a revolution in attacking football as part of the Ajax Amsterdam and Netherlands Total Football teams of the 1970s. His inimitable playing style was based on exceptional unorthodox technical skill combined with thrilling flair, acceleration and speed, an acute awareness of his team mate's position around the pitch and the ability to bring them into play with a precise complex angled pass – leading one sports writer tagging him "Pythagoras in boots". His name became synonymous with imaginative and electrifying football that led to glory and the adulation of fans the world over. Later on, he went on to fulfil what very few great players seldom achieve - to also become a great manager as he led Barcelona to domestic and European cup domination in the early '90s.

Hendrik Johannes Cruijff (his name registered at birth not Cruyff, as most English speaking media uses, and in fact is how his father's name is spelt - whereas his mother's is also Cruijff) was born on 25th April 1947 in Betondorp, an Amsterdam suburb, in the Netherlands. His family lived across the street from the old Ajax stadium, where his mother worked as a cleaner. At 10 years old he was chosen from over 200 children to join the Ajax youth team, where he worked his way up to the first team 7 years later.

Overflowing with unpredictable flair and innovative skill Cruijff was central to Rinus Michels' revolution at Ajax Amsterdam. Michels modernised the game by refining the concepts of the offside trap (whereby the defence moves forward in unison in a line to catch the opposition's attacker offside). He was most most famous for Total Football. An adventurous fluid attacking style of play where each player can play in another's position, thereby keeping an organised tactical system but with the creativity to confound opponents and constantly create space to move into, while the ball is passed around. It means every player requires astute tactical awareness, positional acumen, technical skill and physical stamina. Cruyff epitomised this - playing as a centre-forward he would turn up all over the pitch where he could do most damage to the opposing team (on the wing, midfield, in the hole behind the strikers, deep, even defending). With teams as a whole turning increasingly defensive it breathed new excitement into the game for spectators, commentators and players alike. When it worked it was breathtaking to watch, often simply leaving their opponents standing. Unsurprisingly the "total footballer" became a firm favourite of fans everywhere. Cruyff always wanted football to entertain, but he also wanted people to think and talk about football wherever he was – however, at times his outspoken nature landed him in trouble (including being

Widely regarded as one of the world's most gifted footballers, Johan Cruyff, spearheaded a revolution in attacking football as part of the Ajax Amsterdam and Netherlands Total Football teams of the 1970s.

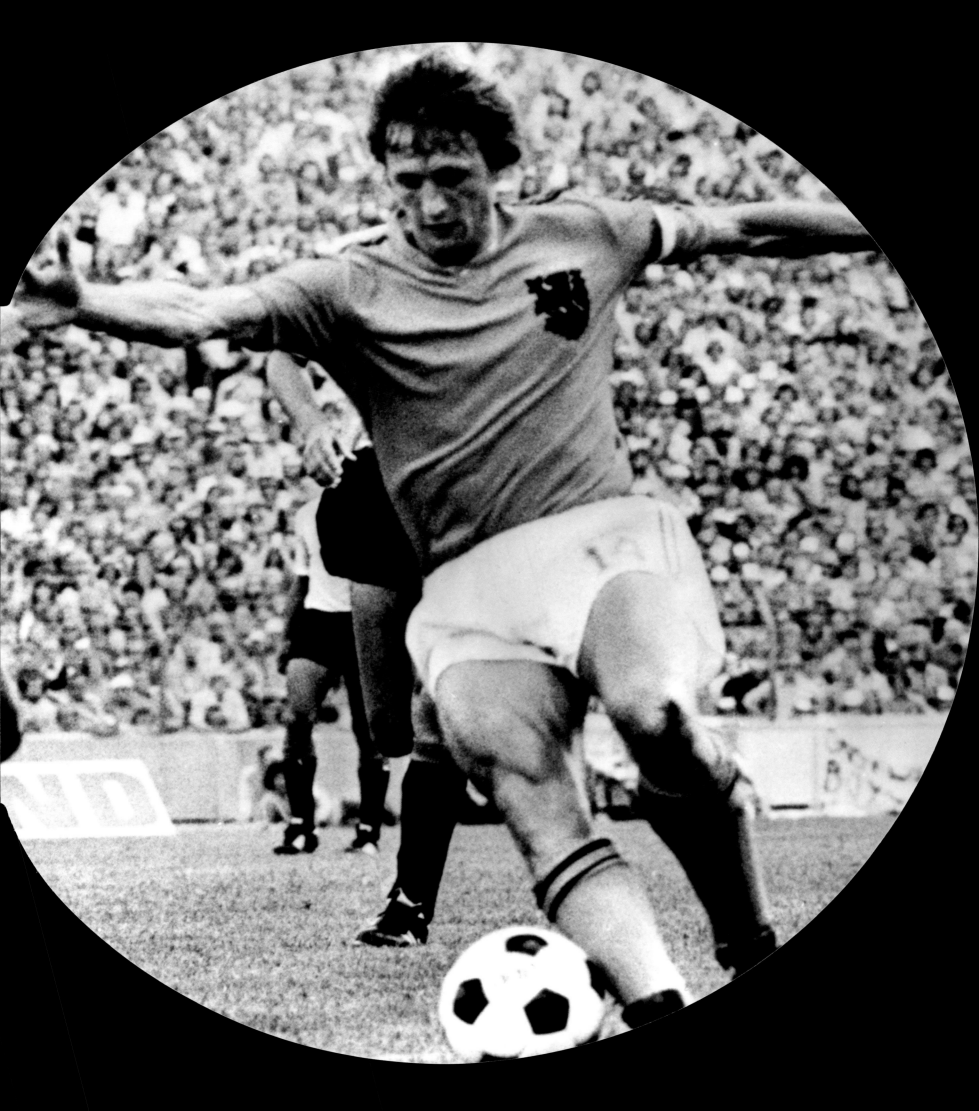

JOHAN CRUYFF

sent-off in his second international against Czechoslovakia and banned for a year by the Dutch FA). An enigmatic character, accused of at times being aloof and temperamental on the pitch, his unorthodoxy extended beyond his playing with his insistence on wearing number 14 throughout his career (when teams always wore 1-11) and only wearing two black stripes on the arms of his Netherlands jersey unlike the three worn by his team mates.

Having made his debut against FC Groningen in 1964, scoring a consolation goal as Ajax lost 3-1, he went on to make 275 appearances overall, scoring 204 goals. As Ajax went on to dominate the Dutch league before conquering Europe. In his first stint with the club they won 6 Dutch titles (1966, 1967, 1968, 1970, 1972, 1973) and four Dutch Cups or KNVB Beker (in 1967 beating NAC Breda 2-1, 1970 PSV 2-0, 1971 Sparta 2-1 after a replay, and in 1972 FC Den Haag 3-2), as well as an extraordinary series of three consecutive European Champions Cups (defeating Panathinaikos 2-0 in 1971, Inter Milan 2-0 in 1972, and Juventus 1-0 in 1973). They also won the Intercontinental Cup in 1972, beating Independiente of Argentina 4-1 on aggregate.

In 1973 Cruyff rejoined coach Rinus Michel, who had moved to Barcelona, for a world record at the time £922,000 (a seemingly small amount by today's standard), endearing himself to Barca's fans by telling the press he had chosen them over arch-rivals Real Madrid as he refused play for a club associated with fascist dictator Franco. His time was a success as he inspired Barca to break Real's domination of La Liga by lifting the trophy in his first season of 1973/74. He also further endeared himself to the fans by choosing a Catalan name, Jordi, for his son. The Dutch national team, with Rinus Michels now in charge, were favourites for the 1974 World Cup and with their skill lit up the finals - despite rivalry within the team between players of bitter rivals Ajax and Feyenoord. As well as teams such as Uruguay and uncharacteristically Brazil trying to physically intimidate and kick them out of the game. They defeated Uruguay 2-0, surprisingly drew 0-0 with Bulgaria, and Sweden 4-0, before the 2nd group stage where they beat Argentina in a sensational 4-0 performance (Cruyff was electric, scoring twice), East Germany easily 2-0, and a 2-0 victory over Brazil. The media billed the final as a showdown between German cool efficiency (epitomised by Beckenbauer) versus the imaginative flair of the Netherlands (personified by Cruyff). After a sensational opening, where the Dutch strung together 15 consecutive passes and scored a penalty without their opponents even kicking the ball, the West German team were left stunned. As for the opening 30 minutes the Dutch passed the ball freely but made the fatal mistake of not killing off the game, before their opponents led by Beckenbauer started to control the midfield and struck back to win 2-1. It was a bitter disappointment for the Netherlands. Cruyff continued to play a central role in the qualification campaign for the 1978 World Cup but

106

JOHAN CRUYFF

having scored 48 goals in 143 games for Barcelona and 33 goals in 48 games for the Netherlands, retired in 1978 prior to the finals. Despite being begged to rejoin his national team he refused to travel to Argentina, boycotting the games as the military junta who had taken control in a coup two years earlier, were still involved in the torture and disappearance of dissidents. The Netherlands made it to the finals, finishing again as runners-up to the hosts – this time 3-1 in extra time.

Like many of the games stars, Cruyff was lured out of retirement to play in the lucrative yet ill-fated North American Soccer League. In an attempt to create a vibrant soccer league in the traditionally unreceptive but potentially massive market of the United States, millions of dollars were spent to bring aging stars such as Pelé, Cruijff, Beckenbauer, Gordon Banks, George Best, Eusébio, Carlos Alberto, Gerd Müller and Bobby Moore to clubs around America in the 1970s, however, the project ultimately failed. Cruyff chose the Los Angeles Aztecs where he added 14 goals in 27 games, before moving on to the Washington Diplomats scoring a further 12 goals in 32 games. He then returned to Europe for a brief ten match spell at Spanish team Levante and a handful more games for the Diplomats, before returning for two seasons to Ajax, adding 14 goals in 36 games and two more league championship titles in 1982 and 1983. In 1984 he was incensed when Ajax refused to renew his contract at the age of 37. Cruyff responded by joining their fiercest rivals Feyenoord in his final season as a player, scoring 11 goals in 33 games, inspiring them to win the championship and the KNVB Beker (Dutch Cup) beating Fortuna Sittard 1-0.

Cruyff was always a deep thinker about the game so it is little surprise that he became a coach after he ended playing. Some bridges must have been repaired but he

returned to his former club Ajax in the 1985/86 season, where he failed to win the league but triumphed in the KNVB Beker (in 1986 beating RBC Roosendaal 3-0, and again in 1987 against FC Den Haag, 4-2 after extra time). He also led them to a 1-0 victory over East German team Lokomotiv Leipzig in the European Cup Winners Cup in 1987. Following his path as a player in 1988 he moved to Barcelona and led them to 4 consecutive league titles in 1991-94, a Copa del Rey (Spanish Cup) in 1990 against arch rivals Real Madrid 2-0, as well as European trophies in the Cup Winners Cup (against Italy's Sampdoria 2-0 in 1989), and in the Champions Cup (beating Sampdoria again in 1992, 1-0 after extra time), Barca's European total of 11 trophies over 8 years), Despite winning a total of 11 trophies over 8 years, and being arguably Barca's most successful manager to date, he fell out with the chairman, Josep Lluís Núñez, and was sacked in 1996 – despite this he is still known at the Nou Camp as El Salvador (the Saviour) for his time as player and coach. Cruyff was also known for smoking 20 cigarettes a day, however, after undergoing double heart bypass surgery in 1991, he gave up and led an anti-smoking campaign organised by the Catalan government.

After years of fundraising activities, Cruyff wanted to consolidate his work and in 1997 he set up the Johan Cruyff Foundation. The charity operates to improve the mental and physical wellbeing of under privileged children (especially those less able and with special needs), through sport, physical exercise and play based projects, often in combination with education both in the Netherlands and around the world. The football maestro is now helping to make less fortunate people's lives better through his generosity after giving so much pleasure to fans around the world through his football skills.

107

DAVID BECKHAM

David Beckham is famous beyond football, with millions of dollars in sponsorship and advertising deals, a high profile marriage to a pop star, a lavish lifestyle, books, films, and constant intense media scrutiny; he is one of the most recognisable faces in the world today and has become the epitome of both the good and bad aspects of the modern game. At times it is hard to remember that he is a footballer, but he is also the consummate professional, an inspirational captain, continues to train hard, delivers deadly crosses from the right wing, and an excellent free kick specialist. However, his time in football has been a roller coaster ride of lows and highs. Also, sitting uneasily with his celebrity status, "Posh and Becks" (England's other Royal Family), is his dedication to his family – who have been threatened twice by foiled kidnapping plots. Now with an outstandingly lucrative offer to move to play for Los Angeles Galaxy it seems football and Hollywood glamour will mix at last.

David Robert Joseph Beckham was born into a family of ardent Manchester United fans on the May 2nd, 1975 in Leytonstone, England. He grew up in this east London working class neighbourhood, his father was a kitchen fitter and his mother a hairdresser, with a younger and older sister. He inherited his parent's love of the game and Manchester United, playing for local youth team Ridgeway Rovers and enrolling at the age of 12 in one of

Bobby Charlton's football schools in Manchester. He had trials for local team Leyton Orient and attended Tottenham Hotspurs school of excellence but signed Manchester United schoolboy forms on his fourteenth birthday and in 1991, he left home at 16 to sign on to their Youth Training Scheme. He starred as part of an excellent youth team (that included future internationals Ryan Giggs, Paul Scholes, Gary Neville, Nicky Butt, Keith Gillespie and Robbie Savage), winning the FA Youth Cup in 1992, and inevitable comparisons to United's 1950s famous youth team, the Busby Babes. That year he also made his first team debut against Brighton and Hove Albion in the Rumbelows (or League) Cup. He continued to improve as a player in the youth and reserve team, before being loaned to Preston North End to gain first team experience during the 1994/95 season, where he made 5 appearances, before returning to United to make a handful of Premiership appearances towards the end of season, after playing his league debut against Leeds United.

The following season Sir Alex Ferguson chose to show confidence in his young players, bringing them through to replace those leaving instead of purchasing stars from other clubs. Ferguson proved his critics wrong as United went on to win the Premier League and the FA Cup (1-0 against Liverpool) in 1996. Beckham played an integral part in the team, playing 33 games and scoring 7

Beckham is one of the most recognisable faces in the world today and has become the epitome of both the good and bad aspects of the modern game.

FOOTBALL CHAMPIONS

DAVID BECKHAM

goals. In September that year he made his England debut against Moldova in a World Cup qualifying match, a 3-0 away victory. The following season he continued his form as a United regular and was awarded the PFA Young Player of the Year in 1997 and became an even greater celebrity when it emerged that he was dating one of the pop group Spice Girls, Victoria Adams (known as Posh Spice). He was left out of England's first two opening matches of the 1998 World Cup in France but became a national hero after scoring a stunning free kick against Colombia to secure progress into the knockout stages. However, in an intense pulsating match against arch-rivals, Argentina with the game tied at 2-2, Beckham was fouled by Diego Simeone and while lying on the floor lashed out, kicking Simeone in front of the referee – who produced a straight red card. With England down to ten men and 44 minutes remaining the team battled on bravely and with 9 minutes left defender Sol Campbell headed the ball into the net, only for the goal to be disallowed. After another 30 goalless minutes of extra time with 1 less player, the game came down to a penalty shoot out. Paul Ince and David Batty missed to give Argentina victory and break English hearts. Beckham became public

enemy number 1, with a hate campaign and death threats aimed at him (much as would happen against future United player Cristiano Ronaldo in 2006), as he was made scapegoat for England's elimination. It undoubtedly had an impact on the game but the media and critics were virtually silent on Campbell's seemingly good disallowed goal and why manager Glenn Hoddle had refused to practise penalties.

There is a feeling that this outpouring of animosity towards Beckham was also a reflection of a widespread antipathy towards United, his high profile extravagant lifestyle and his wife even. It showed great strength of character to survive the next few months, and under Alex Ferguson's protective tutelage he produced excellent form to help United to an unprecedented treble in 1999: winning the English Premier League on the final day of the season, the FA Cup (beating Newcastle United 2-0) and, in a last gasp injury time 2-1 victory over Bayern Munich. In his personal life it was also a time of joy with the birth of his first child, Brooklyn, and a lavish marriage to Victoria.

Late in 2000, after a disappointing European Championship, during which Beckham was still vilified by a section of the England supporters, he was rewarded

At times it is hard to remember that Beckham is a footballer, but he is also the consummate professional, an inspirational captain, continues to train hard, delivers deadly crosses from the right wing, and an excellent free kick specialist.

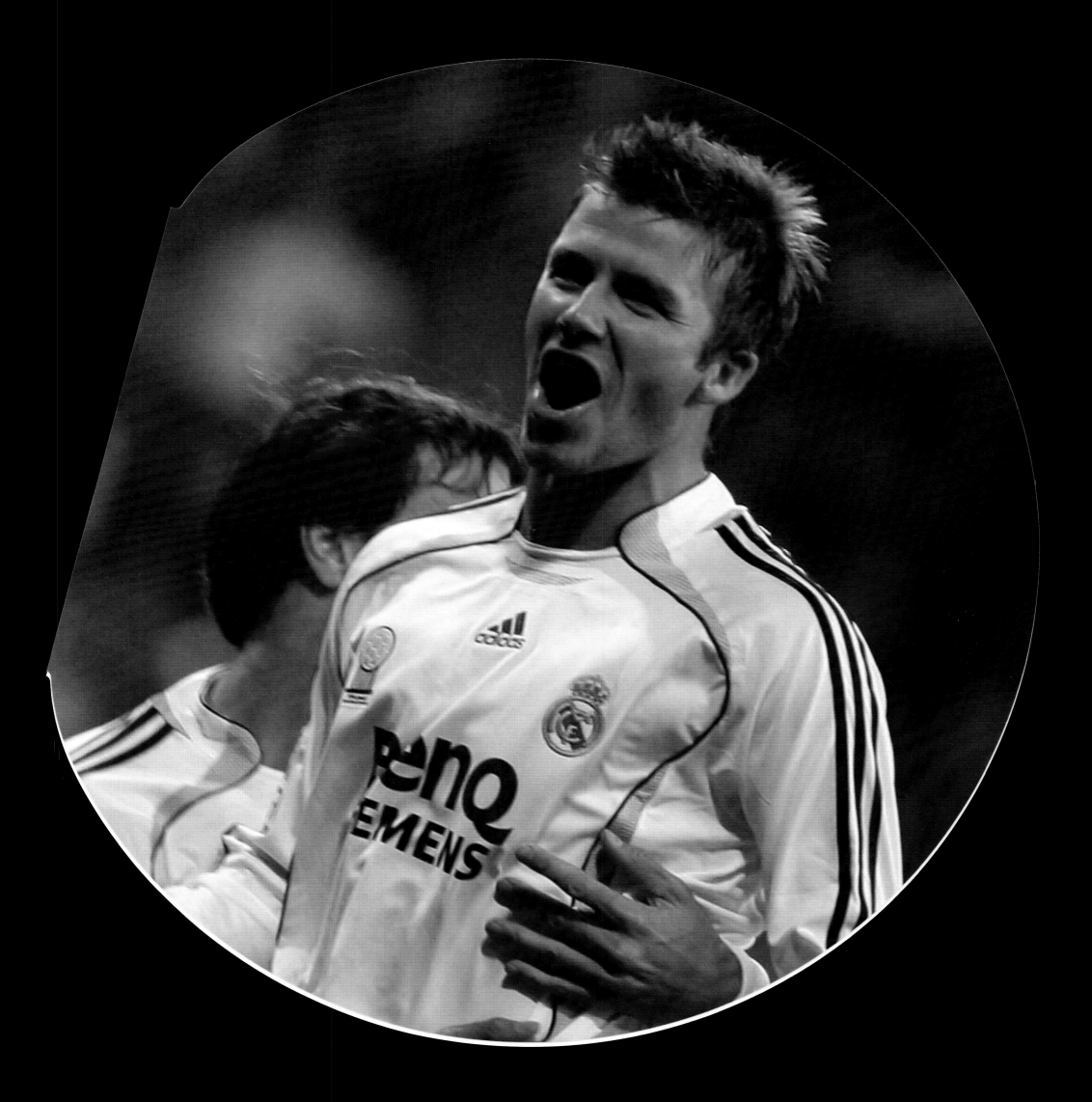

ALFREDO DI STEFANO

Alfredo di Stéfano became a legend within the peerless Real Madrid team of the 1950-60s, who dominated European football. His striking partnership with Ferenc Puskás was one of the most lethal in the history of the game. He is one of very few players to play for 3 national teams, Argentina, Colombia and Spain. A powerful determined attacker with incredible stamina and versatility he would play in defence, midfield and attack throughout the game.

The son of Italian immigrants he was born on the 4th July 1926 in the district of Barracas in Buenos Aires, Argentina. While working on his parents suburban farm, where it is said he got his stamina from, he started playing for youth team Los Cardales and after helping them to win the amateur championship he was signed in 1943 by Argentinean powerhouse River Plate. Despite picking up a few caps, stiff competition for positions meant he was loaned out to Club Atlético Huracán for the 1946/47 season where he scored 10 goals in 25 appearances (including a winner against River Plate). Recalled, he became the league's top scorer in 1947. As he established himself in the first team, earning the nickname La Saeta Rubia (or The Blonde Arrow), he was also called up to the national team (scoring 6 times in 6 games in the Copa América in 1947), but in 1949

Argentine football ground to a halt as football players went on strike. Unable to play Alfredo moved to Bogotá to play for Colombian team Club Deportivo Los Millonarios (or simply Millonarios) where he played from 1949 to 1953 – this was a golden age for the club winning the Colombian title in 1949, 1951, 1952 and 1953 with Alfredo as top scorer in 1951 and 1952 – such was the level of skill that they were nicknamed Ballet Azul (or the Blue Ballet, their home strip is blue). He also at this point played 4 games for the Colombian national team, although these games are not recognised by FIFA.

In 1953, Millonarios toured Spain to play exhibition matches. What followed, as Real Madrid and Barcelona both fought to sign Di Stéfano, remains a source of bitter recrimination to this day – although it could also be viewed as adding insult to injury rather than something new, as the enmity between the two clubs has its roots in the Spanish Civil War, as well as regional and class politics. Di Stéfano had agreed to sign for Barcelona, FIFA authorised the transfer, but dictator Franco – who wanted his (at that point mediocre) Real team to gain international respectability for his fascist regime – leant heavily on the Spanish FA, who then refused to recognise the transfer. In the meantime, Santiago Bernabéu (a Franco loyalist installed to run Real, was busy

Above: Alfredo Di Stefano, Real Madrid's honourary president, poses with the new British signing for Real Madrid, David Beckham at Sport city in Madrid, 2nd July 2003. Opposite: A powerful determined attacker with incredible stamina and versatility he would play in defence, midfield and attack throughout the game.

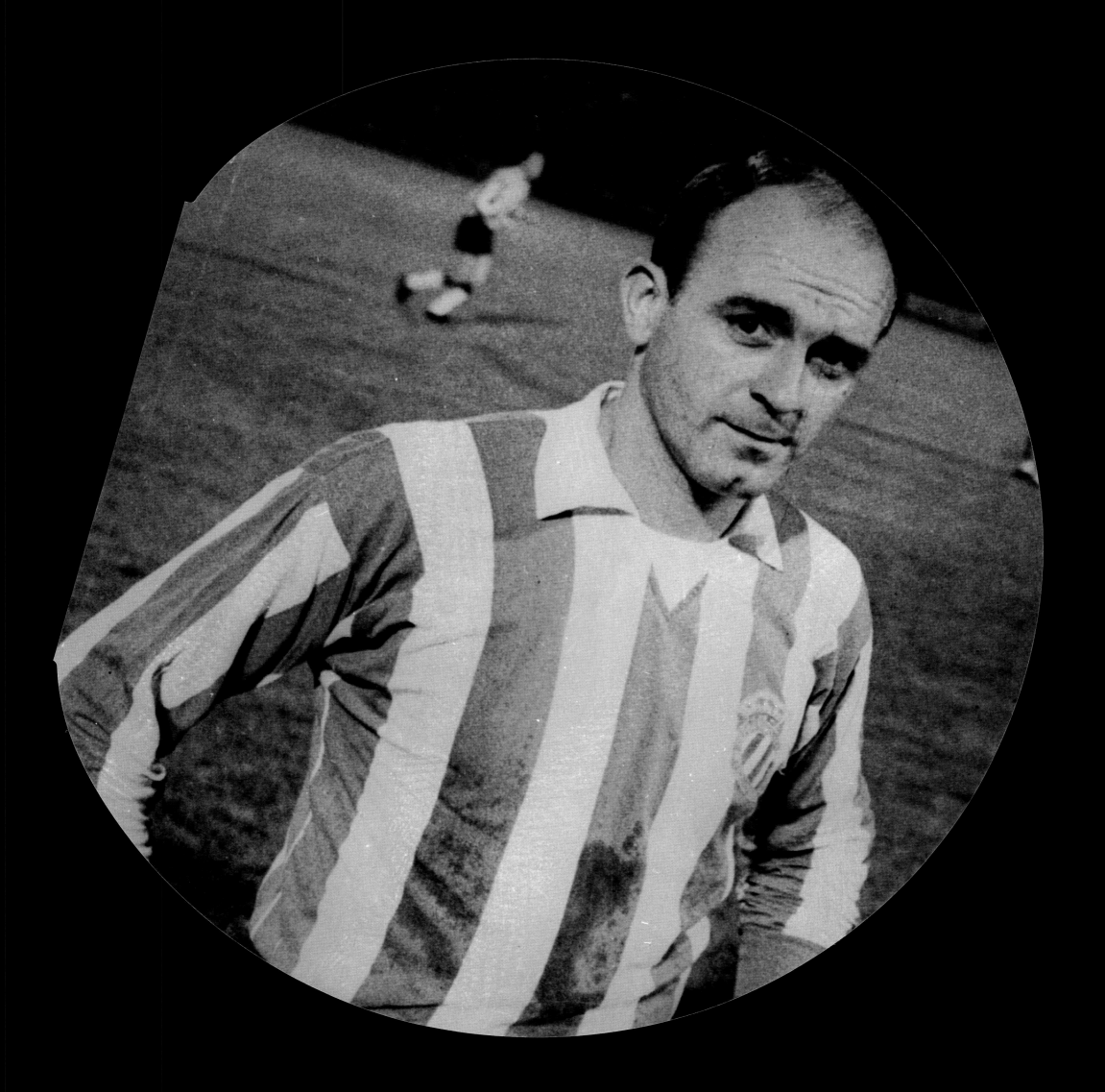

ALFREDO DI STEFANO

restructuring the club and building a team full of world class players including his legendary striking partners Ferenc Puskás and Raymond Kopa) negotiated a deal with Di Stéfano – to play 2 year for both clubs (which never became a reality due to behind-the-scenes pressure). Real supporters counter that in fact it was Barcelona's heavy-handed attempt at negotiating with Di Stéfano's clubs that caused the problems. Whatever the truth, Di Stéfano made an enormous impact on the league (including a hat-trick the first time Real Madrid met Barcelona after the controversy) and on the team as they became virtually unbeatable: winning 8 Spanish league titles (1954, 1955, 1957, 1958, 1961, 1962, 1963 and 1964) and the Spanish Cup (1962). It was in Europe that this record was even more astounding as they won the European Champions Cup a record 5 consecutive times (1956-60) – incredibly Di Stéfano scored in all 5 finals.

Becoming a Spanish national in 1956 made Di Stéfano eligible to play for his 3rd national team and went on to made 31 appearances for Spain, scoring 23 goals. Towards the end of his career, Alfredo was rumoured to have fallen out with the club's chairman, and moved to Barcelona club Espanyol – where he played for 2 seasons before finally retiring from playing at the age of 40. He then moved into coaching and became a successful manager - winning the Argentinean league with Boca Juniors (1970) and River Plate (1980); the Spanish league and cup with Valencia (1971 & 1979) as well as the European Cup Winners Cup (1980, beating Arsenal on penalties); he also managed Portuguese side Sporting Lisbon (1974-75) before returning to Real Madrid – where he was able to guide them to 2 consecutive 2nd places (1982-84). In 2000 he was named as Honoury President of Real Madrid.

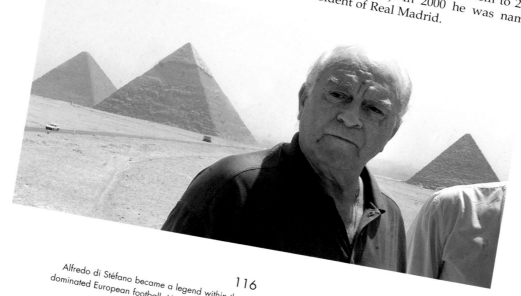

116

Alfredo di Stéfano became a legend within the peerless Real Madrid team of the 1950-60s, who dominated European football. His striking partnership with Ferenc Puskás was one of the most lethal in the history of the game.

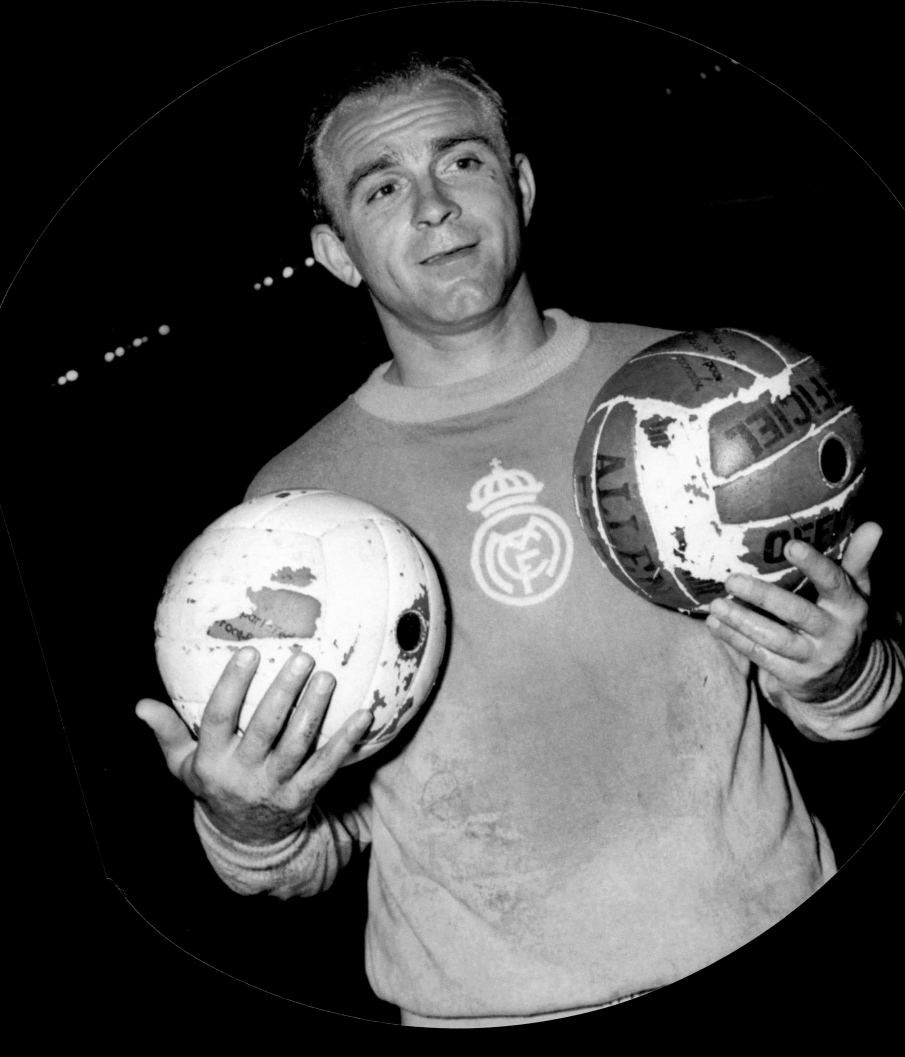

DINO ZOFF

Dino Zoff was a veteran goalkeeper of exceptional ability, renown for the cool and confident way in which he kept goal for Juventus and Italy. Holding numerous records he is the oldest winner of the World Cup, which he lifted in 1982 as Italy's captain.

Dino Zoff was born on 28th February 1942 in the small provincial town of Mariano del Friuli in the north-east of Italy, not far from the Slovenian border. Growing up he dreamt of being a goalkeeper, not an illustrious striker like most, but despite raw talent he was rejected by Inter Milan and Juventus in his teens for being too frail and not tall enough. He began working hard and training constantly, while playing for local team Marianese. He was spotted by a scout and moved to local Serie A team Udinese but only made a handful of appearances before moving on to Mantova in 1963, where he began to establish himself in the first team with 93 appearances. However, it was after a move to Napoli in 1967 that he flourished, playing a 143 games, he began building a reputation for remaining calm under pressure and a reliable shot-stopper. He was also able to transfer this cool confident temperament into the international game. Making his debut in 1968 in the quarterfinals of the European Championship against Bulgaria, before going on to lift the trophy for the first time. Although he

would go on to play for Italy a record 112 times he was second choice to Enrico Albertosi in the 1970 World Cup runners-up team, who lost to an awesome Brazil side 4-1.

In 1972, he was transferred to The Old Lady of Italian football, Juventus, where he spent 11 glorious years: winning the Italian league 6 times (1973, 1975, 1977, 1978, 1981, and 1982). Italian Cup twice (beating Palermo in 1979 and Verona in 1983), as well as the UEFA Cup (1977, beating Basque team Athletic Bilbao on the away goals rule after a 2-2 aggregate draw). During this time Dino Zoff helped set an exceptional record at international level as Italy shut out some of the best attackers in the world, including Brazil and England, for over 12 consecutive games. Zoff's incredible unbeaten run was eventually halted after 1,142 minutes by Manno Sanon of Haiti in the 1974 World Cup - where Italy had failed to impress. However, this consistency laid the foundations for later Azzuri success that began in the 1978 World Cup in Argentina. Italy started well with 3 victories (beating and eventual winners Argentina 1-0, France 2-1, and Hungary 3-1) but were knocked out by the Dutch total football master-class of Cruijff, Neeskens, Krol, Rep and Rensenbrink with Zoff disappointingly beaten from 40 yards by Arie Haan to give Italy 4th place. A finish repeated in the 1980 European Championship, as hosts they lost an epic 9-8 penalty shoot out for 3rd place to Czechoslovakia.

Dino Zoff was a veteran goalkeeper of exceptional ability, renown for the cool and confident way in which he kept goal for Juventus and Italy. Holding numerous records he is the oldest winner of the World Cup, which he lifted in 1982 as Italy's captain.

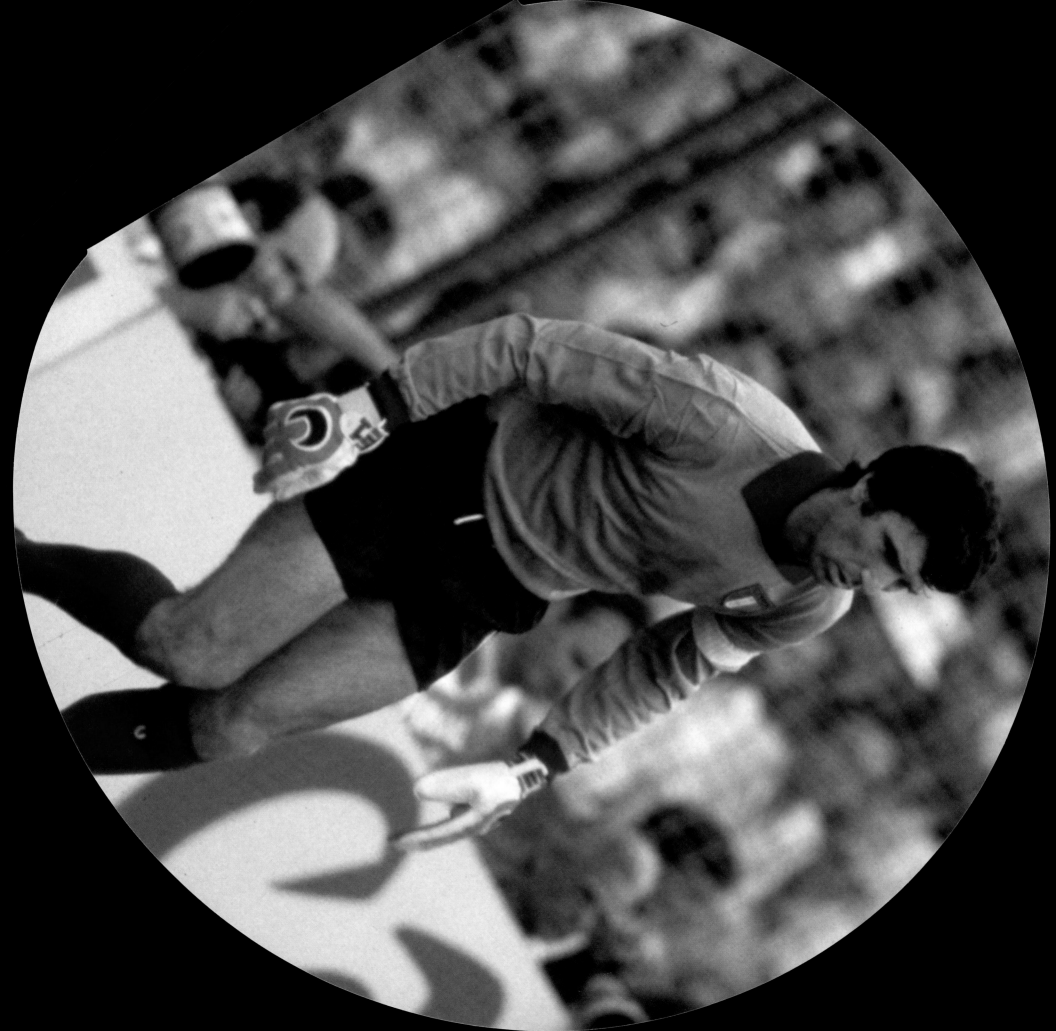

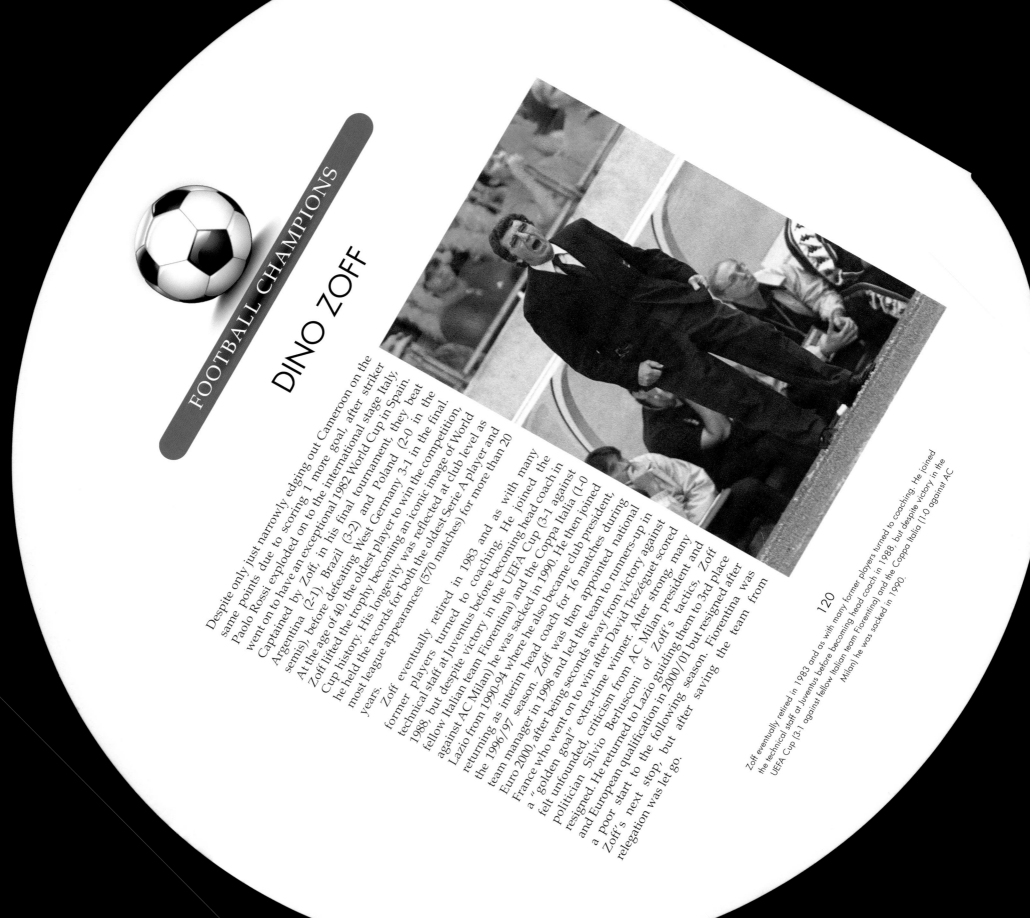

FOOTBALL CHAMPIONS

DINO ZOFF

Despite only just narrowly edging out Cameroon on the same points due to scoring 1 more goal, after striker Paolo Rossi exploded on to the international stage Italy, went on to have an exceptional 1982 World Cup in Spain. Captained by Zoff, in his final tournament, they beat Argentina (2-1), Brazil (3-2) and Poland (2-0) in the semis) before defeating West Germany 3-1 in the final. At the age of 40, the oldest player to win the competition, Zoff lifted the trophy becoming an iconic image of World Cup history. His longevity was reflected at club level as he held the records for both the oldest Serie A player and most league appearances (570 matches) for more than 20 years.

Zoff eventually retired in 1983 and as with many former players turned to coaching. He joined the technical staff at Juventus before becoming head coach in 1988, but despite victory in the UEFA Cup (3-1 against fellow Italian team Fiorentina) and the Coppa Italia (1-0 against AC Milan) he was sacked in 1990. He then joined Lazio from 1990-94 where he also became club president, returning as interim head coach for 16 matches during the 1996/97 season. Zoff was then appointed national team manager in 1998 and led the team to runners-up in Euro 2000, after being seconds away from victory against France who went on to win after David Trézéguet scored a "golden goal" extra-time winner. After strong, many felt unfounded, criticism from AC Milan president and politician Silvio Berlusconi of Zoff's tactics, Zoff resigned. He returned to Lazio guiding them to 3rd place and European qualification in 2000/01 but resigned after a poor start to the following season. Fiorentina was Zoff's next stop, but after saving the team from relegation was let go.

120

Zoff eventually retired in 1983 and as with many former players turned to coaching. He joined the technical staff at Juventus before becoming head coach in 1988, but despite victory in the UEFA Cup (3-1 against fellow Italian team Fiorentina) and the Coppa Italia (1-0 against AC Milan) he was sacked in 1990.

EUSÉBIO

Eusébio's name is synonymous with Benfica and Portuguese football. Nicknamed the Black Pearl or the Black Panther, the Mozambique born forward was blessed with an abundance of speed and a fierce right-footed shot that was both powerful and accurate. His success with Benfica in the Portuguese league and Europe, combined with his scintillating form at the 1966 World Cup made him a living legend in Portugal and throughout the game.

Eusébio de Silva Ferreira was born on 25th January 1942 in the poor Mafalala district of Lourenço Marques (now Maputo), the capital of Mozambique – at the time a Portuguese East African colony. After the death of his father, at the age of 5, Eusébio's outlook seemed bleak. However, he excelled in sport including sprinting and basketball, and began playing football for Sporting Clube de Lourenço Marques. In his late teens Eusébio's talent was spotted by Brazilian footballer and coach Bauer, who recommended him to Brazilian club São Paulo but they showed little interest. While visiting victory. In 1963/64 he scored a prodigiously talented player he had recently seen in Africa by Benfica's coach Bela Guttman. After discussing Eusébio with Bauer, he flew down to see Eusébio's talents for himself a few days later and signed him

victory. In 1963/64 he scored 28 goals in 26 games – a position he held for the next 4 seasons (doing even better with 42 goals in 26 games), again in seasons (in the latter scoring 40 times in 30 appearances). Personal recognition followed when he won European

immediately. During this time, it was common practice for Portuguese clubs in the colonies to tap African talent, with many players going on to star for Portugal at international level (including Matateu, Mário Coluna, Alberto da Costa Pereira, Hilário, Shéu – all from Mozambique, as well as Fernando Peyroteo and José Águas from Angola). Ironically the club he was playing for was a feeder club for Benfica's bitterest rivals Sporting – acrimony followed in Portugal, Eusébio was even hidden in a small fishing village until the fuss had died down.

At Benfica Eusébio flourished, becoming as well known for his humility and sportsmanship as his explosive acceleration and prolific pinpoint shooting. In 1962 he scored twice in a thrilling European Champions Cup final as Benfica defended their title – coming back from 2-0 and then 3-2 down – to become the first team to beat the legendary Real Madrid side of Ferenc Puskás and Alfredo di Séfano in the tournament, with a memorable 5-3 victory. In 1963/64 he scored 28 goals in 26 games – a position he held for the next 4 seasons (doing even better with 42 goals in 26 games), again in 1969/70 and 1972/73 seasons (in the latter scoring 40 times in 30 appearances). Personal recognition followed when he won European

Eusébio's name is synonymous with Benfica and Portuguese football. Nicknamed the Black Pearl or the Black Panther, the Mozambique born forward was blessed with an abundance of speed and a fierce right-footed shot that was both powerful and accurate.

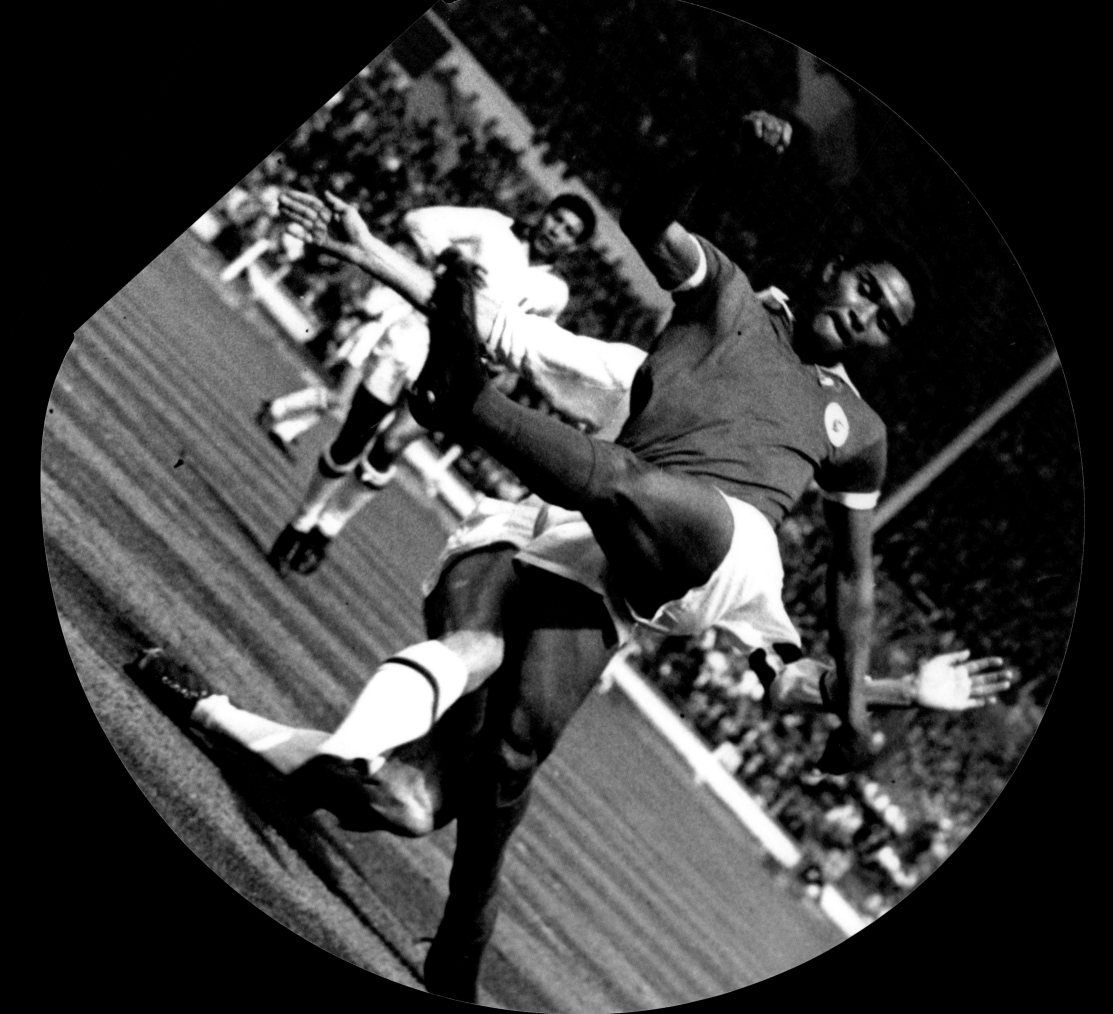

EUSÉBIO

Footballer of the Year in 1965. His goals helped Benfica dominate the domestic Liga as eleven times champions (in 1961, 1963-65, 1967-69, and 1971-74). While they also won the Portuguese Cup in 1962, 1964, 1969, 1970, and 1972, further European success eluded them. Although they reached the finals in the European Champion's Cup in 1963 (losing to AC Milan 2-1), 1965 (losing to Inter Milan 1-0) and also in their famous 1968 defeat to Manchester United (4-1 after extra time).

Eusébio made an inconspicuous international debut for Portugal in a 1962 World Cup qualifying match against European minnows Luxembourg. Despite scoring, his team went down to a shock 4-2 defeat. However, when Portugal qualified for the World Cup in 1966 for the first time, Eusébio emerged as top scorer and one of the stars of the tournament. Portugal beat Hungary 3-1 in their opening match, followed by a 3-0 victory over Bulgaria (including Eusébio's first goal), and most spectacularly they beat and eliminated the 1958 and 1962 champions Brazil 3-1, with Eusébio hitting the back of the net twice. In the quarter-finals they met South Korea who stormed to a 3-0 lead within 25 minutes, but Eusébio's magic rescued Portugal with 4 goals, in an amazing fight back that ended 5-3. Despite scoring (and having a couple of goals disallowed), in the semi-finals,

there would be tears as Portugal were beaten by two Bobby Charlton goals to send England into the finals 2-1. They did, however, 2 days later manage to claim 3rd place beating the Soviet Union 2-1. Although Eusébio would be Portugal's all-time leading scorer, with 41 goals in 64 matches – only surpassed by Pauleta in 2005 - it would be the only time Eusébio would grace a major international tournament.

Despite such success at Benfica his career ended there controversially in 1974, when he was dumped after receiving a bad knee injury and being told he would never play again. He defied predictions, however, playing for various teams in America (Boston Minutemen, Los Vegas Quicksilver and New Jersey Americans), Canada (Toron to Metro-Croatia), Mexico (CF Monterrey) and for lesser Portuguese teams (SC Beira-Mar and União de Tomar) before finally hanging up his boots in 1978.

Eusébio is still greatly revered today in Portugal and by football fans around the world. His presence is still felt by the Portuguese national team who hold him as an inspiration and it was Eusébio, a disconsolate figure on the podium, as the European Championship trophy was presented to Greece after their shock defeat of Portugal in Lisbon in the final of Euro 2004.

Opposite: Eusebio in tears after Portugal's defeat to England in the semi final of the 1966
World Cup at Wembley Stadium, 26th July 1966.

GEORGE BEST

George Best was one of the best footballers in the world, comparable even to Pelé, Johan Cruyff and Diego Maradona. However, his mercurial genius and magical skill were overshadowed by a wild self-destructive streak that would lead him to quit top-level football at only 26 and to his death eventually in 2005. Despite playing for Manchester United, and being pivotal to their European glory, he would never grace the major international or European tournaments of the World Cup or European Championship as he played for Northern Ireland as an international. One can only imagine how much greater his recognition and admiration would have been if someone so uniquely talented had played for Brazil, England or even Manchester United now (with today's mass media coverage). But it will forever remain speculation and conjecture. As the television chat show host Michael Parkinson wrote, in a moving eulogy, that the biggest tragedy surrounding George Best's life was that neither the public, his friends or Best himself would ever know what he could have been or achieved.

George Best was born in Belfast, Northern Ireland on 22nd May 1946. He grew up on the Protestant Cregagh public housing estate in the southeast of the city, with his father (a shipyard iron worker) and his mother (from whom Best joked he had inherited his athletic skill and love of alcohol), a brother and four sisters. From an early age he was obsessed with football, even taking a football to bed with him for many years, and would spend all day playing and running though the terraced streets dribbling a tennis ball to hone his skills. Each Christmas he would receive the same presents: a new football, kit and football boots. But the local teams and talent scouts continually overlooked him for being too small and skinny and rejected him for being too professional game. With his dream beginning to fade he left school at 15 to become a printers apprentice. A week later, Manchester United scout, Bob Bishop, spotted Best and telegrammed Sir Matt Busby with the famous words: "I believe I've found you a genius."

Best moved to Manchester to live in lodgings and was initially shy and overawed by his team mates, but trained hard before making his debut at Old Trafford in September 1963 against West Bromwich Albion. His ability with both feet to keep the ball under his complete command was evident from the beginning. In an era of tough tackling defenders Best would torment them by impishly dancing around them, passing the ball off their shins, through their legs, or dribbling straight past them in a slalom like run. He played on the wing and was equally good on either foot, excellent at heading, with a good eye for goal. He was also a brave player too and would not be afraid to tackle and defend when needed. At times he would exasperate his team mates with his virtuoso skill if it came undone, having lost the ball would often work twice as hard to win it back. His legendary status as a player came from his time in a terrific Manchester United side, playing alongside (and often outshining) Bobby Charlton and Denis Law, who won the English league in 1965 and

George Best was one of the best footballers in the world, comparable even to Pelé, Johan Cruyff and Diego Maradona. However, his mercurial genius and magical skill were overshadowed by a wild self-destructive streak that would lead him to quit top-level football at only 26 and to his death eventually in 2005.

GEORGE BEST

1967. He also gained international recognition for his magnificent performance to destroy Eusébio's mighty Benfica's 100% European home record, scoring twice in Lisbon in an outstanding 5-1 rout, during the 1966 European Cup quarter-finals, before losing to Yugoslavia's FK Partisan in the next round. They went on to become the first English team to win the trophy in 1968. In a rematch with Benfica, United won 4-1 with a superb solo goal by Best that ended with him walking the ball into the net. That year, at only 22, Best was at the pinnacle of the game, and was named English and European Footballer of the Year. However, as Best reflected; "I was born with a great gift and sometimes with that comes a destructive streak. Just as I wanted to outdo everyone when I played, I had to outdo everyone when we were out on the town."

In the 1960s, the Belfast Boy quickly shot to fame during an era of social upheaval and an explosion of popular culture. He was the first footballer to become a pop-star pin-up celebrity. With his cheeky charm, urchin good looks, fashion, and playboy lifestyle he was dubbed the fifth Beatle - and with it came all the temptations of a rock 'n' roll lifestyle. By the late '60s his lifestyle was starting to overtake his love of the game as he opened two nightclubs in Manchester, a clothing boutique, and continued to party hard – womanising with famous actresses and models, gambling, and drinking. There is an oft told story of Best, not long after quitting United, ordering vintage champagne from room service, the latest Miss World was lying on the bed, £20,000 in cash he'd won earlier in the hotel casino spread around the room, as the porter, after pocketing a £50 tip, asked – where did it all go wrong George? Later

on, Best quipped about his life; "I spent a lot of my money on booze, birds and fast cars. The rest I just squandered."

With the retirement of Manchester United's manager Sir Matt Busby in 1969, who was something of a father figure to George, combined with the decline of United's fortunes on the pitch his behaviour became more rebellious and erratic before he announced his retirement in 1972. He was convinced to continue but by 1974 Manchester United infuriated by his lack of commitment, including failure to show up for training and even matches, sacked him - after making a total of 470 appearances, mesmerising thousands of supporters, and scoring 179 goals (including being United's top scorer for 1968 and 1970-72 – an incredible feat for a winger). He would attempt numerous comebacks – that included playing for Ireland's Cork Celtic (1975-76); back in England for Fulham (1976-78), and brief spells at Stockport (1975) and Bournemouth (1983); in America for the Los Angeles Aztecs (1976-78), Fort Lauderdale Strikers (1979) and San Jose Earthquakes (1979-80 and 1981); a season for Scottish team Hibernian (1979-80); before finally playing his last professional games in Australia for the Brisbane Lions (1983). It was not all failure during this period. His time in the United States started positively, as he enjoyed the anonymity of life in America and also counted his time at Fulham in the 2nd division, playing alongside aging stars Rodney Marsh and Bobby Moore, as some of his happiest times - where despite having lost some of his pace was still able to show off his skills. Inevitably, however, before long his personal demons and alcohol would derail him.

In some ways Best was thrown into the deep end of

Opposite: In the 1960s, the Belfast Boy quickly shot to fame during an era of social upheaval and an explosion of popular culture. He was the first footballer to become a pop-star pin-up celebrity.

GEORGE BEST

fame and unprecedented media hysteria without protection before its impact was really understood. He went from having nothing to having everything and anything he wanted and more thrown at him. Sir Matt Busby and Manchester United can only be partly blamed for his downfall as they themselves were dealing with a new phenomenon. In today's game, young stars are groomed for the pressure, media attention and potential pitfalls the game brings from the start. It has, for better or worse, become part and parcel of the modern game. However, if Best had been able to play for an United manager such as Sir Alex Ferguson, who has brought the best out of players as potentially difficult as Eric Cantona, Cristiano Ronaldo, David Beckham and Roy Keane, the difference it could have made not just on the pitch but on the impact on his life may have been very different. Of course, only "may" as Best was surrounded by people who tried to "save" him and loved him arguably more than he did himself.

Despite making a comeback as a popular sports commentator in the 1990s it was felt he was living on borrowed time. Eventually his chaotic turbulent lifestyle - which had hit numerous low points since giving up playing (paralytic TV appearances, bankruptcy, occasional abusive and violent outbursts including assaulting a police officer, a jail sentence for drink driving, two divorces, being rushed to hospital, etc) - and chronic alcoholism caught up with him. He was

given a liver transplant in 2002, attempted to stay dry and succeeded for a while before starting to drink again. In October, 2005 he was rushed into hospital again with flu like symptoms, the side-effects of the immunosuppressant drugs used to stop his body rejecting his liver transplant, meant he had increased susceptibility to infections starting with his kidneys before spreading to his lungs. He fought his deteriorating condition for longer than doctors expected and while close to death sent messages to those he loved.

On 20th November he organised for the British tabloid News of the World to publish a picture of himself in hospital with a final message: "Don't die like me." 5 days later he passed away. His funeral route, which started at the family home in Cregagh before travelling to Stormont (Northern Ireland's Parliament Buildings), was lined by more than 100,000 well-wishers and mourners, with a further 25,000 inside the grounds itself for a service with family, celebrities and politicians before being taken to a private ceremony to be buried next to his mother (who had also died of alcoholism).

It is a pity that for many he will be better remembered for his lifestyle off the pitch rather than the maverick footballer Pelé saluted as the best player in the world. Those who saw him will never forget his magic. As Best said, "Pelé called me the greatest footballer in the world, that is the ultimate salute to my life."

It is a pity that for many he will be better remembered for his lifestyle off the pitch rather than the maverick footballer Pelé saluted as the best player in the world. Those who saw him will never forget his magic. As Best said, "Pelé called me the greatest footballer in the world, that is the ultimate salute to my life."

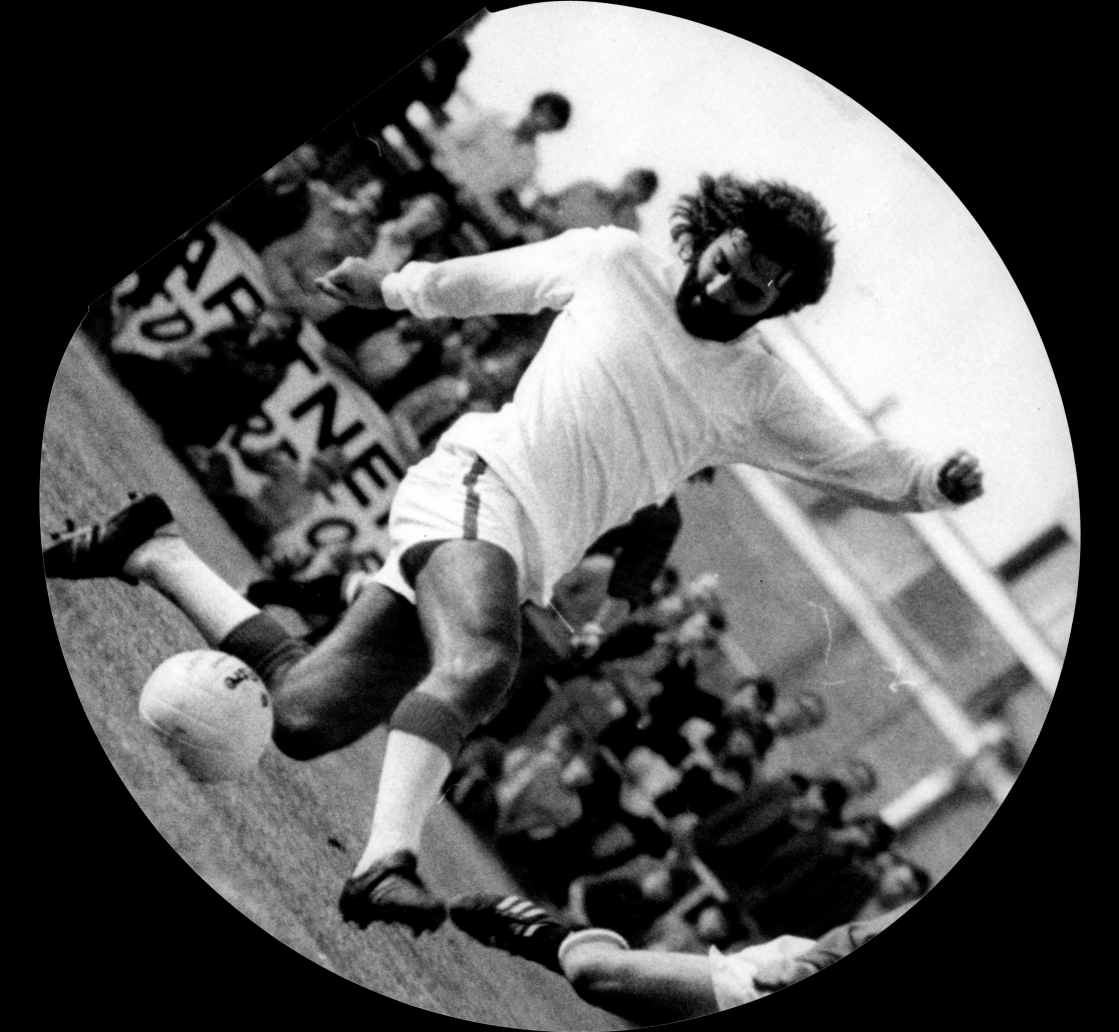

MARADONA

Maradona is the only player who consistently challenges Pelé for being the best footballer in the history of the game. His stocky strong physique, combined with devastating acceleration and great balance, was fused with technical brilliance and unpredictable flair, which meant he could emerge from trouble to dribble his way through a clutch of defenders and score or set up a team mate for an assist.

He is a larger than life personality who wears his large heart on his sleeve – something that is all too often missing in today's game of media groomed and often publicly bland professionals. He was also the saint and the sinner rolled into one, which led to plenty of confrontations with the authorities on and off the pitch. A flawed genius, it appears that the same wellspring that drives his rare brilliance is also infused with a self-destructive tendency that has led to alcohol and cocaine addiction. Whatever the truth is about one of football's most enigmatic personalities, he is still widely worshipped in Argentina and at his best Maradona was an intense, mesmerising, exceptional player and performer.

Diego Armando Maradona was born on 30th October 1960 into a poor family in the shantytown district of Villa Fiorito on the southern outskirts of Buenos Aires, Argentina. At the age of 10 he was spotted playing for the local team Estrella Roja, and caught the bus to an ill-fated trial where the head coach did not believe the skinny short Diego, with his curly hair was in fact a child but a talented adult dwarf trying to get one over on him

Maradona is a larger than life personality who wears his large heart on his sleeve – something that is all too often missing in today's game of media groomed and often publicly bland professionals.

and demanded to see ID- which Diego did not have. Eventually, the coach contacted his parents and signed him for Argentinos Juniors youth team, known as Los Cabollitas (The Little Onions). One of Argentinos Juniors nicknames is El Semillero (or Seed Garden) as it has produced so many good players from its youth system "nursery" – it was in this environment that Maradona's raw talent was nurtured. He starred for the youth team (who went 136 matches unbeaten) and at halftime would entertain the senior team's fans with his ball juggling and skills. Maradona made his senior team debut as a substitute ten days before his 16th birthday against Talleres de Córdoba before going on to be a mainstay of the team. In no time at all he was also called up to play for Argentina in a friendly against Hungary in February 1977 but was bitterly disappointed when he was not included in the hosts 1978 World Cup squad. He became a club legend at Argentinos over the 5 seasons he was there, playing 166 games and scoring 111 goals, before Boca Juniors, the team he had fanatically supported all his life, signed him for £1 million in 1981. Again debuting against Talleres de Córdoba before having a successful season in front of Boca's fanatical fans in La Bombonera stadium, scoring 28 goals in 40 games and winning the Argentinean league.

By the time of the 1982 World Cup finals in Spain Maradona was firmly established in the national team, however, the defending champions and Maradona had a disappointing tournament: losing 1-0 to Belgium in the opening match, before wins against Hungary (4-1, including 2 Maradona goals) and El Salvador (2-0), sent

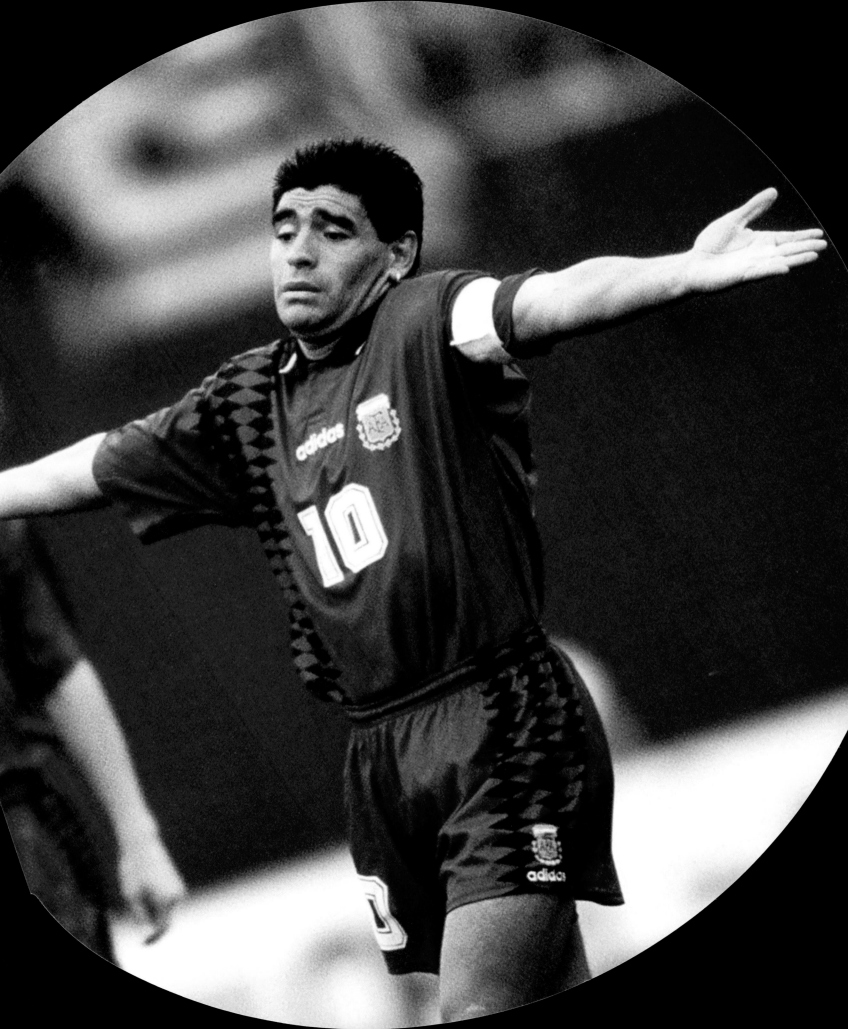

MARADONA

them through to 2nd stage group defeats against eventual winners Italy 2-1 and a 3-1 defeat against Brazil (in which Maradona was sent off near the end). He remained in Spain, however, to play for Barcelona, setting a new world record transfer fee of £5 million. His time there was difficult. Maradona did not get on with his first manager and then contracted hepatitis. After his return he suffered a career threatening injury from a bad foul that kept him out of the team for 15 weeks. It is also rumoured that at this time he was introduced to cocaine.

Despite this, he still scored 38 goals in 58 appearances over two seasons, before falling out with the club president Josep Lluís Núñez and leaving for Napoli in 1984.

Throughout the 1986 World Cup in West Germany Maradona demonstrated his brilliance, with 5 assists and 5 goals, as he captained Argentina to victory. Arguably, one game epitomises Maradona's flawed genius better than any other. Argentina's quarter-final victory over England 2-1. Maradona scored the opening goal on the 51st minute, in a tense match; however, while jumping with England keeper Peter Shilton, he used his hand to score illegally. The referee failed to see it and let the goal stand. Afterwards Maradona was unrepentant saying it was scored a little by his own head and a little bit by the hand of God. Three minutes later though he scored a sublime goal that has been named the goal of the Century and atoned for his cheating earlier (although England fans may disagree). He received the ball in his own half, turned and ran more than half of the field, dribbling past the challenges of 5 England players before beating Shilton for a second time. Argentina triumphed 2-1. He then scored another 2 to beat Belgium 2-0 in the semi-finals. The finals, witnessed West Germany trying to double mark Maradona, however, the genius still

contributed and lifted the trophy after a 3-2 victory. Returning to club football in his third season, he also became a club legend, as the unfashionable team from the south of Italy fought hard to win the most revered trophy in Italian football, the Scudetto (league title) in 1987 and again in 1990, as well as the UEFA Cup (in 1987, beating VfB Stuttgart 5-4 on aggregate).

The 1990 World Cup saw Maradona carrying an injury, as Argentina stuttered through the early rounds. They were nearly knocked out at the first stage, before narrowly beating Brazil 1-0, and needing penalties to get past Yugoslavia and Italy to get to the finals. In a poor tense match they were beaten by a dubious West German penalty five minutes from time to lose 1-0. With Argentina knocking Italy out of the World Cup, when he returned to play in Serie A opposing supporters targeted Maradona for unremitting abuse, while controversy began to dog Maradona off the pitch. Questions were raised about his friendship with the mafia underworld and he was banned for 15 months after testing positive for cocaine. It was the start of a long period of attempted come backs, scandals and health issues as he gained weight and eventually admitted to cocaine addiction. After he left Napoli in 1992 he joined Sevilla in Spain for a year but left after a bust up with the coach in 1993 He returned to Argentina and briefly played for Newell's Old Boys and even returned to prove his He played in two games (including a fabulous goal against Greece) before testing positive for ephedrine in the following game – although his personal trainer had given him a power drink that contained the substance – he was sent home. Argentina were eliminated shortly after. He finally hung up his boots at the age of 37 after playing a

134

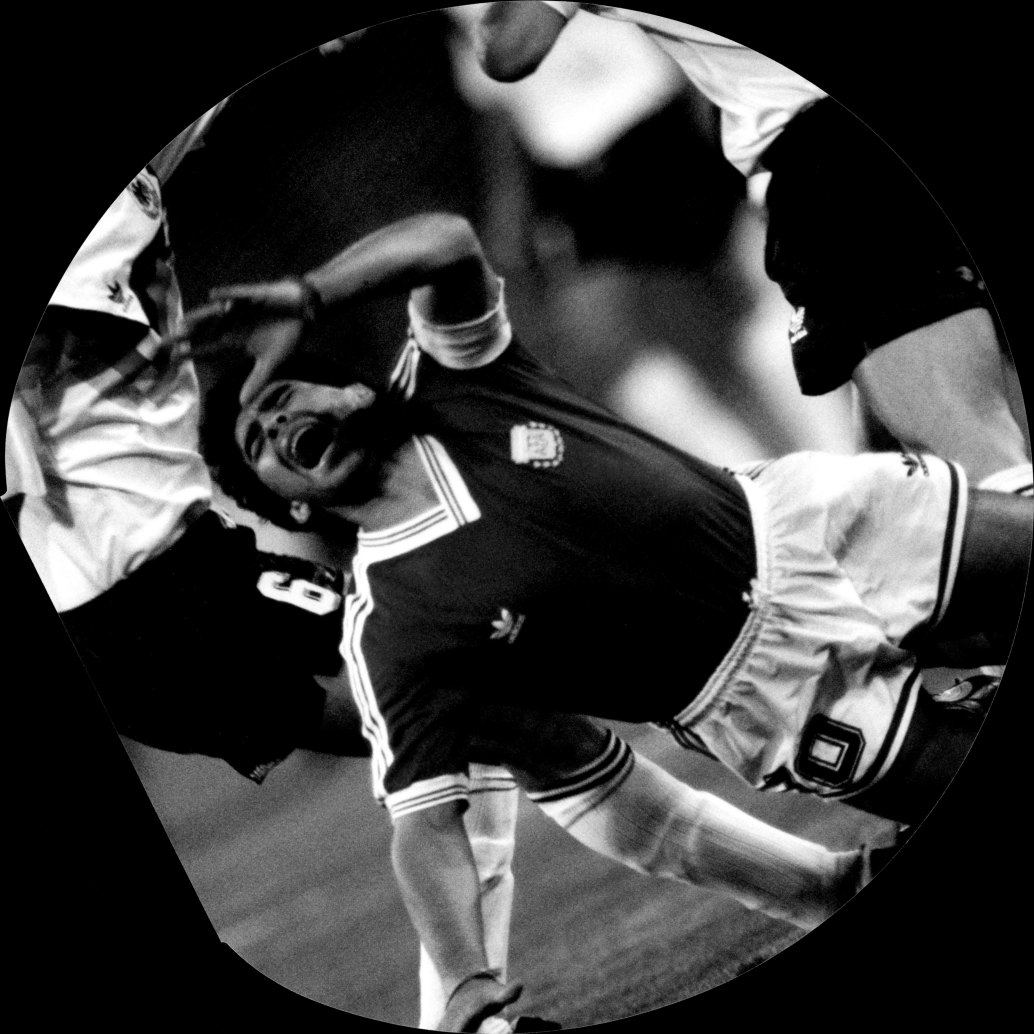

MARADONA

final season in 1995/96 for his team, Boca Juniors.

After leaving football there have been reoccurring concerns about his health and erratic behaviour, which many attribute to drugs and alcohol abuse. Since 2002 he has spent much of his time in Cuba. In April 2004 he was rushed to hospital in Buenos Aires after a heart attack, but returned to Cuba after emerging from intensive care. He then made a public comeback of a very different kind as a talk show host in Argentina. Looking relaxed and confident, with his own TV show host La Noche del 10 or The Night of the #10 (the jersey number he immortalised), he topped ratings in 2005 as he interviewed Pelé, Fidel Castro (who he has publicly supported and has a tattoo of), Mike Tyson, Zinedine Zidane and Ronaldo. Always seen as a man of the people, rising up from bottom to the top, he has increasingly hit the headlines for his political views in support of Venezuela's Hugo Chávez and protesting against President George Bush's visit to Argentina. However, inevitably it would seem, his self-destructive demons dragged him down again. In March 2007 he was admitted into hospital for acute hepatitis and alcohol abuse. Numerous rumours surfaced that he was dead but he was discharged in May, after being transferred to a rehabilitation clinic. Not long after he appeared in the Argentinean media to announce he had given up drinking and had been clean from drugs for over two years. It was a shabby drawn out ending to a glorious career, but his brilliance still burns brightest in the memories of football fans around the globe and in Argentina he is still revered as much more than a sportsman but rather a religious phenomenon, where he is commonly referred to as a God.

After the resignation of Argentina national football team coach Alfio Basile in 2008, Diego Maradona immediately proposed his candidacy for the vacant role. According to several press sources, his major challengers included Diego Simeone, Carlos Bianchi, Miguel Ángel Russo and Sergio Batista.

On October 29, 2008, AFA chairman Julio Grondona confirmed that Maradona would be the head coach of the national side from December 2008. On 19 November 2008, Diego Maradona managed Argentina for the first time when Argentina played against Scotland at Hampden Park in Glasgow which Argentina won 1-0. The city of Glasgow plays a significant part in Maradona's history as it was at Hampden Park in Glasgow that Maradona scored his first goal for Argentina in 1979.

At the World Cup finals in June 2010, Argentina started by winning 1–0 against Nigeria, and then defeated South Korea 4–1, with a hat-trick from Gonzalo Higuain. In the final match of the group stage Argentina won 2–0 against Greece to win their the group and advance to a second round meeting with Mexico. After defeating Mexico 3–1, Argentina was in turn routed by Germany, 4–0 in the quarter finals to go out of the competition. Argentina was ranked 5th in the tournament. After the defeat to Germany Maradona admitted that he was considering his future as Argentina coach, "I may leave tomorrow," he said. On 15 July 2010, the Argentine Football Association said that he would be offered a new 4 year deal that would keep him in charge through to the summer of 2014 when Brazil stages the World Cup, however on 27 July the AFA announced that its board had unanimously decided not to renew his contract.

Opposite: Maradona scored the opening goal of the 1986 World Cup on the 51st minute, in a tense match. While jumping with England keeper Peter Shilton, he used his hand to score illegally. Afterwards Maradona was unrepentant saying it was scored a little by his own head and a little bit by the hand of God.

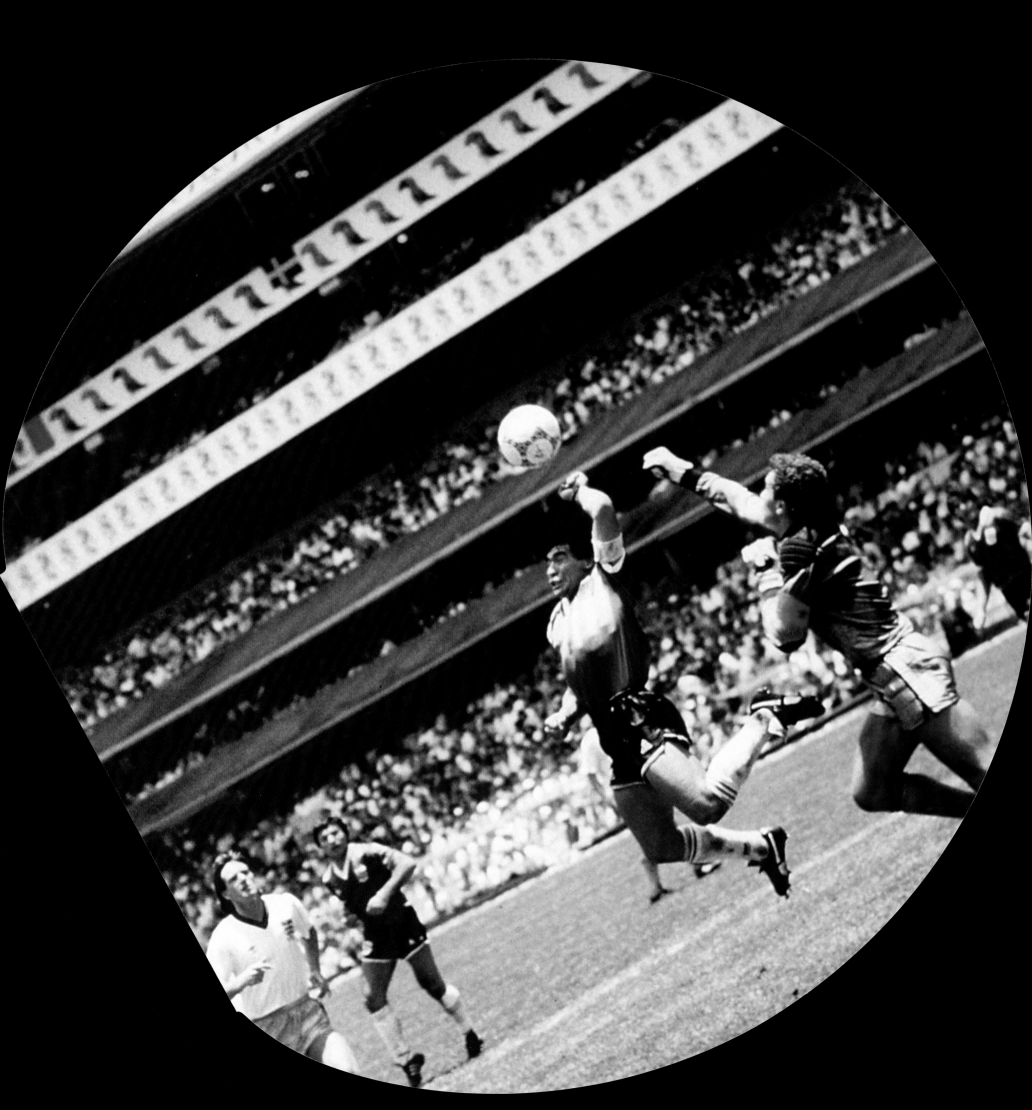

ROGER MILLA

Le Vieux Lion, or The Old Lion, as Roger Milla is fondly referred to was one of the first African players to become a major star on the world stage. He played in three World Cups for Cameroon, and at the age of 38, when most players have retired, he inspired them to the quarter-finals of Italia 1990. His sheer love of the game endeared him to football fans around the world and his success has been an inspiration for modern African football.

Albert Roger Miller was born on May 20th, 1952 in Yaoundé, the capital of Cameroon. His father worked on the railway, a job that meant his family had to move regularly. Wherever Roger went he would make new friends through playing football. His skill earned him the nickname Pelé and at the age of 13 he signed for Éclair de Douala. 5 years later he moved to Léopard de Douala where he won the Cameroon League in 1972 and soon moved again to Tonnerre de Yaoundé – winning the Cameroon Cup (1-0 against Canon de Yaoundé), the African Cup Winners Cup in 1975 (against Cote d'Ivoire team Stella Club d'Adjamé 5-1 on aggregate), and were runners up (against Nigeria's Shooting Stars 4-2 on aggregate) in the following year – when he also won the African Player of the Year.

1977 was a massive year for Milla, who had changed his name from Miller to sound more African, when he moved to Europe to play with French team Valenciennes, however, his big break (and promised financial success) never materialised as he spent most of the next two years in the reserves, before moving to AS Monaco and then on to Bastia the year after. Although he had spent much of his time on the bench and injured he did manage to break into the national team. It would take another move though before Milla was able to really establish himself – this time at Saint-Etienne where he scored 33 goals in 62 games (1984-86), before moving again to Montpellier where he was also successful scoring 41 times in 102 appearances (1986-89). He took part in Cameroon's first World Cup in Spain 1982 in which the Indomitable Lions surprised and delighted supporters around the world with strong performances to draw against Peru (0-0), Poland (0-0) and Italy (1-1). They were unbeaten but desperately unlucky as they were eliminated because, eventual winners, Italy – although tied on points - had scored more goals than Cameroon, even more galling as Milla had a goal dubiously disallowed against Peru that could have taken them through. Cameroon, and with it African football, had arrived on the world stage.

With Milla as talisman, Cameroon lifted the African Cup of Nations in 1984 beating Nigeria 3-1 in the final and were runners-up in 1986 to Egypt losing on penalties. However, with a poor showing at the 1984 Summer Olympics and narrowly failing to qualify for the 1986 World Cup Roger Milla retired and started working as a coach at Montpellier. He then moved to the small French island of Réunion in the Indian Ocean, to relax and enjoy his retirement. He couldn't quite hang up his boots though and played for

Milla played in three World Cups for Cameroon, and at the age of 38, when most players have retired, he inspired them to the quarter-finals of Italia 1990.

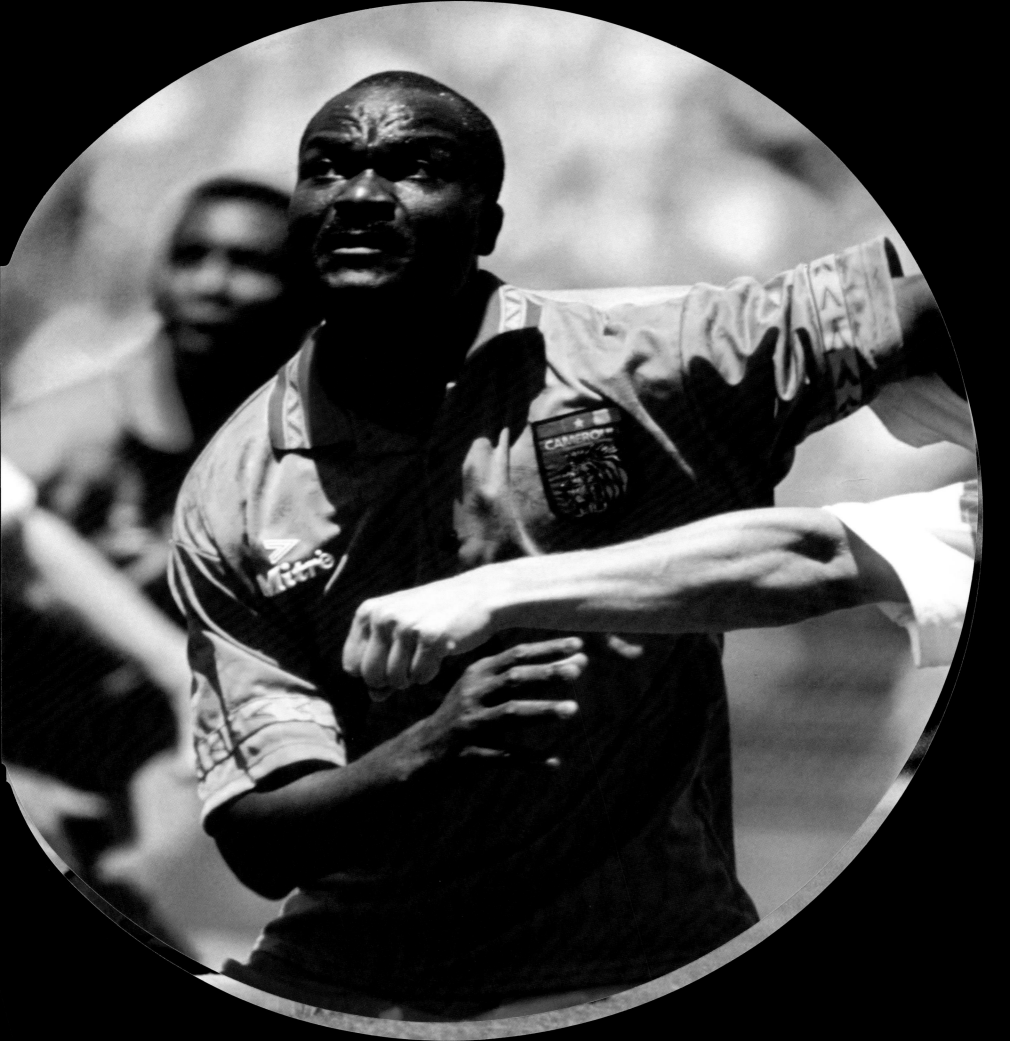

GERD MÜLLER

M üller was unusual for a football player. He was stocky, not particularly tall (at 1.70 metres/ 5'6") or fast but he had unsurpassed predatory goal-poaching instincts and positioning, combined with great balance which gave him the ability to twist and turn quickly, a powerful aerial presence and excellent acceleration over short distances – meant he was a ruthless "fox in the box", snatching goals from scraps in and around the penalty box often at crucial times in big games. On the Euro 2008 website, they remember Müller's ability to score "…from impossible positions: standing up, lying down, sitting down and when falling, with his head, with his right and left feet, with the knee, his heel and with his toes, Müller even struck with his stomach and backside."

Gerhard Müller was born in the historic Bavarian town of Nördlingen in Germany on November 3rd, 1945. While completing an apprenticeship as a weaver his football career started at local side TSV 1861 Nördlingen in the 1963/64 season making an immediate impact, scoring 46 goals in 31 games. It was impossible for such talent to go unnoticed and FC Bayern Munich soon came knocking, however, today's giant of German football was at that point in Regional Liga Süd (the Southern Regional League, a division below the Bundesliga). Propelled by Müller's 35 goals in 32 league matches – and the skills of future star goalkeeper Sepp Maier and sweeper Franz Beckenbauer – Bayern were promoted and began their own march to glory to become

one of the largest, most successful teams in Europe. The following season they finished 3rd, won the German Cup and qualified for the European Cup Winners Cup (today's UEFA Cup, which they won against Glasgow Rangers 1-0), and would go on to win the Bundesliga and German Cup double in 1968/69. This was also the season Müller really hit his stride in the top flight, winning league top scorer with 31 goals in 30 games. His success with Bayern continued; winning the league and German Cup double again an incredible three times in 1972, 1973 and 1974. Further European glory followed also as Bayern dominated the European Champions Cup as champions for 3 consecutive seasons – in 1974 (beating Atlético de Madrid 4-0 in a replay, with 2 goals from Müller), 1975 (scoring the winner in the 2-0 victory over Leeds United) and 1976 (beating AS Saint-Étienne 1-0). They also won the Intercontinental Cup in 1976 beating Cruzeiro of Brazil 2-0 – with Müller opening the scoring on an icy first-leg in Munich. He also topped the league scoring charts 7 times (1967, 1969, 1970, 1972,1973, 1974 and 1978) finishing with 365 goals in 427 league appearances, 80 goals in 64 German Cup games and a record 66 goals in 74 European Cup (including Champions Cup, Cup Winners Cup and Fairs/ UEFA Cup) appearances.

Müller's phenomenal goal scoring and success at club level were mirrored with West Germany's national team. Making his debut against Turkey in 1966 he went on to score an awesome 68 goals in 62 internationals. The 1970 World Cup in Mexico, arguably the best ever held, saw

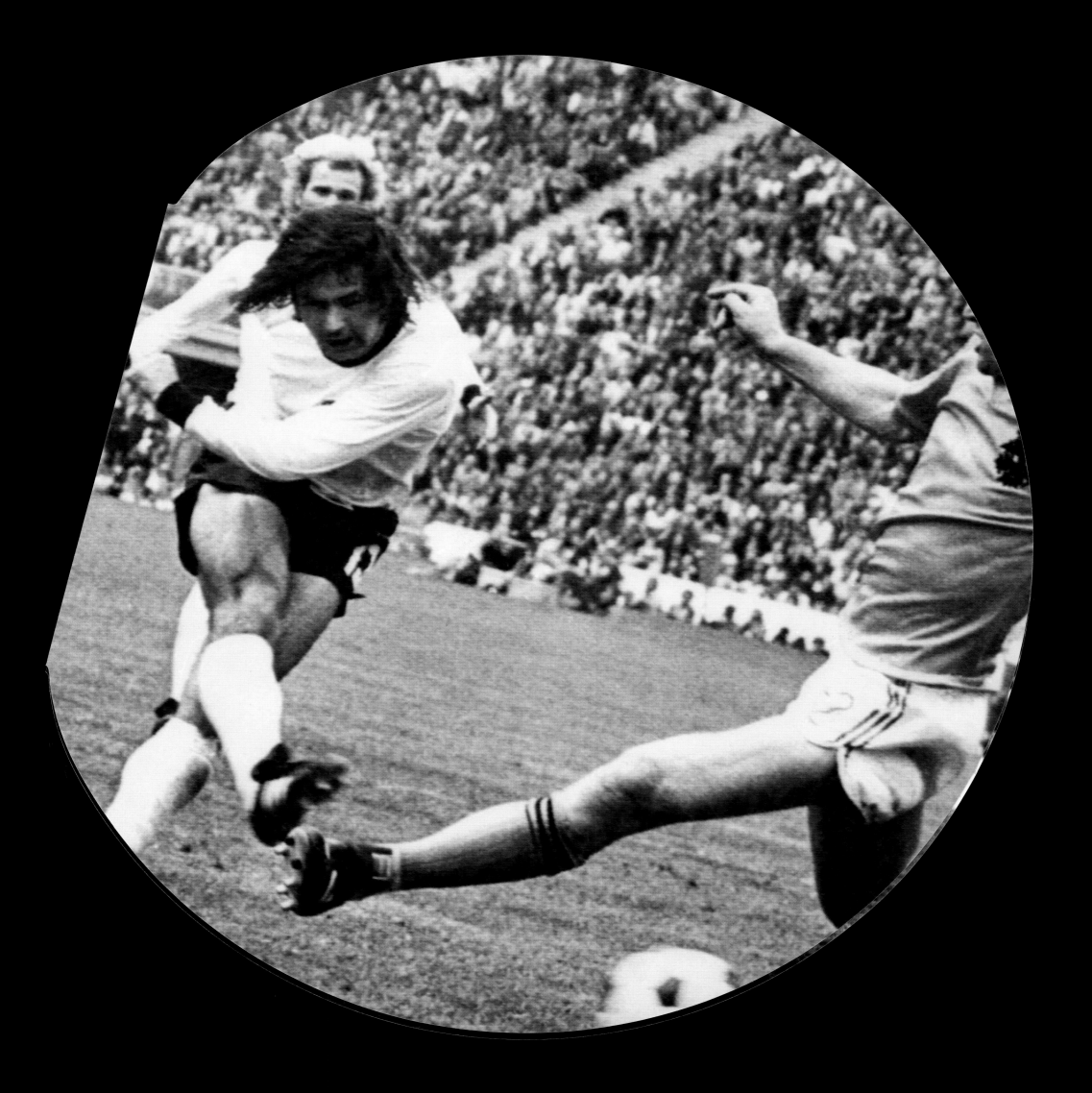

PELÉ

Pelé is the embodiment of Brazilian football –playing the game to a samba beat, with spellbinding flair and creativity. His autobiography coined the phrase the Beautiful Game and there can be no more fitting description of his own ability. Pelé played as an inside forward, striker and playmaker with visionary passing, slalom like dribbling, and an almost supernatural goal scoring ability. Scoring over a thousand goals, he also holds the record for being the youngest winner of the World Cup and is the only player to have won the World Cup three times. After collecting his 3rd winners medal, the headline in the English newspaper, The Times, read; "How do you spell Pelé? G-O-D."

Pelé was born Edson Arantes do Nascimento on the 23rd October, 1940 in a small city called Três Corações in Minais Gerais, a state in the south-east of Brazil. He had a fairly typical Brazilian upbringing, living in a small crowded house with a leaking roof, in a family that struggled to make ends meet and, of course, playing football whenever he could barefoot in the streets with his friends. Unable to afford a real football they would play with a sock stuffed with newspapers and rags tied with string. Despite material hardship, it was a close family and his parents taught him to respect the innate qualities of people, the importance of keeping a promise, and to live with dignity. It was these personal qualities that people around the world would come to love later in his life, as much as the sublime football he played.

Still a child, his family moved to Baurú in the interior of São Paolo state. His father was also a professional player, known as Dondinho. The family moved with his employment but when he was injured would lose their income – before getting his big break a serious knee injury ended his career prematurely. Dondinho became the first coach and fan of his son Edson, originally nicknamed Dico by the family (and even fought those who started calling him Pelé). Playing in the streets, his prodigious talent shone brightly. Despite which his mother, after witnessing her husband's difficulties, worried about the insecurity of a footballer's life and wanted something better for her son. Pelé wanting to help supplement his family's income began shining shoes. Starting in his family's neighbourhood (an area where half the people were barefoot) he met with little success, so convinced his mother to allow him to work at the Baurú Athletic Club stadium on match days and at the railway stations in town. It was around this time his aunt Maria gave him his first pairs of shoes, which had belonged to her boss's son. He was only allowed to wear them for church and special occasions, however, he ruined them when he decided to see what it was like to play football in shoes rather than barefoot. At the age of 11 he was playing for an amateur uncoached team called, Ameriquinha, when his flair was spotted by former World Cup player Waldemar de Brito and asked him to join a youth team he coached. At the age of 15, Waldemar took him for a trial at Santos football club, in the city of São Paolo, where he declared to a disbelieving board that

Scoring over a thousand goals, Pele also holds the record for being the youngest winner of the World Cup and is the only player to have won the World Cup three times.

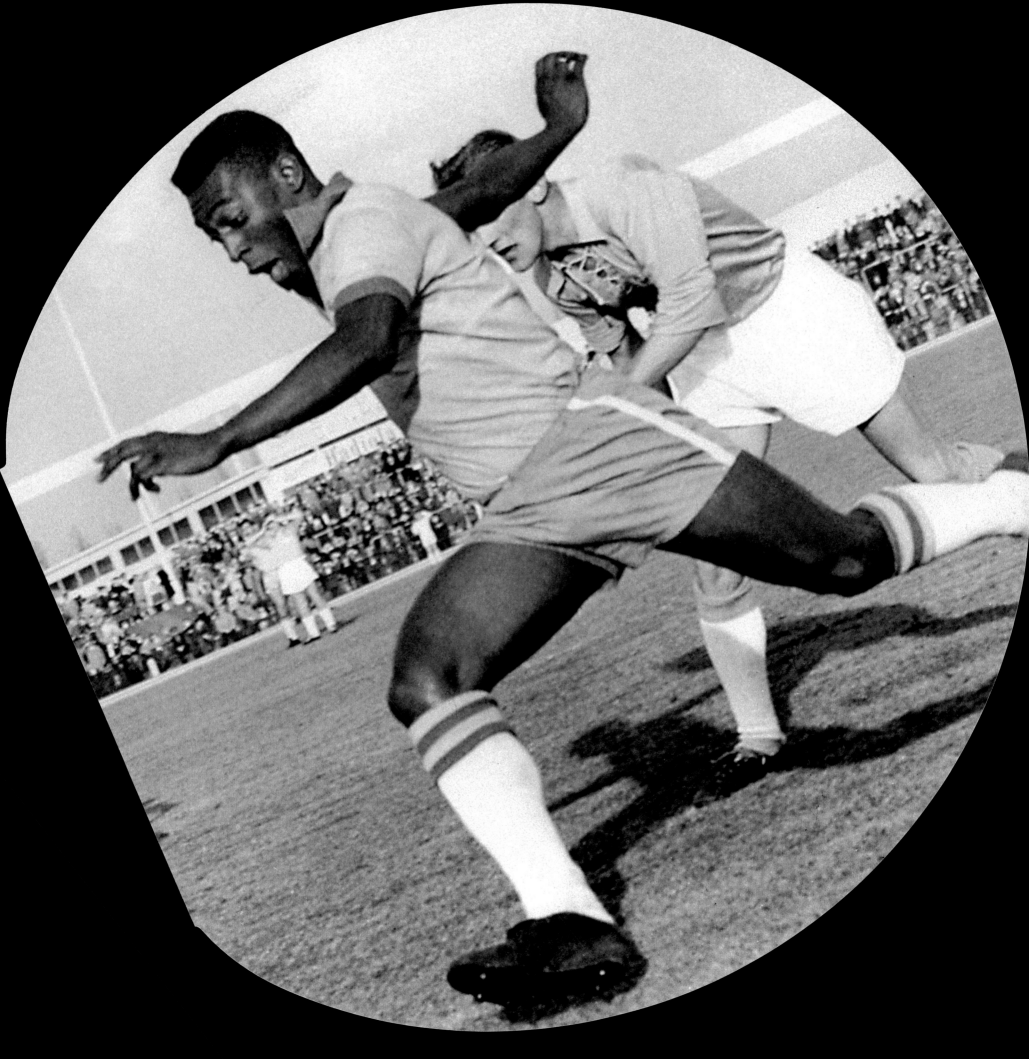

PELÉ

Pelé would become the greatest soccer player in the world. His incredible odyssey truly began playing for the youth team, before quickly making his senior team debut, scoring as a substitute in September 1956, still only 15 years old. In the first league game for Santos he scored 4 goals in one game. The next season he established himself in the first team to finish São Paolo's state league top scorer with 32 goals.

Pelé's meteoric rise continued as he was called up in 1957 to make his national team debut against Argentina, scoring the only goal in a 2-1 loss in 1957. However, with the 1958 World Cup in Sweden the virtually unknown 17 year old thrilled the world to become a legend. After Brazil's two opening group games, Pelé made his World Cup entrance against the USSR, although he did not score Brazil won 2-0. In the quarter-finals Pelé scored the only goal to knockout Wales, before scoring a hat-trick in a 5-2 demolition of France to put Brazil into the final. The final was a classic demonstration of attacking football and flair with Brazil hammering hosts Sweden 5-2 to win the World Cup for the first time. Pelé scored twice – the first included controlling the ball on his chest, flicking a beautiful precise lob over the nearest defender, before quickly nipping around him to sweetly volley into the net. Pelé, the youngest ever winner of the World Cup, crying tears of joy while hugged by his team mates after the final whistle will forever remain an iconic image of the World's biggest competition.

Pelé continued his phenomenal form for Santos, where he remained top scorer for every season between 1957 to 1965 – during which Santos dominated the Campeonato Paulista (state league champions in 1958, 1960, 1961, 1962, 1964, 1965, 1967, 1968, 1969 and 1973), the national Taça Brasil (1961, 1962, 1963, 1964 and 1965),

as well as the Copa Libertadores (beating Peñaro of Uruguay 3-0 in a replay in 1962, and Boca Juniors of Argentina 5-3 on aggregate in 1963). Santos soon capitalised on the Black Pearl's fame and travelled the world to play exhibition matches against its top teams, with Pelé receiving a percentage from each game he became one of the era's best paid athletes. By the 1962 World Cup finals in Chile Pelé was a global sensation. Brazil started with a 2-0 victory over, Pelé scored a wonder goal dribbling past 4 players before beating the keeper, however, 10 minutes into the next match against Czechoslovakia he pulled a thigh muscle trying a long-range shot and did not play again. Brazil still won, beating Czechoslovakia 3-1 when they faced each other again in the final itself. With the elite of European clubs trying to sign him, it is rumoured the government of Brazil declared him an official national treasure to prevent him moving overseas. If 1962 had been a disappointment, 1966 was even worse as Brazil struggled in England which saw the team struggle, before losing against Hungary 3-1 (during which Pelé was rested), before playing against a violent Portuguese side that literally kicked him out of the tournament, much to the disgust of spectators and commentators, and with it Brazil were knocked out at the first group stages. After which Pelé announced that he would not play again in the World Cup after such bad treatment and lack of protection from the referees. In 1967, his appearance with Santos during a short tour of exhibition matches in Nigeria created a 48-hour ceasefire in the Biafran civil war so both sides of the conflict could see him play. Pelé hit another incredible milestone by scoring his 1000th goal from a penalty against Vasco da Gama in 1969. Known as O Milésimo (The Thousandth), it was widely

PELÉ

celebrated in Brazil, as he dedicated it to all the poor children in Brazil.

Luckily for Brazil and the football world in 1970 Pelé was convinced to return for his final World Cup in Mexico. Pelé playing alongside Jairzinho, Rivelino, Carlos Alberto, Gérson, and Tostão were sensational and many believe formed the nucleus of one of the best teams ever seen on a football pitch. They were drawn in a tough group that included Czechoslovakia, Romania and defending world champions, England. Brazil beat Czechoslovakia 4-1, with Pelé scoring one and narrowly missing an audacious lob over Czech goalkeeper Ivo Viktor from the halfway line. In an unforgettable high-quality match England, who defended brilliantly, were beaten 1-0 by a Jairzinho goal set up by Pelé. Earlier he was certain to have scored with a bullet header but Gordon Banks somehow denied him with an agile flying dive to scoop the ball away before crossing the line, it is commonly referred to as the "Save of the Century". He opened the scoring against Romania from a free-kick and then added a second, before the game ended 3-2. In the quarter-finals they beat Peru 4-2, before beating Uruguay 3-1 in the semi-finals. The game also contained another piece of Pelé brilliance as he broke free of the defence to chase a ball knocked into space by Tostão, the Uruguayan keeper Ladislao Mazurkiewicz raced off his line to meet the ball, but Pelé sent the ball right as he ran left, leaving the keeper in no man's land as Pelé turned and shot, narrowly missing the net. Brazil outplayed Italy in the final, running out 4-1 winners – including a headed goal from Pelé and two assists - to be crowned the best team in the world for an unprecedented third time and in honour were allowed to keep the Jules Rimet trophy permanently.

Pelé wanted to leave the game while at the top. He played his last international match in a 2-2 draw against Yugoslavia in July 1971 and stayed with Santos for four more successful years, retiring in 1974 – after which Santos as a tribute permanently retired his number 10 jersey. However, he was soon out of retirement as he was tempted north to play in the lucrative North American Soccer League (NASL) for the New York Cosmos in a multi-million dollar deal (rumoured to be somewhere between $2.8 million or as high as $4.5 million). Despite being past his prime he still sparkled and gave the NASL a new level of glamour before retiring in 1977. His last game was an emotional exhibition match against Santos, as he played one half for either team before being carried on his colleagues shoulders around the stadium in a lap of honour in front of a capacity crowd at the Giant's Stadium.

After such an illustrious career Pelé devoted much of his time to charity, especially those helping underprivileged children through the United Nation's Children Fund (UNICEF), as well as also been made Brazil's Minister of Sport for 3 years. As well as advertising sponsorship, he has written an autobiography, and appeared in a number of films and documentaries, that included starring alongside Michael Caine and Sylvester Stallone in the 1981 classic. He is still an influential presence on football's global stage and is revered around the world not just for his skills but also his passion for the "Beautiful Game", sportsmanship and humility.

MICHEL PLATINI

Michel Platini always looked like he was a split-second ahead of everyone else on the pitch. Technically brilliant and one of the best passers of the ball the game has seen, he unlocked the toughest of defences by orchestrating attacks from midfield as a creative playmaker. He was also a prolific scorer from midfield and dead-ball situations for both club and the fabulous French national team of the 1980s. Off the pitch he was a practical joker who loved the fine things in life (good wine, good food and even continued smoking throughout his career), all of which for him was as important as being an athlete.

Michel François Platini was born on 21st June 1955 in the small village of Joeuf, in the north-eastern French region of Lorraine. Much has been made of Platini being the son of an Italian immigrant labourer with few roots in France – the country he captained so successfully. However, as in much of football folklore elements of truth merge with fiction. Michel's grandfather was indeed originally from the Piemonte region of northern Italy (which borders France and Switzerland) but settled in the area while searching for work in the aftermath of World War II. The Platini household spoke French, however, and Platini saw himself as a third generation immigrant. He was often irritated by the ignorance and lack of respect shown towards immigrants and the positive role they have played in France and its football. Unlike many of his generation who went on to play football professionally, who were taught in sporting academies, Platini learnt his skills playing in the street. His father,

Aldo Platini, a former footballer and coach, also took a keen interest in his son's football. He instilled the importance of moving the ball quickly through passing rather than running, as well as anticipating who to pass to before receiving the ball – qualities that would stay with Platini for life.

He began playing for his hometown youth side AS Joeuf, where he attracted the attention of top-league side FC Metz, a team the young Platini himself supported. But his early career looked doomed, injured for his first trial, he then fainted on his second while taking a fitness test, leading the doctor to diagnose him with a weak heart. Unperturbed he joined the reserve side of their less glamorous rivals AS Nancy-Lorraine in September 1972. Outstanding performances brought him into first team contention but he had to wait until 3rd May 1973 to make his full senior team debut against Nîmes. As he attempted to establish himself in the squad he suffered a double fracture to his left arm and was unable to play for the remainder of the season as Nancy were relegated to Ligue 2. Platini returned to play a pivotal role in helping the team cruise to the title and promotion, scoring 17 goals (many from his speciality free kicks). The next season, Platini served his National Service in the French army but played whenever possible – helping the side reach the semi-finals in the French Cup and Ligue 1 safety. As Platini's football began to flourish he was called up to make his international debut against Czechoslovakia in March 1976, again scoring from a free kick, and played in France's Olympic squad later that year. Success followed with Nancy's victory in the 1978

Opposite: Despite fierce competition from big clubs all over Europe Platini moved to Juventus, and despite a difficult adjustment period, when he nearly left and criticism from the Italian media, it was the club where he enjoyed the most success.

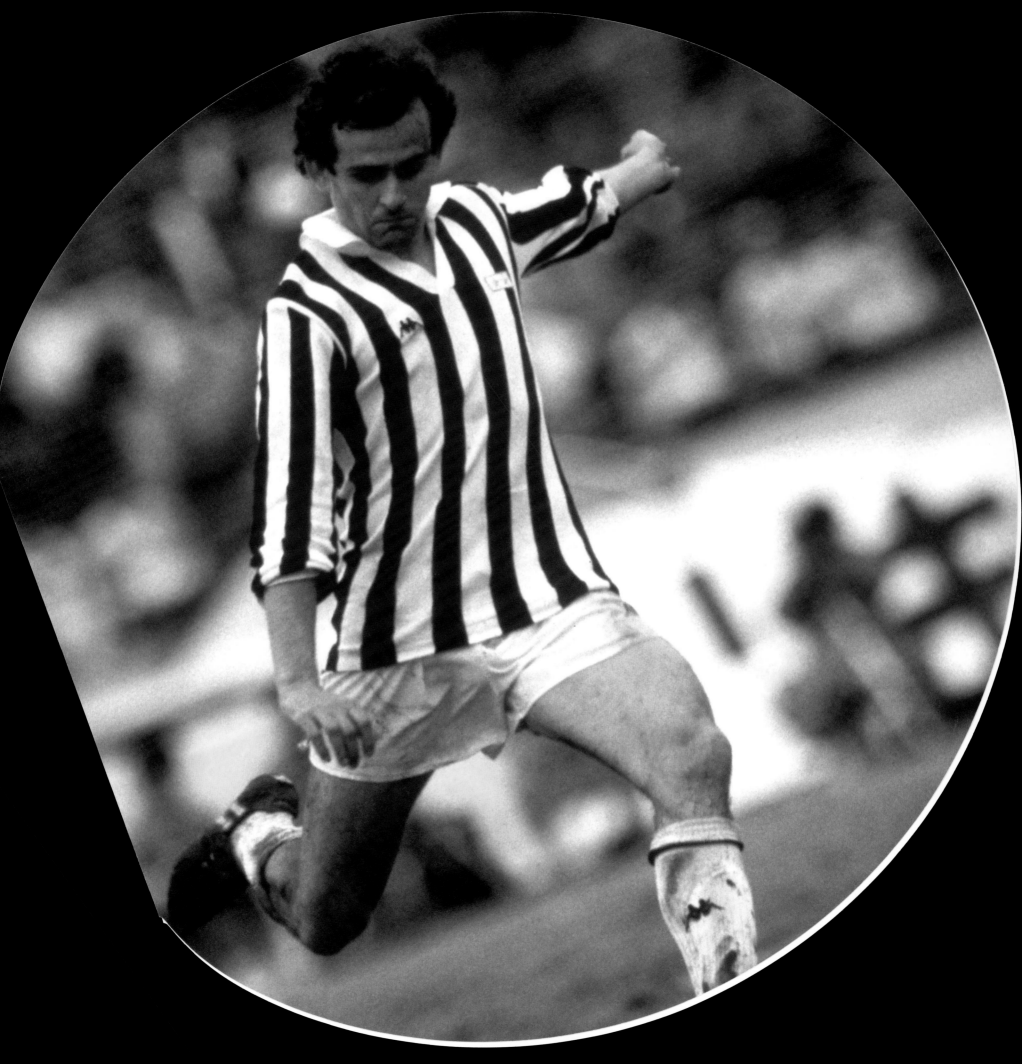

FOOTBALL CHAMPIONS

RONALDINHO

Ronaldinho blushes when he is compared to Pelé and Zico, and when asked by a journalist about how he felt being the best player in the world, he simply answered that he did not even feel he was the best player at Barcelona. However, such modesty cannot hide his irrepressible achievements: FIFA World Player of the Year in 2004 and 2005, as well as European Player of the Year in 2005. His best position is just behind the strikers but his technical ability and flair mean he can operate anywhere in attack or midfield. At home in Brazil he is commonly referred to as Ronaldinho Gaúcho to distinguish himself from his namesake Ronaldo (who is already referred to as Ronaldinho, or "little Ronaldo"). Gaúcho being the name commonly used for people from the Rio Grande do Sul region of Brazil.

Ronaldo Assis de Moreira was born in a favela in Porto Alegre, Brazil on 21st March 1980. His father was a shipyard worker and stadium security guard, while his mother worked as a civil servant at the town hall. When his older brother, Roberto, started playing professionally for one of the city's major team's, Grêmio, it provided the family with an unknown financial security. In an attempt to convince the young star not to move to Europe, the club bought the family a nice villa to live in. It was here, tragically, that his father João died in an accident in the

family pool when Ronaldinho's was 8. Roberto began looking after his family financially and also as a guiding light in the youngsters life. His own career, however, was cut short by injury before it could reach its full potential. Before soccer Ronaldinho loved playing futsal (a form of fast indoor 5-a-side soccer) and beach football – which, in part, explains some of his exceptional close ball control skills. The youngster's prodigious talent was recognised early, with his brother taking him to Grêmio's youth set-up, and was even captured on film scoring 23 goals in a 23-0 win. Recognition followed as he starred in Brazil's Under-17 World Cup win in Egypt, being named best player of the tournament. In 1998 he made his professional debut for Grêmio and a year later his debut for Brazil's senior team against Latvia. Not long after he came on as a substitute in the Copa América to score an exceptional goal in a 7-0 demolition of Venezuela. Later that year he was part of the Confederations Cup, he scored in every game he played but was injured for the final, where they lost 4-3 to Mexico. With his club, he scored 22 goals as he helped Grêmio win the Brazilian squad in the championship) and the Campeonato Gaúcho (state Cup) in 1999. However, in 2000 his contract ran-out. Despite being happy at the club he was seeking a new challenge. With Europe beckoning, top French side Paris

154

Opposite: Still young, with the world and a ball at his feet there should still be many more moments of mesmerising magic on the pitch from Ronaldinho for fans around the world.

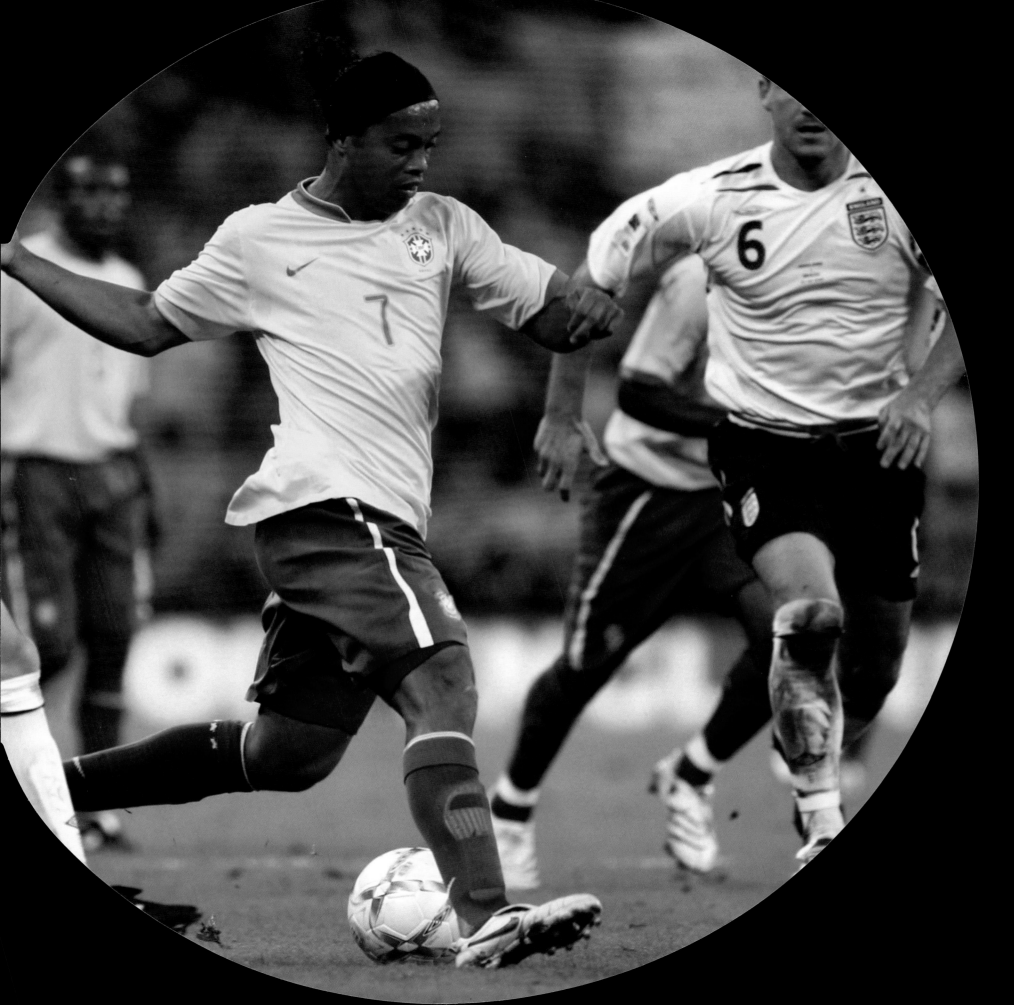

RONALDINHO

Saint-Germain (PSG) underwent months of intense negotiations before Ronaldinho was finally allowed to leave for (some believe a relative bargain) Euro 4.5 million in June 2001.

Ronaldinho's undeniable skills continued to grow during his two seasons at PSG but he also began to hit the headlines for disciplinary problems and his interest in partying with the Parisian nightclub scene. Even so, he still scored 68 goals and played a significant part in Brazil's 2002 World Cup victory in South Korea – including scoring the winner against England in the quarter-finals with an audacious free kick to lob David Seaman before being harshly sent-off 7 minutes later. Another season and more controversy followed at PSG, when he stated publicly he wanted to move on. The elite of Europe's clubs lined-up to capture his signature, and for a long time it looked like he would become a Manchester United player but it was Barcelona who triumphed with a £20 million transfer in 2003 and a reported 5 year contract worth Euro 25 million.

Since arriving at Camp Nou Ronaldinho has continued to mature both as a player and a person to become one of football's great icons. His ability to turn a match with a piece of footballing magic and mesmerising skills have made him central to Barça's recent success and won him the adoration of football fans the world over. Despite the club struggling in the first half of the season he arrived, they picked up excellent form with a 17 game unbeaten run to finish 2nd and with it qualifying for the Champions League. Momentum carried on into the 2004/05 season when they won the league. Ronaldinho was awarded FIFA World Player of the Year in both 2004 and 2005, as well as the Ballon D'Or (European Footballer of the Year) in 2005. The club continued to grow even stronger in 2006 winning La Liga again and winning Europe's most coveted club competition, the UEFA Champions League, defeating Arsenal 2-1 in the final. Along with glory with Barcelona he has also become central to Brazil's national team. Leading them to Confederation's Cup victory in Germany 2005 with a 4-1 victory over Argentina. There were high expectations of Brazil, and even higher of Ronaldinho, to star at the 2006 World Cup, however, he was a shadow of his potential. As Brazil, after a lacklustre tournament, were knocked out at the quarter-final stage by a resplendent France 1-0. Media criticism and Brazilian fans anger increased when Ronaldinho was caught partying in Barcelona days later with fellow international Adriano.

He brought up 200 games with Barcelona in 2007 but transferred to AC Milan shortly after, having turned down an offer from Manchester City thought to be worth £25 million. Despite his extrovert skills and reaching the pinnacle of the game he remains close to his humble roots and family (with his brother Roberto working as his manager and his sister Deisi as press coordinator). Despite having returned to good form and being named as a member of the 30-man provisional squad that was submitted to FIFA on 11 May 2010, he was not named in Coach Dunga's final squad of 23 for the Brazilian squad in South Africa for the 2010 World Cup despite his deep desire to do so. Critics have claimed that the exclusion of players such as Ronaldinho, Alexandre Pato, Adriano and Ronaldo signals a move away from the classic Brazilian attacking "Joga Bonito" style of play.

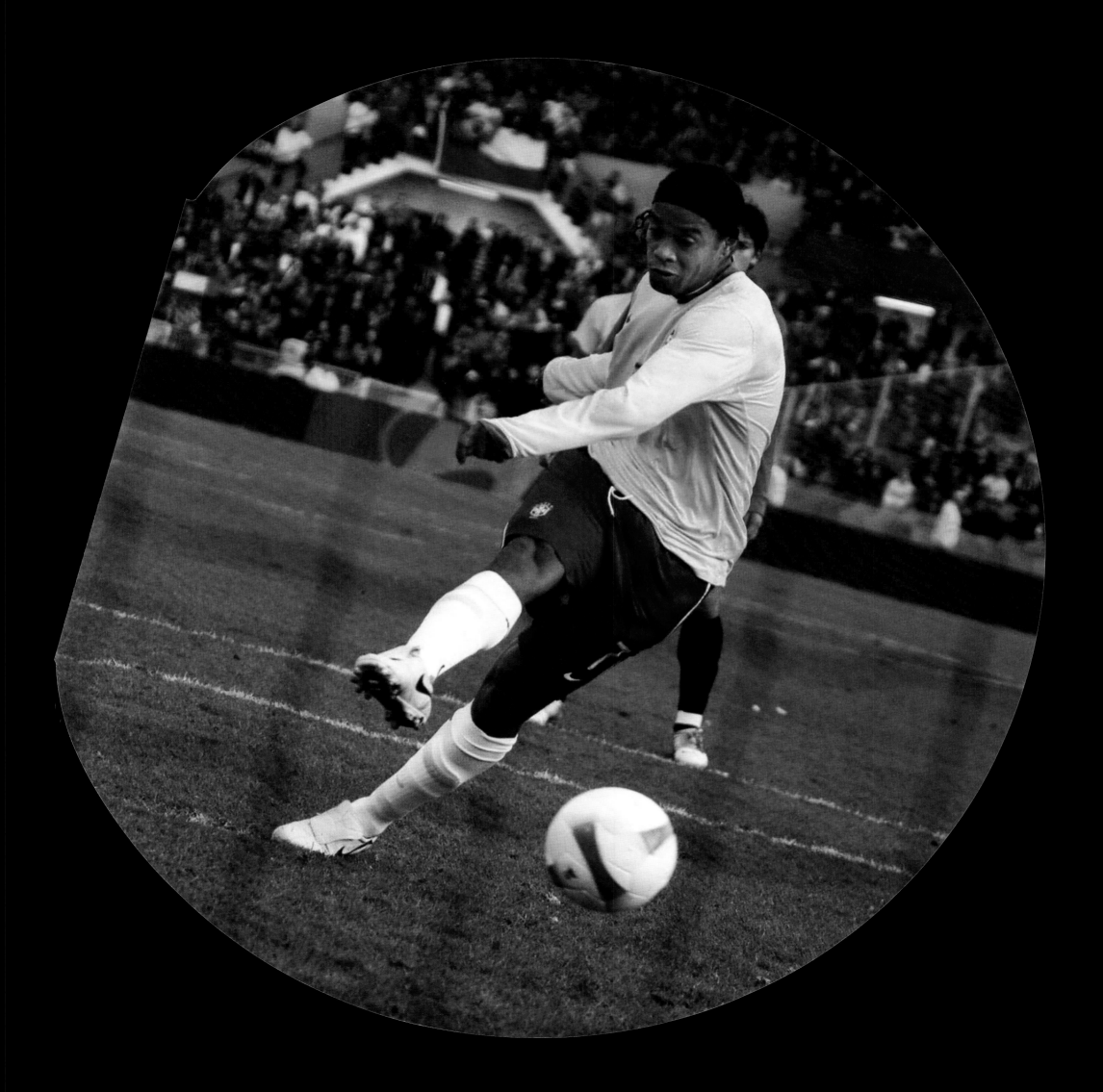

RONALDO

Known as The Phenomenon (El Fenómeno in Portuguese, or O Fenômeno in Spanish), Ronaldo is generally regarded as one of the most dangerous strikers to ever play the game – with the ability to beat almost any defender with pace and traditional Brazilian flair, allied with great body strength and power. Having won the World Cup twice with Brazil in 1994 and 2002, he now also holds the competition's all-time scoring record after scoring 15 times in 19 games over 3 World Cups. He has also won the FIFA World Player of the Year 3 times in 1996, 1997 and 2002.

Ronaldo Luis Nazário de Lima was born on 22nd September 1976 in Bento Ribeiro, a poor working-class neighbourhood on the outskirts of Rio de Janeiro, Brazil. Like most Brazilian children he started playing football barefoot with his friends in the streets, preferring to play than go to school, before his tremendous talent was spotted playing with the youth team of São Cristóvão by former Brazilian star, Jairzinho – who recommended the young Ronaldo to the Brazilian national youth team and his own former club in the city of Belo Horizonte, Cruzeiro Esporte Clube (better known as Cruzeiro). He became a teenage prodigy for the club scoring 12 goals in 14 league games in 1993 and was rewarded with a call-up to the Brazilian senior team at the age of 17, before making his debut against Argentina in March 1994. Later that year he was a member of the

World Cup winning squad in the USA but was taken for the experience rather than to play, due to his age, and remained on the bench.

With another goal in his first game of the 1994 season, Dutch giants PSV Eindhoven swooped for the youngster for a fee of Euro 6 million (£3.2 million). Critics argued it was an exorbitant amount for a teenage player but Ronaldo more than delivered, scoring 51 goals in 53 appearances over the next 2 years. Helping PSV to lift the KNVB Beker (Dutch Cup) in 1996 beating Sparta Rotterdam 5-2 in the final and was also the league's top scorer in 1995. With growing popularity and recognition in Europe, bigger clubs soon took notice with Barcelona clinching his signature for £10.25 million. Again another enormous fee that proved to be shrewd business, as he topped the Primera Liga's scoring charts in the 1996/97 season with 34 goals (with 13 more in the Spanish Cup and European Cup Winners Cup), before another move this time to Inter Milan for a world record (at the time) of Euro 30.5 million (£19 million), which it is rumoured greatly saddened Ronaldo who had felt at home in Barcelona. A time during which he also won his first World Player of the Year award (1996) – at only 20 years old, he remains the youngest winner ever - and struck the winning penalty in a 1-0 victory to win the 1997 European Cup Winners Cup against Paris Saint-Germain. He also played a crucial role in Brazil's victory in the 1997 Copa América, scoring 5 goals, as they

Despite the luxury lifestyle and huge sums of money surrounding his career, Ronaldo has refused to forget his humble roots and has regularly used his own wealth and celebrity status to help those with less.

MARCO VAN BASTEN

Until his career was cut short by injury, Marco van Basten, was one of the most lethal strikers to play the game. Nicknamed the Swan of Utrecht due to his agility, he was strong on the ball, good at volleying and excellent in the air, with good tactical understanding and off the ball positioning to create goal scoring opportunities. All facets of his play that made him a great forward, but what added another dimension to the striker was how the pressure of big matches brought the very best out of him, scoring when the goals were needed most.

Marcel van Basten was born on 31st October 1964 in Utrecht, in the Netherlands. At the age of 7 Marco started playing for local club UVV while dreaming of becoming a world famous gymnast one day. However, he continued playing and after ten years joined another Utrecht club Elinkwijk. His obvious potential was quickly spotted by the talent scouts of Dutch giants Ajax Amsterdam, whom he joined in 1981. He made his debut in his only game of the season as a substitute for the iconic Johan Cruyff-managing to score in a 5-0 rout of NEC Nijmegen, in April 1982. In the following season he managed a respectable 9 goals in 20 matches as Ajax won the Dutch league. However, it was the following season when Van Basten really exploded on to the football scene scoring an amazing 28 goals in 26 games as he dominated the league top scorer charts from 1984 to 1987. With technical brilliance, agility, excellent heading ability and consistent prolific scoring he won games and

created incredible statistics: scoring 37 in 26 games (1986) and 31 goals in 27 matches (1987). With this Van Basten became a mainstay of the Dutch national team, after his debut in a 3-0 victory over Iceland in 1983, he went on to score 24 goals in 58 matches – including 5 in one match against Malta in 1990. However, it was at the European Football Championship (Euro 88) in West Germany that Van Basten really shone. Becoming the competitions top scorer with a hat-trick against England, the winner against the hosts to put the Netherlands into the final, in which he scored a fabulous volley from an acute angle to help the Dutch win the trophy for the first time against the Soviet Union 2-0.

After scoring 151 goals in 172 matches for Ajax Van Basten was lured to Italy in 1987 as media magnate (and future Italian Prime Minister) Silvio Berlusconi brought in world class players (that would also include fellow Dutchman Ruud Gullit and Frank Rijkaard) in an attempt to rebuild AC Milan – a team recovering from bankruptcy, relegation and corruption charges. Again he scored in his debut, this time from the penalty spot as AC Milan beat Pisa 3-1. Even though AC Milan won their first Scudetto (Serie A championship) in his first season was not a great success as he combated a niggling ankle injury which restricted him to 11 league games, scoring 3 goals – while he also scored 5 times in 5 Coppa Italia matches and made 3 UEFA appearances. The following season, however, he was in excellent form making 48 appearances and scoring a total of 32 goals in all competitions - helping Milan to a

Van Basten became a mainstay of the Dutch national team, after his debut in a 3-0 victory over Iceland in 1983, he went on to score 24 goals in 58 matches – including 5 in one match against Malta in 1990.

FOOTBALL CHAMPIONS

MARCO VAN BASTEN

4-0 European Cup victory with 2 goals against Romania's Steaua Bucharest in the final. Although they were unable to retain the Serie A title the following year, Van Basten still finished top scorer in a league renown for its defensive qualities. Milan defended the European Cup, with a 1-0 victory over Benfica. The next couple of seasons were disappointing with a poor World Cup in 1990 for the Netherlands, little success in Serie A for AC Milan and Van Basten falling out with their manager Arrigo Sacchi (who was sacked by Berlusconi to keep Marco at the club). In 1992, with the arrival of his successor, Fabio Capello, AC Milan began an amazing run of form to remain unbeaten in Serie A for the whole season to lift the Scudetto. Van Basten again became the league's top scorer with 25 goals in 31 games. Playing great attacking football, the Netherlands also improved to reach the semi-finals of Euro 92 in Sweden before being knocked out by eventual surprise winners Denmark in a penalty shoot-out - with Van Basten's spotkick saved by Peter Schmeichel. The following season, Marco continued his excellent form and it looked like it would be one of his best in an already glittering career as he was named both FIFA and World Soccer magazine's World Player of the Year. However, only 3 months into the season his recurrent ankle injury which had plagued him since his arrival in Italy ended his playing days. Despite an enormous effort and numerous further operations over a two year period. His final appearance came in the Champions League final defeat by French team Olympique de Marseille.

Despite repeatedly stating he would never manage a football team, and enjoying the beginning of his retirement with his family, playing golf and tennis, he

missed football and undertook a KNVB (Royal Netherlands Football Association) coaching course. In 2003 he became assistant manager with the Ajax second team before, somewhat surprisingly due to his lack of management experience, was named as the new manager of the Dutch national team in July 2004. Van Basten took little time to stamp his authority on the squad, who despite brilliant players and occasional excellent performances, repeatedly failed to deliver - largely due to infighting as large egos and reputations clashed. He dropped famous names such as Patrick Kluivert, Edgar Davids, Clarence Seedorf, Roy Makaay, Mark van Bommel, and (even more controversially) Ruud van Nistelrooy and looked beyond the "Big Three" (Ajax, PSV Eindhoven and Feyenoord) who usually filled the team sheet to other Dutch teams such as AZ Alkmaar for players. His attempt to rejuvenate the team seemed to pay off as the team remained unbeaten in the 2006 World Cup qualification group. In the finals in Germany they survived Group C commonly referred to as the group of death, starting with a tricky opening match against Serbia & Montenegro which they won 1-0, a pulsating 2-1 victory over unlucky Côte d'Ivoire, and finished with a hard fought 0-0 draw against Argentina, but were knocked out in the next round with both sides being shown 2 red cards. Despite dissapointment at their exit this was Portugal in the next round with both sides being shown Van Basten's first competitive defeat as manager. He stepped down from coaching the national side at this point and took over coaching Ajax.

164